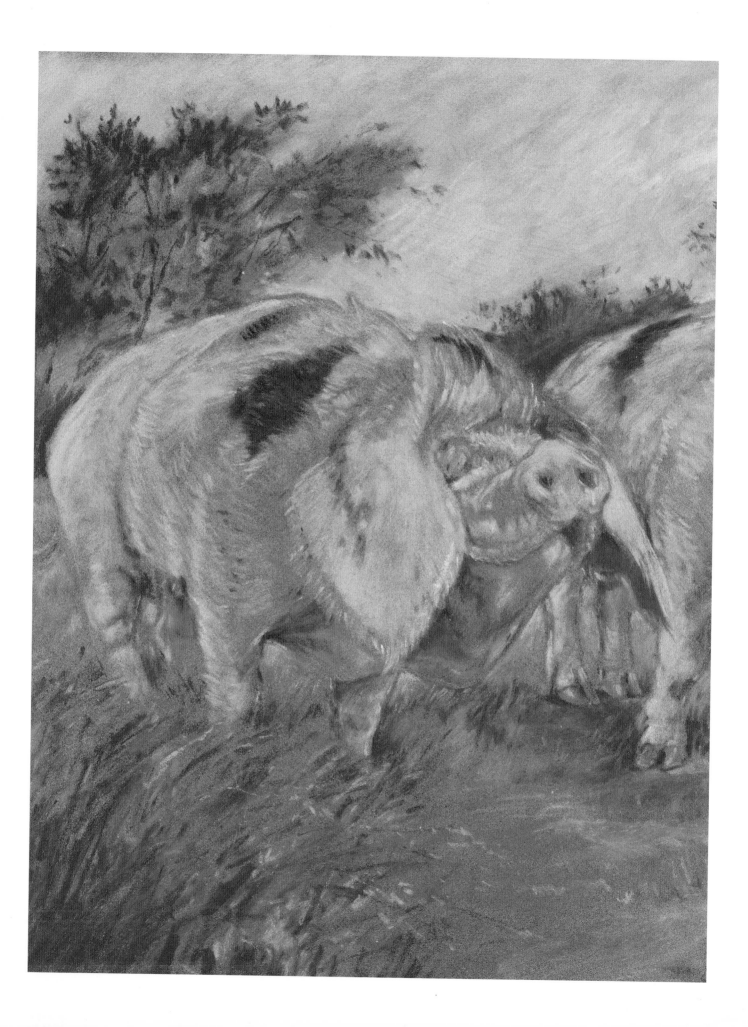

Drawing and Painting
Animals
Problems and Solutions

TRUDY
FRIEND

David and Charles

To all my animals, past and present

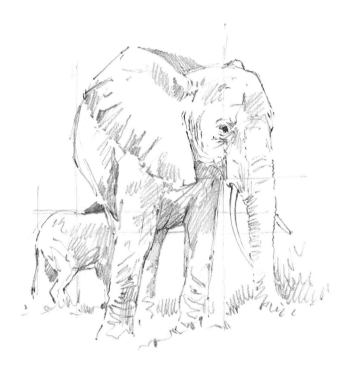

A DAVID & CHARLES BOOK
Copyright © David & Charles Limited 2006

David & Charles is an F+W Publications Inc. company
4700 East Galbraith Road
Cincinnati, OH 45236

First published in the UK in 2006

Text and illustrations copyright © Trudy Friend 2006

A catalogue record for this book is available from the British Library.

ISBN-13: 978-0-7153-2221-5 hardback
ISBN-10: 0-7153-2221-4 hardback

ISBN-13: 978-0-7153-2223-9 paperback
ISBN-10: 0-7153-2223-0 paperback

Printed in China by RRD
for David & Charles
Brunel House Newton Abbot Devon

Commissioning Editor Freya Dangerfield
Project Editor Ian Kearey
Editorial Assistant Louise Clark
Art Editor Lisa Wyman
Designer Jodie Lystor
Production Controller Kelly Smith

Visit our website at www.davidandcharles.co.uk

David & Charles books are available from all good bookshops; alternatively you
can contact our Orderline on 0870 9908222 or write to us at FREEPOST EX2
110, D&C Direct, Newton Abbot, TQ12 4ZZ (no stamp required UK only); US
customers call 800-289-0963 and Canadian customers call 800-840-5220.

The *Problems and Solutions* series of books from David & Charles grew
out of a series of articles that Trudy Friend wrote for *Leisure Painter*
magazine. *Leisure Painter* was first published in 1967 and is now the
UK's most popular painting magazine, helping beginners and amateur
artists to paint in all media. The magazine is available from all good
UK newsagents or direct from the publisher on subscription. Write to:
Leisure Painter magazine, Caxton House, 63/65 High Street, Tenterden,
Kent TN30 6BD; or telephone 01580 763315. Further information is
available on the website at: www.leisurepainter.co.uk

Contents

INTRODUCTION	4
MATERIALS	6
Monochrome media	6
Coloured dry media	8
Wet media	10
Mixing colour media	12
TEXTURES	14
LINE AND FORM	16
TONE	20
HEADS AND FEATURES	22
MOVEMENT	24
BODY MASS AND LIMB RELATIONSHIPS	26
EXERCISES IN ACCURACY	28
WITH AN ARTIST'S EYE	31
DOMESTIC PETS	34
Dog	36
Cat	38
Rabbit	40
Guinea pigs	42
Mouse	44
Shetland pony	46
FARM ANIMALS	48
Bulls	50
Pig	52
Goat	54
Sheep	56
Horse	58
Cockerel	60
Duck	62
ZOO ANIMALS	64
Elephant	66
Rhinoceros	68
Hippo	70
Lion	72
Tiger	74
Monkey	76
Camel	78
Giraffe	80
Zebra	82
WILD ANIMALS	84
Red fox	86
Badgers	88
Otter	90
Beaver	92
Grey squirrel	94
Grey wolf	96
Moose	98
Grizzly bear	100
BIRDS, REPTILES & INSECTS	102
Golden eagle	104
Parrots	106
Emperor penguins	108
Mute swan	110
Toad	112
Crocodiles	114
Butterfly	116
Grasshopper	118
CONCLUSION	120
INDEX	121

Introduction

With this book I will be helping you...

to love your art,

to live your art

and see the world go by

as colour, texture, line and form

and with an 'artist's eye'.

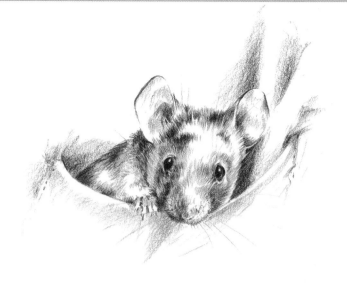

A love of animals inspires many artists to include them in their drawings and paintings, even if they choose not to specialize in animal portraiture.

For some their desire to draw and paint the animal world is accompanied by a fear of misrepresentation, due to lack of knowledge. Whether it is the inclusion of sheep or cattle in a pastoral landscape or the portrayal of a pet cat or dog, it is often the fear of 'spoiling' the former or even how to start the latter that inhibits progress or prevents these avenues from being explored.

Getting past the problems

With knowledge and understanding, however, fear recedes and confidence takes its place. It is also true that discipline leads to freedom, and by learning the basic disciplines of close observation and practising accurate representation, the freedom to draw and paint animals in any medium is achieved.

Observation and accuracy

To this end the importance of close observation is mentioned frequently in this book, both in the introductions and the themes themselves; exercises in accuracy are also included in relation to many of the animals within the themed sections. Once correct proportions of the animal have been achieved, the use of directional strokes in pencil, pen or brush will give the impression of three-dimensional form. The artist can work from life, photographs or memory (imagination), but it is wise to practise the former in order to build a 'memory bank' for future reference before attempting the latter – otherwise, disappointment may result from lack of awareness.

With an artist's eye

Learning to look 'with an artist's eye' increases an awareness of the fact that portraying animal subjects may be approached in the same way as with any other subject – by looking for shapes (both positive and negative) and using guidelines that help place components correctly. This forms the scaffolding upon which the image is built, and the feeling for animals, which is what prompts their depiction in the first instance, can then take over so that they can be portrayed in the artist's own individual style.

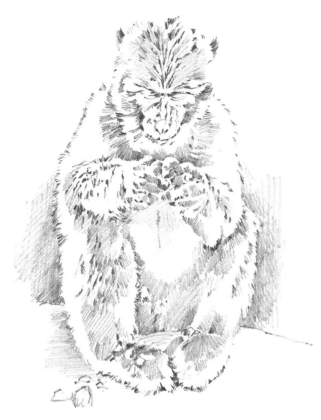

Choosing a medium

When considering how to portray the subject of animals, it is often the feeling we have for a particular species that encourages us to use a certain medium. For example, soft, fluffy fur may suggest pastel, and smooth shining coats with strong highlights may lead to using watercolour. Solid areas of wrinkled skin may be depicted with the use of acrylic – enhancing textured detail – and herds of animals against desert backgrounds may suggest the use of gouache.

Detailed drawings could present small mammals in a delicate way by the use of coloured pencils, tinted ink drawings or watercolour pencils. In addition, any animal subject benefits from initial monochrome drawings and sketches; for these, there is a vast choice, including graphite pencil, carbon and charcoal pencils, Conté pencils and sticks, as well as Graphitint (coloured soluble graphite pencils). Black animal fur can be successfully suggested by the use of watersoluble graphite – either alone or mixed with watercolour for a hint of hue in the highlights.

There are numerous opportunities for mixing media, and I have included a few mixed-media options in the themes, sometimes as simply as enhancing watercolours with pencil.

Materials
Monochrome Media

Pencils

There are many varieties of pencils available; because the range is readily available, the Derwent selection I have made includes Graphic Sketching and charcoal pencils plus Graphitone (solid pencil-shaped graphite) and Graphitint (coloured soluble graphite pencils).

The Graphic Sketching selection ranges from the hard H to the soft 9B. By using the wide (chisel) side of the pencil, created by making a tonal block initially, these broad strokes are possible. The strip can then be turned in order to draw in details with the narrow edge – in the same way that a 'detail' brush would be used when painting.

Making a tonal block before you start to draw produces a 'chisel' shape, resulting in a wide line

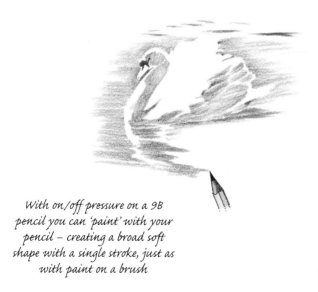

With on/off pressure on a 9B pencil you can 'paint' with your pencil – creating a broad soft shape with a single stroke, just as with paint on a brush

Derwent Graphic (Sketching)

Here, I have demonstrated differences between HB, 4B and 9B pencils in comparison with the softer charcoal pencil. Carbon pencils also achieve rich tones and exciting contrasts when used on smooth white paper surfaces.

For larger areas that require tonal variations and interesting lines on loosely drawn images, Graphitone is ideal; and to introduce a colour to monochrome drawing, a terracotta drawing pencil can be used.

Graphic Sketching pencil

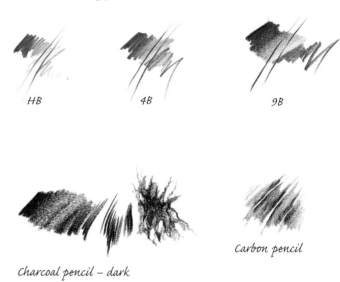

HB *4B* *9B*

Charcoal pencil – dark *Carbon pencil*

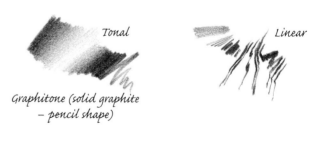

Tonal *Linear*

Graphitone (solid graphite – pencil shape)

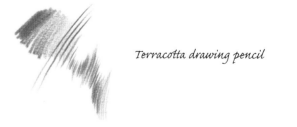

Terracotta drawing pencil

Nib and brush pens

Because pen and ink effects vary according to the surface upon which they are used, I have demonstrated them on two different papers.

The first is a smooth surface, showing linear and stippled applications. Next, I use textured paper to illustrate the marks made by black pigment liner pens and, as a comparison, a sanguine Pitt Artist pen.

A watersoluble brush pen is ideal for loosely drawn images that are to receive clear water washes.

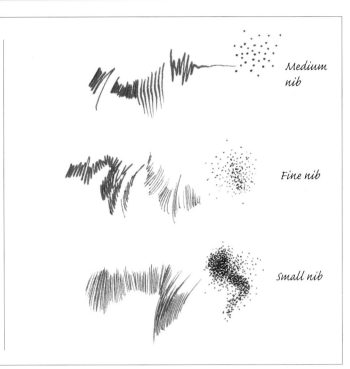

Medium nib

Fine nib

Small nib

Nib and brush pens

Brush pen

Watersoluble pens

Watersoluble fineliner pen images look effective when washes are added; they can also be drawn on to damp paper, which encourages the pigment to 'bleed'.

Stabilo Fineliner pen

With water applied

Waterproof pigment liner pens

01

05

Pitt Artist pen (sanguine waterproof ink)

Watersoluble nib brush pen

Watercolour pencils

Derwent Graphitint pencils, in a range of subtle hues, may be used as a monochrome media both wet and dry. Pastel pencils also respond to the addition of water.

Derwent watercolour pencil – chocolate

Graphitint pencil

With water applied

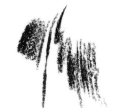

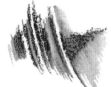

Pastel pencil

With water applied

Coloured Dry Media

Pastels

Whether you use pastel pencils or soft pastel sticks, working on a textured support (either tinted or coloured) can produce interesting effects. In many cases the supporting hue can be allowed to show through the pastel layer, giving a unity, and in addition, white or pale pastel hues contrast effectively upon the darker ground.

Soft pastel sticks can be used on their sides for broad, sweeping strokes that cover large areas.

Soft pastels

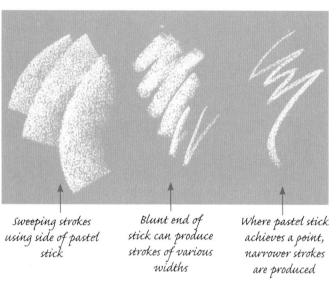

Sweeping strokes using side of pastel stick

Blunt end of stick can produce strokes of various widths

Where pastel stick achieves a point, narrower strokes are produced

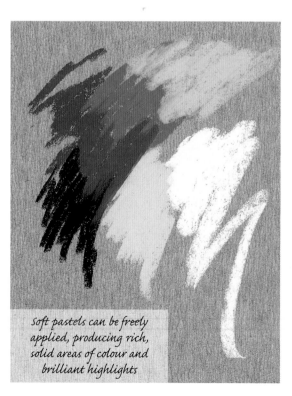

Soft pastels can be freely applied, producing rich, solid areas of colour and brilliant highlights

Soft coloured drawing pencils

These pencils have different effects when placed upon a variety of surfaces, depending upon the tint and texture of the support. Three examples are shown below, with the same palette of colours of Derwent soft drawing pencils used on three different supports shown opposite.

Pastel pencils

Applied to form solid mass

Overlaid colours

From solid into texture

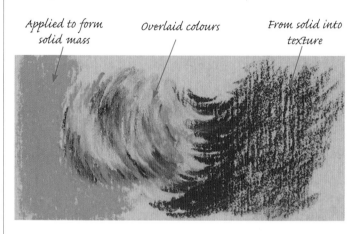

Sweeping strokes allow the colour of the support to show through

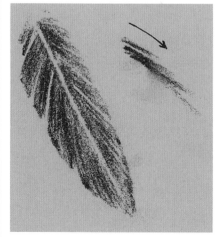

The support's colour can enhance the pastel hue

Supports

Lightweight white
Bockingford paper

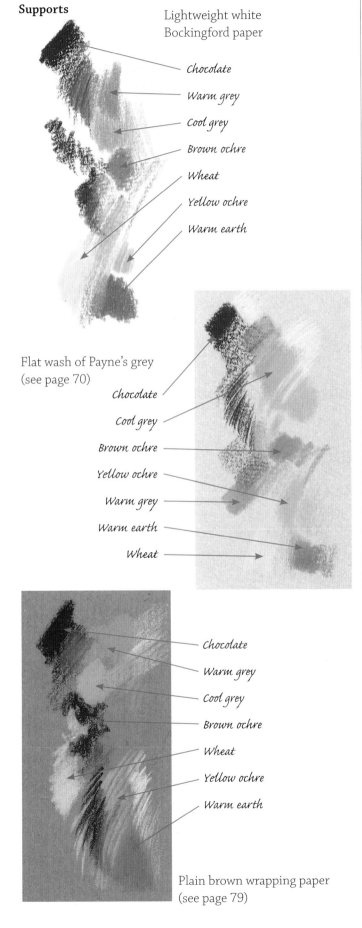

Chocolate

Warm grey

Cool grey

Brown ochre

Wheat

Yellow ochre

Warm earth

Flat wash of Payne's grey
(see page 70)

Chocolate

Cool grey

Brown ochre

Yellow ochre

Warm grey

Warm earth

Wheat

Chocolate

Warm grey

Cool grey

Brown ochre

Wheat

Yellow ochre

Warm earth

Plain brown wrapping paper
(see page 79)

Watercolour pencils

These pencils can be used wet or dry. I have demonstrated
them here on a smooth Saunders Waterford HP surface and
on a grey-tinted textured Bockingford surface.

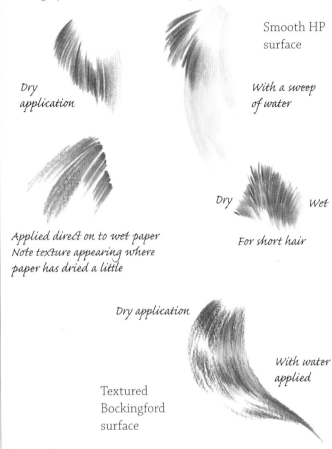

Smooth HP
surface

*Dry
application*

*With a sweep
of water*

Dry *Wet*

For short hair

*Applied direct on to wet paper
Note texture appearing where
paper has dried a little*

Dry application

*With water
applied*

Textured
Bockingford
surface

Brush pens

These versatile pens can be used with delicate pressure to
create fine lines, heavier pressure for wider strokes and
areas of solid colour, or varied-pressure lines – as well as for
the stippling method.

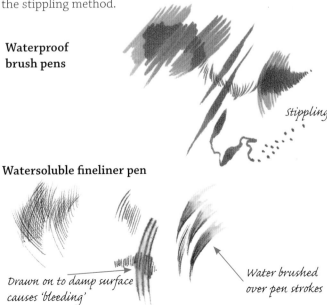

**Waterproof
brush pens**

Stippling

Watersoluble fineliner pen

*Drawn on to damp surface
causes 'bleeding'*

*Water brushed
over pen strokes*

Wet media

Watercolour

This is an exciting and versatile medium, and there are many techniques to explore, including wet-in-wet, dropping in, drybrush, overlaid washes and glazing. These, with the method of introducing highlights by lifting off, are covered here and in the various themes.

The use of a limited palette works well with animal subjects, so it is a good idea to purchase artists'-quality paint (as opposed to students'-quality) right from the start, and to gradually add to your range as you progress.

These examples have been executed on Rough surface watercolour paper, which is very effective for the drybrush method and also enhances other techniques.

Wet-in-wet

Dampen paper with clean water

Pick up pigment from palette on to brush and touch paper with tip

Pigment bleeds into damp surface, leaving diffused edges

Overlaying

Overlaying shadow area by applying single stroke of pale shadow tone

Short stroke application

Contoured short strokes placed one after the other to blend also retain untouched paper within the mass to suggest highlights or lighter hairs

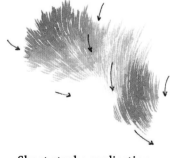

Drybrush

With less liquid in the brush, pigment is dragged across rough paper to produce a drybrush effect

Dropping in

After a pale hue has been applied, a darker hue can be dropped in close to the untouched paper to create strong contrasts

Glazing

A glaze can be swept across already-painted areas, to increase depth of hue

Lifting colour

While the watercolour wash is still wet, squeeze brush after rinsing in clean water and place over pigment to draw it from the paper, leaving a lighter tone

Gouache

This medium is opaque watercolour with a matt finish. With white in the palette, gouache can be very effective when used upon a tinted support or darker hues. These examples were painted on tinted Bockingford.

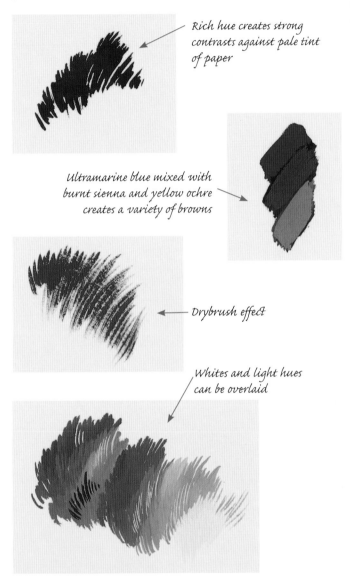

Rich hue creates strong contrasts against pale tint of paper

Ultramarine blue mixed with burnt sienna and yellow ochre creates a variety of browns

Drybrush effect

Whites and light hues can be overlaid

Gouache can be reconstituted with the addition of water, unlike acrylic

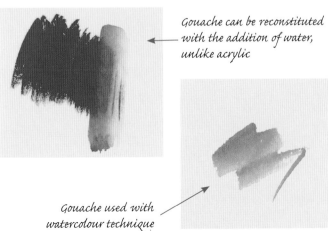

Gouache used with watercolour technique

Acrylic

A versatile medium, acrylic can be applied thickly, with medium consistency or in the same way as watercolour washes. Once dry it cannot be reconstituted, which means it is also useful as a base colour for other media – for example, under pastels or to make a coloured support for gouache.

When applied thickly, acrylic can be scratched out to give various textures; and used as translucent watercolour washes, it produces some exciting overlaid effects.

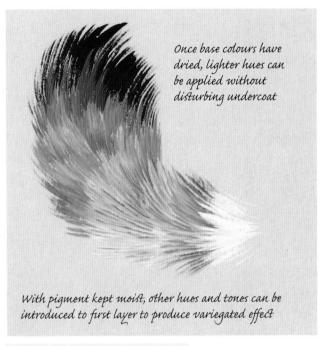

Once base colours have dried, lighter hues can be applied without disturbing undercoat

With pigment kept moist, other hues and tones can be introduced to first layer to produce variegated effect

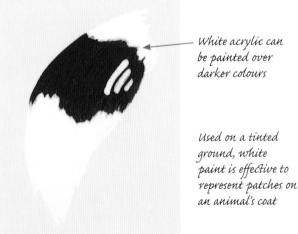

White acrylic can be painted over darker colours

Used on a tinted ground, white paint is effective to represent patches on an animal's coat

Thick paint application Scratching surface while paint is still wet

Blended with water for more diluted effect

Mixing Colour Media

Watercolour
Mixing watercolour for depicting fur

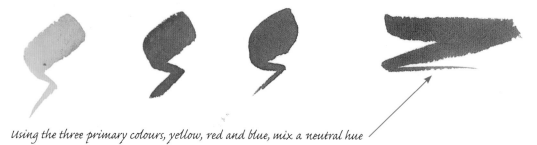

Using the three primary colours, yellow, red and blue, mix a neutral hue

This exercise shows you how to create the shadow shapes that form between lighter areas of fur.

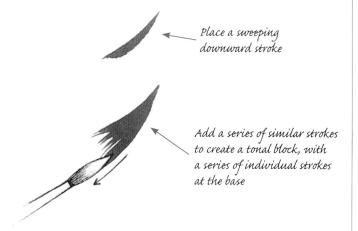

Place a sweeping downward stroke

Add a series of similar strokes to create a tonal block, with a series of individual strokes at the base

In this exercise you can see how to achieve shadow texture and highlight on the pad of an animal's paw.

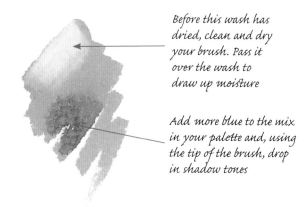

Before this wash has dried, clean and dry your brush. Pass it over the wash to draw up moisture

Add more blue to the mix in your palette and, using the tip of the brush, drop in shadow tones

Blending a background colour around an image can be practised in this little exercise.

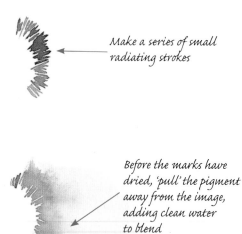

Make a series of small radiating strokes

Before the marks have dried, 'pull' the pigment away from the image, adding clean water to blend

Practise long hair impressions with curved strokes.

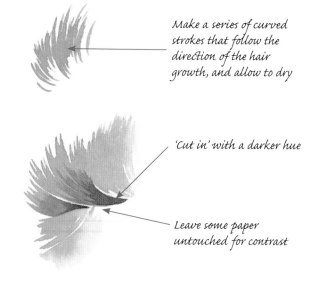

Make a series of curved strokes that follow the direction of the hair growth, and allow to dry

'Cut in' with a darker hue

Leave some paper untouched for contrast

Acrylic

Mixing colour

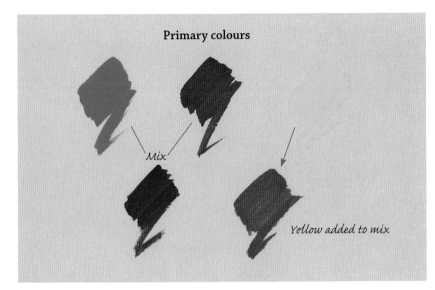

Primary colours

Mix

Yellow added to mix

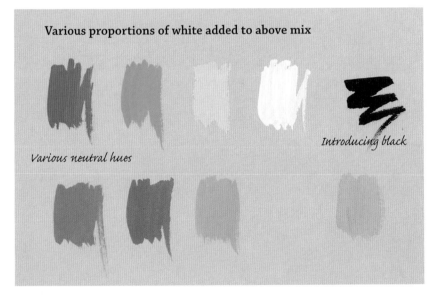

Various proportions of white added to above mix

Various neutral hues

Introducing black

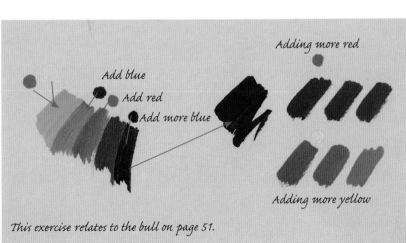

Adding more red

Add blue

Add red

Add more blue

Adding more yellow

This exercise relates to the bull on page 51.

Applying acrylic

After you have practised mixing a variety of hues in acrylic, these can be used for different effects.

Flat brush application – useful for plain backgrounds

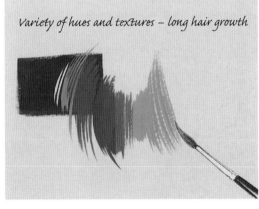

Variety of hues and textures – long hair growth

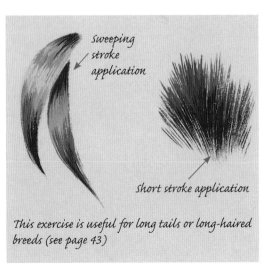

Sweeping stroke application

Short stroke application

This exercise is useful for long tails or long-haired breeds (see page 43)

Textures

Hair and wool

Two totally different textures, hair and wool, make an interesting comparison. The former can be achieved by the use of lines, and the latter with more regard for tonal shapes.

Problems

The illustration on the right demonstrates the difficulties some artists experience when attempting to depict smooth hair on an animal with a short coat and sheep's wool (see page 57) or a curly-coated effect (see page 48).

Pencil

In the illustrations below you can see how line and tone can be used for both different textured surfaces. Lines that indicate folds of wool-covered skin on a sheep need to be depicted unevenly in order to give a natural effect.

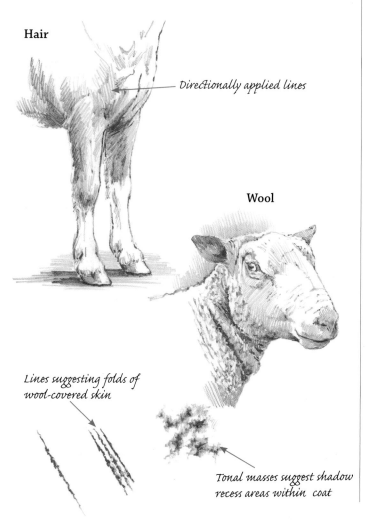

Hair

Directionally applied lines

Wool

Lines suggesting folds of wool-covered skin

Tonal masses suggest shadow recess areas within coat

Watercolour

Using watercolour you can introduce various hues in the form of washes, over which brushstrokes can be applied, in the form of contoured lines as well as tonal masses.

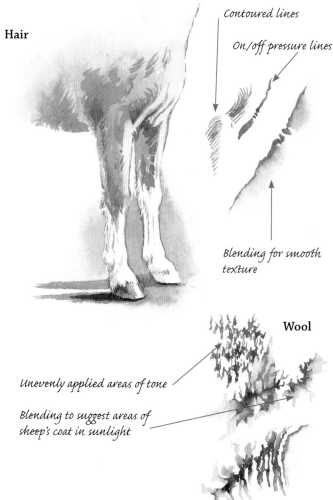

Hair

Contoured lines

On/off pressure lines

Blending for smooth texture

Wool

Unevenly applied areas of tone

Blending to suggest areas of sheep's coat in sunlight

Mixed media

By retaining watercolour washes as underlay, as well as some softened contoured brush marks, you can then apply ink drawing to enhance the effect.

In the illustration below I have used contoured strokes that follow form, crosshatching to enhance areas in shadow, and stippling. The latter shows how identical treatment can be applied to both animal form and background areas.

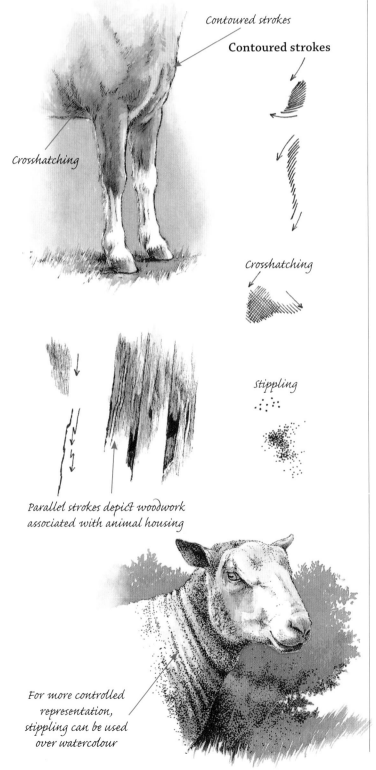

Contoured strokes

Contoured strokes

Crosshatching

Crosshatching

Stippling

Parallel strokes depict woodwork associated with animal housing

For more controlled representation, stippling can be used over watercolour

Detail studies

Pencil is an excellent medium for discovering the intricacies of textured animal skin, and this example shows how close observation of an elephant's body skin and the trunk folds can be depicted by using a combination of line and tone.

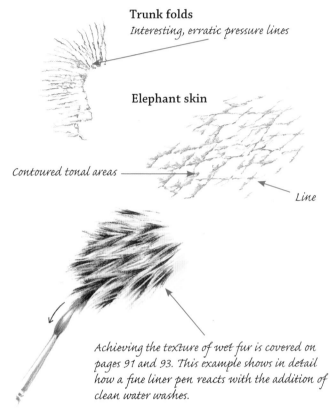

Trunk folds
Interesting, erratic pressure lines

Elephant skin

Contoured tonal areas

Line

Achieving the texture of wet fur is covered on pages 91 and 93. This example shows in detail how a fine liner pen reacts with the addition of clean water washes.

Textured supports

On page 115 a textured support enhances the use of pen work; and you can also use a variety of other papers that have regular, or irregular, textured surfaces. The examples below show the use of soft coloured pencils upon plain brown wrapping paper – see page 79.

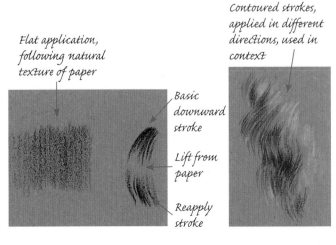

Flat application, following natural texture of paper

Contoured strokes, applied in different directions, used in context

Basic downward stroke

Lift from paper

Reapply stroke

Line and Form

Wandering lines

Line drawing that defines form can be executed in a variety of ways. A 'wandering' line is useful for quick sketches, as the pen or pencil need not be removed from the paper's surface until the image is complete. This allows continuity to be retained throughout the drawing as well as providing an exciting method of working. The first illustration of the duck below was executed using a continuous line (with no variation of pressure placed upon the pen), and from beginning to end the pen remained upon the paper's surface, not being lifted until the image was complete – this line wanders around the form, going back over itself in places where necessary before moving onwards again.

This way of line drawing is very helpful for practising sketchbook work, where you often need to draw swiftly, and where lifting a drawing tool from the paper would break continuity. When used as a method for drawing from life, you can also vary pencil pressure to produce interesting lines.

Interest of line

The series of mouse studies below was drawn using a soft pencil to create rich tones. I made very few marks within the images, except for a few essential contours that help define form. The main interest of line remains around the edge of each animal's shape, and these lines are executed with on/off uneven pressure to achieve interest of representation.

Interesting on/off pressure 'edge' lines

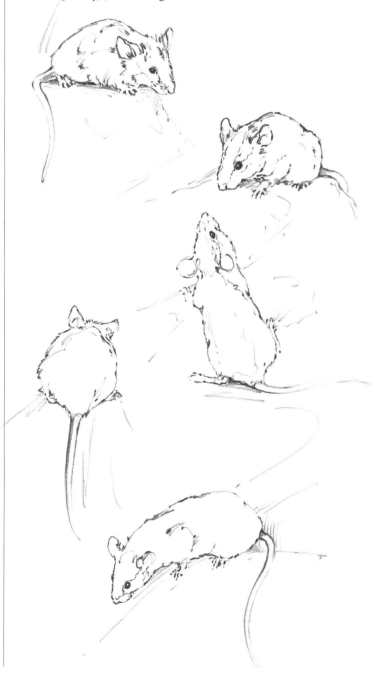

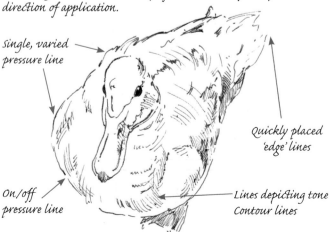

A wandering line finds form
Imagine this to be one continuous piece of brown thread. If you were to pull it, the whole image of the duck would unravel and disappear

A variety of lines create form
This image shows how a variety of lines describe form by their direction of application.

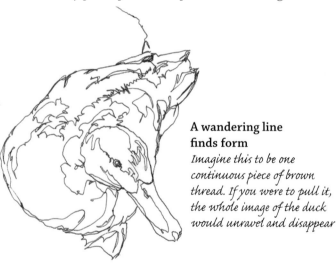

Single, varied pressure line

Quickly placed 'edge' lines

On/off pressure line

Lines depicting tone
Contour lines

Ink on tinted paper

Pen and ink drawing is very popular and there are numerous methods of application, using a variety of pens, on many different surfaces.

The tinted Bockingford paper used here, combined with a mapping pen nib dipped in acrylic ink (raw sienna), enhances linear representation by tint and texture.

On/off pressure lines are combined with a series of tiny strokes on some areas of muzzle and longer, curved strokes depicting the untidy hair found on top of the camel's head and around the neck. Sometimes pressure is lifted completely from the paper to introduce 'lost lines', which usually indicate highlighted areas.

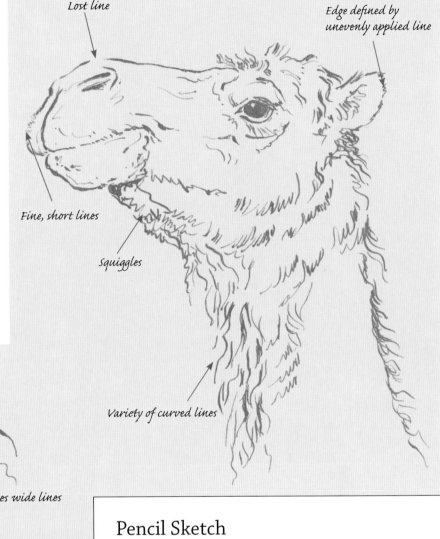

Lost line

Edge defined by unevenly applied line

Fine, short lines

Squiggles

Variety of curved lines

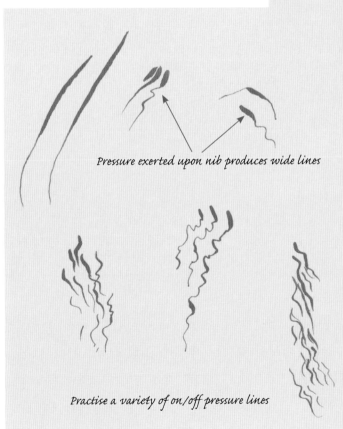

Pressure exerted upon nib produces wide lines

Practise a variety of on/off pressure lines

Pencil Sketch

Showing importance of:
a) Negative shape in a relationship
b) Relationship of dark tones against light

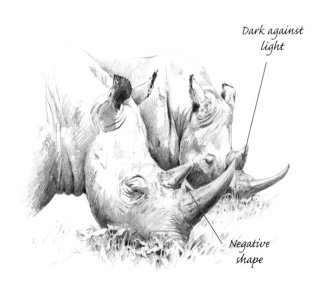

Dark against light

Negative shape

Markings

Lines may also be used to indicate markings – for example, the tabby effect on a cat's fur or, as here, on the fur of a short-coated dog. A series of short strokes (separate lines) are applied in a way that follows contours of pattern over the animal's form – in this instance, outlining the image is unnecessary. Note how much white paper remains untouched by pen on the dog's form, which is mostly defined by the direction of small strokes depicting pattern.

Around the perimeter of the study I have indicated the various considerations necessary for different marks of the pen; establishing a strength of background hues limited the amount of drawing necessary on the dog itself.

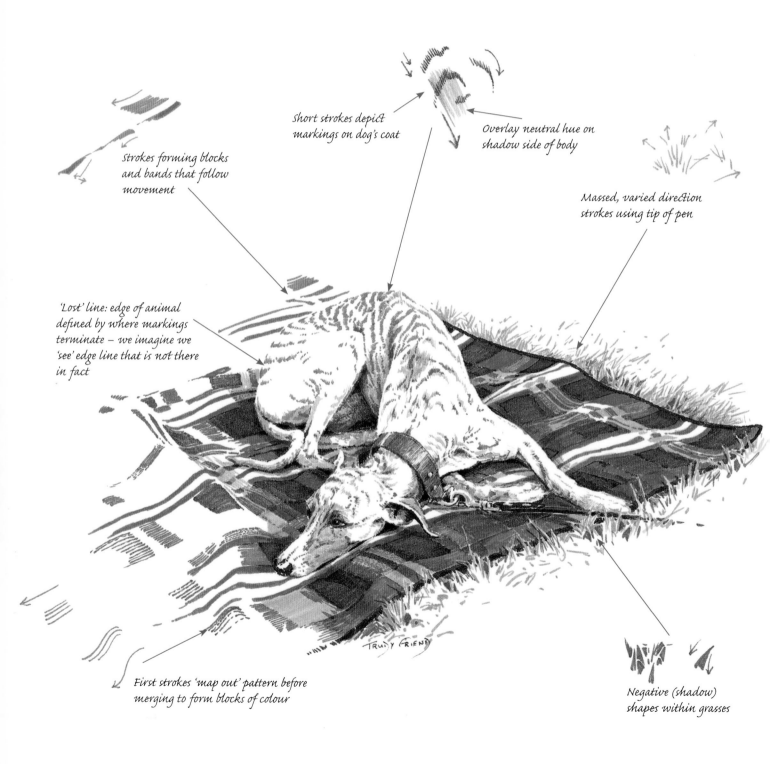

Short strokes depict markings on dog's coat

Overlay neutral hue on shadow side of body

Strokes forming blocks and bands that follow movement

Massed, varied direction strokes using tip of pen

'Lost' line: edge of animal defined by where markings terminate – we imagine we 'see' edge line that is not there in fact

First strokes 'map out' pattern before merging to form blocks of colour

Negative (shadow) shapes within grasses

Pen and watercolour wash

The versatility of pigment liner pens can be seen in these two illustrations, where undermarkings of stripes and pattern are achieved by overlaying ink strokes, to makes lines of varied width for the zebra and blocks of strong tone and hue to indicate patterns in the cat's fur. In both cases a textured paper surface enhances the effect, which is achieved by placing stroke upon and next to stroke, following the form to create contoured impressions.

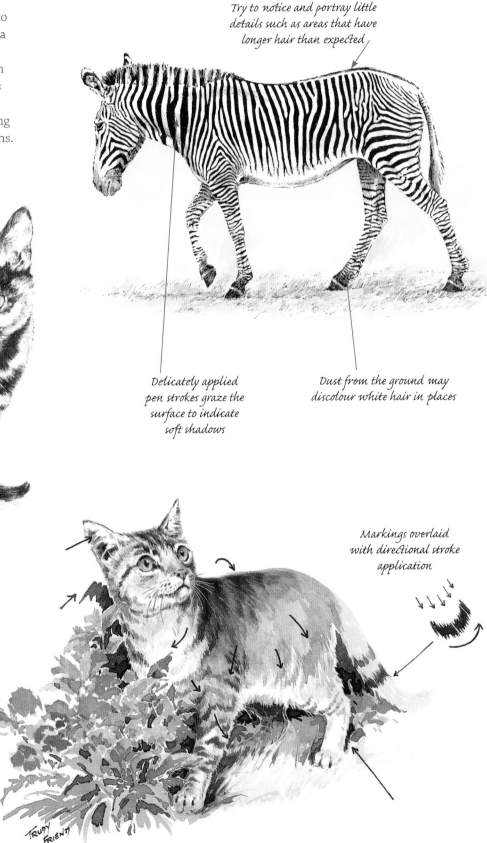

Try to notice and portray little details such as areas that have longer hair than expected

Delicately applied pen strokes graze the surface to indicate soft shadows

Dust from the ground may discolour white hair in places

Markings overlaid with directional stroke application

Tone

Introducing tonal values

Tonal values, from the darkest dark to the lightest light (usually white paper), need careful consideration. Creating contrasts, whether in monochrome media or colour, is what makes images come alive – a very important factor in animal representations.

A tonal scale – from the richest hue to the palest – can be practised in any media and on all sorts of surfaces. Just a few are shown here, and these have varied application to add interest, showing, in some, how they can be used in context to represent hair contours.

Demonstrating tonal variations within hair effect – rich darks against white paper

Three shades using Stabilo Fineliner pens, showing build-up of tone by overlaying and the introduction of white paper between strokes

Derwent Graphitint – *midnight black* *With water applied*

Derwent Graphic Sketching 8B – *dark wash*

With water applied

Derwent Artists – *burnt umber on smooth surface*

Derwent Graphitint – *cool brown* *With water applied*

Derwent watercolour pencil – *chocolate* *With water applied*

Note how colour changes with application of water

Watercolour pencil

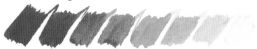

A mix of two hues sharpened into palette – water mixed with sharpenings to produce rich hue, and added in increasing quantities to introduce paler tones.

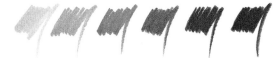

A variety of tonal values achieved with six Pitt Artist's pens in shades of grey. The two darkest shades were achieved by overlaying a second application of ink

Derwent Artists pencil – *burnt umber on textured surface*

Derwent pastel pencil – *chocolate with white added*

Winsor & Newton Designers Gouache

Burnt sienna diluted with water to blend into pale tones *White gouache added to produce paler tones*

Watercolour tonal 'ribbon' *Watercolour tonal blocks*

Tone in composition

Tone adds interest and credibility to interpretations, working with lines to produce interesting effects, and its use in composition is demonstrated in these sketches of cattle in their fields. Here you can see a variety of tonal values working together – paler to depict distance, and stronger for foreground foliage, against which the animal's image contrasts, to bring it forward. Rich, dark, connecting cast shadows lead our eye through the composition.

Problems
Even if this drawing were to receive tone, the composition would prevent interest of presentation

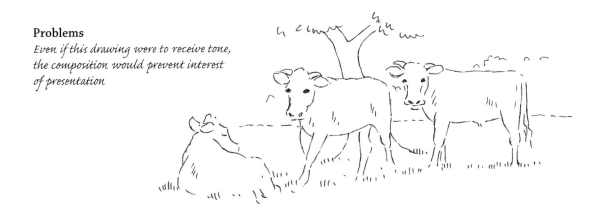

Solutions
Rich darks behind light forms bring animals forward in composition

The three numbered arrows show how our eye is led through the composition by the use of tone.

Part of cast shadow shape from tree

Small cast shadow shape from resting cow

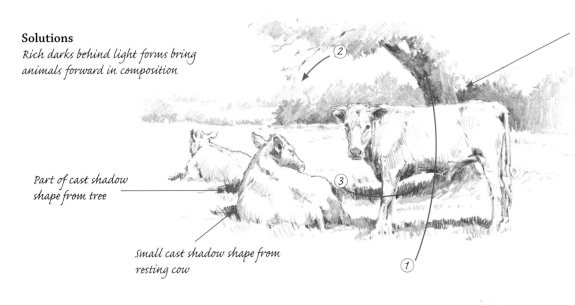

Small tonal shape immediately describes positions of both front legs in relation to chest

Note the variety of tonal values used in just one area of background (the hedge) and within the animal forms

Heads and Features

In the themed sections of this book you will find a variety of animals, birds and reptiles depicted, from which I have chosen just a few examples here in order to give pointers of what to look for in their heads and features.

Pencil study

The delightful, slightly comical, expression on a guinea pig's face, of which a side view is demonstrated in colour on page 43, is drawn below seen from the front to show how the eyes appear when viewed at this angle. The ears on long-coated guinea pigs can be partially hidden behind the thick, silky hair. To depict this, 'cut in' with dark tones to bring the light areas forward.

Always remember to leave strong, clear highlights in the dark eyes and use the whole tonal scale to provide the contrast of darkest darks against lightest lights (the white paper) – as well as the intermediate tones.

Directional strokes

The guinea pig study is a completed drawing, but I have left the one on the above right, the head of a goat, unfinished in order to include a series of arrows – indicating directional stroke application – showing how this defines the form beneath.

Within the longer hair of the beard you can see dark negative shapes. When working in monochrome, consider how white paper works within the tonal range.

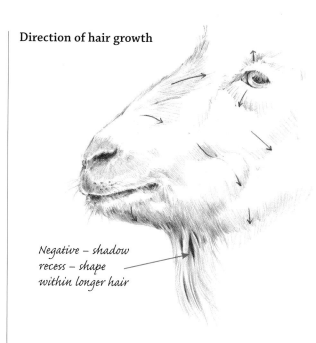

Direction of hair growth

Negative – shadow recess – shape within longer hair

Watercolour study

White paper also plays an important part in watercolour studies, and the illustration below, of a goat's head seen in front of the dark recess of its hut, demonstrates the strong contrast of a white form against an area in shadow.

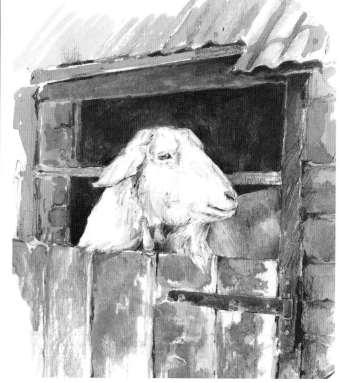

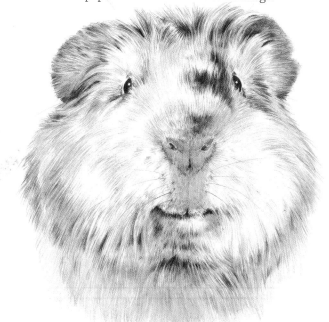

2B and 3B pencils on Bristol Board

Simple profile against dark background

Pen and ink

Working with pen and ink you can produce different effects, depending upon the surface texture of the paper and method used. This ink drawing of a chicken's head, drawn on smooth-surface paper, demonstrates how stippling on the comb area contrasts successfully with longer, contoured strokes used to depict feathered areas.

Soft and subtle

The softness of a duck's plumage is echoed in the softer appearance of its bill as opposed to the chicken's sharp beak. This image was executed on the same smooth paper as that of the chicken on the left, yet you can see a textured effect on the background area as the pencil grazes the surface to build intensity of pigment. I used Derwent Signature coloured pencils, which are highly lightfast.

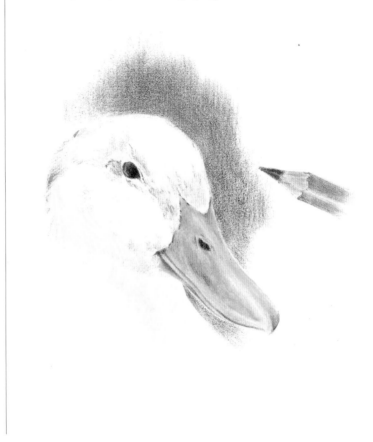

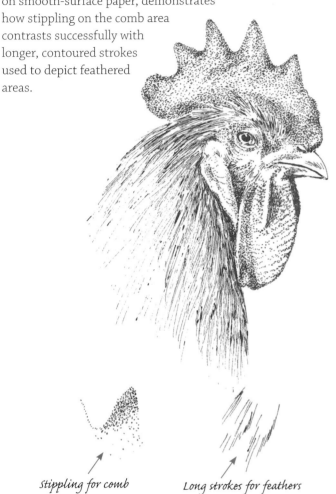

stippling for comb *Long strokes for feathers*

Pen, ink and wash

By gently grazing a pen over the surface of textured watercolour paper a delicacy of line can be achieved, as demonstrated in this head study of a crocodile. This image can be compared to that on page 115.

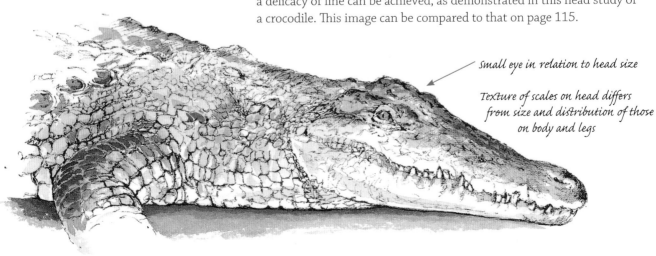

Small eye in relation to head size

Texture of scales on head differs from size and distribution of those on body and legs

Movement

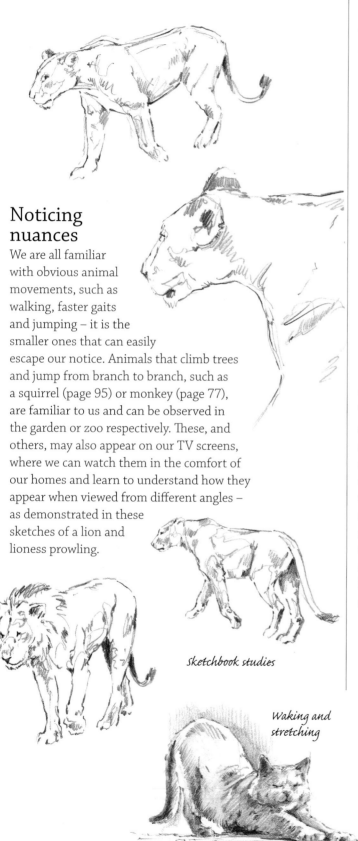

Noticing nuances

We are all familiar with obvious animal movements, such as walking, faster gaits and jumping – it is the smaller ones that can easily escape our notice. Animals that climb trees and jump from branch to branch, such as a squirrel (page 95) or monkey (page 77), are familiar to us and can be observed in the garden or zoo respectively. These, and others, may also appear on our TV screens, where we can watch them in the comfort of our homes and learn to understand how they appear when viewed from different angles – as demonstrated in these sketches of a lion and lioness prowling.

sketchbook studies

Waking and stretching

Small movements

It is helpful to be aware of the smaller, often unnoticed, movements in order to understand more about respective species. This detailed monochrome drawing of a cow cleaning itself shows one of the small movements that can catch our eye and add interest to the animals we observe.

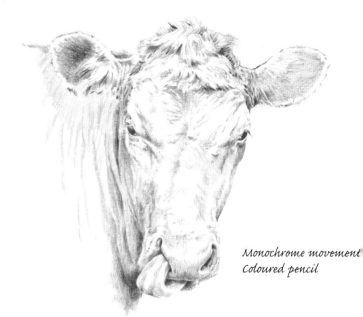

*Monochrome movement
Coloured pencil*

Close to home

We also have the opportunity to observe domestic cats, both at home or out of doors. My sketches of an old farm cat stretching after waking, prior to wandering off to find a comfortable place to rest or lie in wait for an unsuspecting mouse or bird, show obvious movement in the first two studies. The third sketch contains a movement that is less discernible – a turn of the ear to catch an elusive sound.

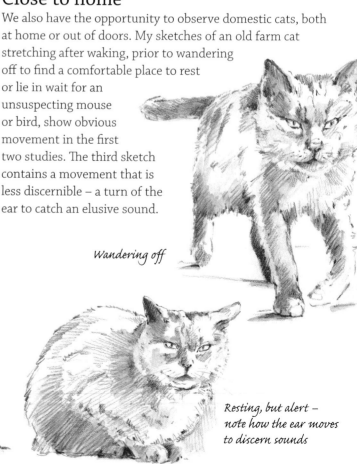

Wandering off

*Resting, but alert –
note how the ear moves
to discern sounds*

25

Other movements

In the themes, you will find other opportunities to notice movement within some of the animal studies: on page 59, where a horse is depicted grazing, there is a slow progression of one leg being placed after another, with a few moments in between. This allows us to be aware of bodyweight being transferred in a more leisurely way from one limb to another. Page 99 demonstrates two different angles of deer's head as it is turned, while the body remains in the same position.

Movement and weight

These two pen studies of an elephant walking show not only leg and shoulder movement at this pace but (in the upper study) how the animal may rest its trunk on a tusk while travelling – a small thing to notice, yet this tells us a great deal about the animal and the way it controls its body parts for convenience or to take weight from certain areas.

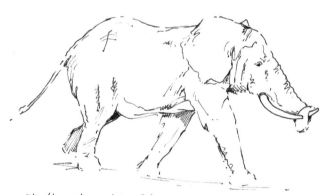

Fineliner pigment pen 0.1

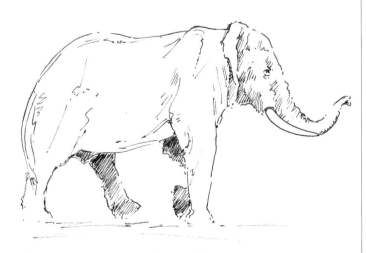

Noticing negatives

Sometimes an animal or bird's movement can create a negative shape that adds interest to its depiction. This becomes more exciting when related to a background that is also moving – such as the water in which the bird stands – giving you even more shapes to notice and include in your artwork (see page 111).

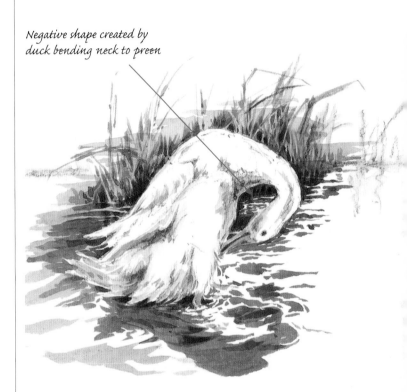

Negative shape created by duck bending neck to preen

Unseen movement

We cannot see the swan's feet so we are only aware of their movement by observing the bow wave in the water as it travels.

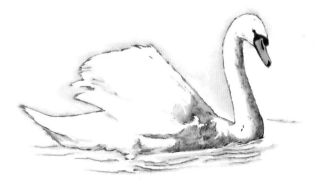

Ripples on surface of water show that legs are moving

Body Mass and Limb Relationships

Body mass in relation to limbs

I hope that you are as fascinated as I am by the diverse shapes, colours, textures and unusual conformations of many animal species – the long neck of a giraffe and a swan, the short necks of a pig and a hippo, the wide, heavy horn of a rhino and the delicate antlers of a deer, are but a few interesting comparisons, as are the length of a mouse's tail in relation to that of its body, the way a monkey uses its hands to eat in the same way that we do, the extraordinary elephant's trunk and the striped coat of a zebra. All these marvellous creatures offer artists endless opportunity for media exploration and methods of execution.

Here I can only briefly cover relationships of body mass; and, for this purpose, I have chosen a pig as my first subject. With a heavy head on an almost non-existent neck, massive shoulders and a bulky body – all supported on short, stocky legs and small trotters – this highly strung, gregarious and naturally curious animal is both clean and responsive to tactile stimulation.

A pig at rest offers an ideal opportunity for detailed drawing and for observing the underside of the trotters. The illustration below depicts forelimbs, and the one above right the hind legs. The latter, when stretched out, can easily be mistaken for the former, were it not for the knobbly hock joints and the teats on either side of the limbs.

Derwent Graphitint pencils were chosen for this subject; I used port for the underdrawing in the study below and as a monochrome hue for the drawing above right.

Pencil used dry

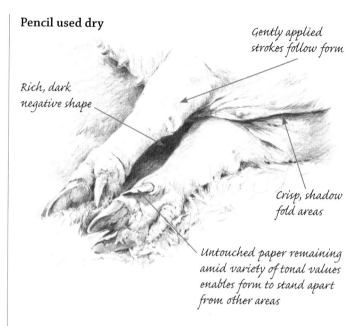

Gently applied strokes follow form

Rich, dark negative shape

Crisp, shadow fold areas

Untouched paper remaining amid variety of tonal values enables form to stand apart from other areas

Detail of head

The acrylic illustration of the pig's head below demonstrates the weight of the fascinating form with its numerous folds (causing the eyes to close), lop ears and permanent 'smile' in repose. Compared with the bland appearance of the pig's body, its head and feet are remarkably complex.

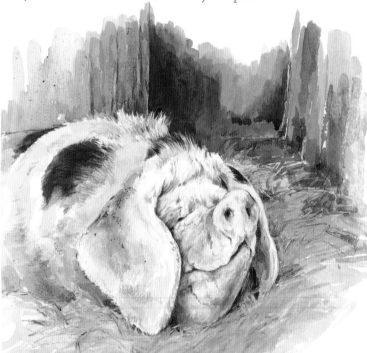

Derwent graphitint blended with water

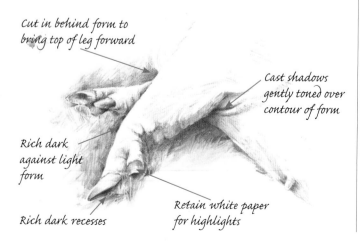

Cut in behind form to bring top of leg forward

Cast shadows gently toned over contour of form

Rich dark against light form

Rich dark recesses

Retain white paper for highlights

Soft and furry

In comparison to a pig, a rabbit, where the first impression may be of short legs beneath a bulky, furry body mass, undergoes a transformation when the powerful extended hind legs propel it forward at great speed or, alternatively, form a firm support for the animal to sit erect and survey its surroundings (see page 41).

Watersoluble pencil and wash

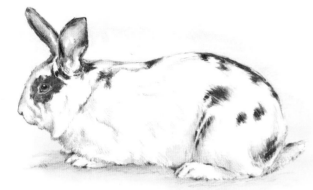

A rabbit's neck appears short within folds of hair but elongates when the animal feeds or stretches forwards.

Short ears, long neck

Both pigs and rabbits may have erect ears or be lop-eared, and this also applies to different breeds of goat. Whether covered in short or longer hair, depending upon the breed, a goat's neck is slender compared to that of a pig or rabbit.

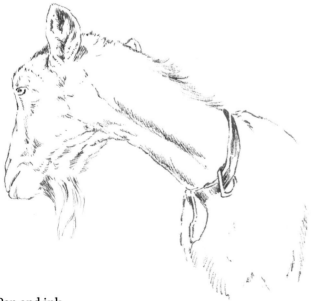

Pen and ink
The long, slender neck of a goat is exposed as the head is turned

Compilation

The illustration below, of a group of swans, includes a little of all the points mentioned in my introductory poem (see page 4), as well as body mass in relation to the supporting structure of legs – you can also see here negative shapes and how our eyes can be led through the composition: a little colour has been introduced for the bills; some feather texture on the necks and body areas; line in the form of shadow lines within wing feathers; and form where both the sides and rear-view aspects of the body bulk are shown.

The Graphitone range of watersoluble pencils includes white; I executed this study on paper that had received a watercolour tinted wash so that I could include a variety of tonal values, both within the forms of the birds and the areas of background that relate to them. A little water was used to blend hues in some areas, with more drawing overlaid to increase intensity of dark tones.

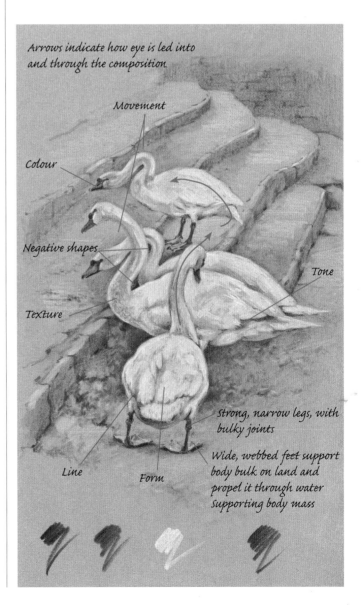

Arrows indicate how eye is led into and through the composition

Movement

Colour

Negative shapes

Texture

Tone

Line

Form

strong, narrow legs, with bulky joints

Wide, webbed feet support body bulk on land and propel it through water Supporting body mass

Exercises in Accuracy

One animal and more

Using photographic references, these exercises are designed to help you understand the importance of observing shapes to depict animal images.

Building shapes

Think of this as building an image upon a scaffold of lines – your guidelines – in order to see (and use) the shapes between. These images may be:

• negative shapes
• shapes between parts of the animal
• shapes between your guidelines and parts of the animal
• shapes between something attached to the animal

Negative shapes

These may be open or closed: on page 29 I have indicated examples of both in blue. The important closed negative does the job of relating two beasts and depicting the correct perspective angle of the upper pole, under which the cows are tied.

The open negative positions the nearest animal correctly in relation to the upper pole. The open end is only there because there is no clear definition as to where the image itself ends.

Shapes between parts

These are not negatives but they are between parts of the animal, within the form. An example of this can be seen on the drawing of the lion below left, with the relationship between the nose, mouth and the side of the muzzle; I have annotated this small 'shape between'. Shapes within the animal's form are particularly helpful to establish when depicting three-quarter views like this.

Shapes between guidelines and parts

Shapes between guidelines and 'edge' lines of the animal help establish an accurate silhouette. When vertical and horizontal lines have been placed in 'key' positions (below left) and are crossing each other, you need only concentrate upon the third side of the triangle to establish accuracy. Look at where the strongest vertical and important horizontal cross: the former actually touches part of the lion's eye. The third side of the triangle is the upper part of the profile.

Shapes between attachments

An example of this is the ring of the head collar on page 30. Look at the shape inside the ring, which consists of two straight lines and one curved. If you forget the fact that you are drawing a ring with leather attached and just look at the internal shape, you can place the attached leather straps at correct angles.

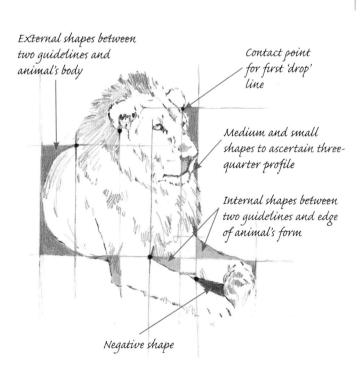

External shapes between two guidelines and animal's body

Contact point for first 'drop' line

Medium and small shapes to ascertain three-quarter profile

Internal shapes between two guidelines and edge of animal's form

Negative shape

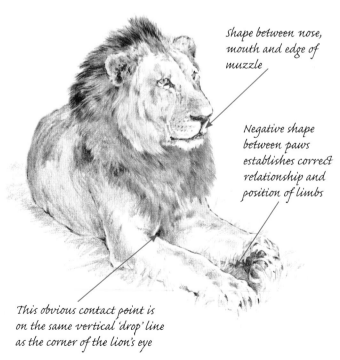

Shape between nose, mouth and edge of muzzle

Negative shape between paws establishes correct relationship and position of limbs

This obvious contact point is on the same vertical 'drop' line as the corner of the lion's eye

Guidelines

To solve the problem of where to start in a complicated arrangement of images, even of a single animal, you need to decide where to place the strongest vertical ('drop') line, cross it with an important horizontal line and see it in relation to one of the above shapes.

On the preliminary drawing of the lion (opposite far left) my initial drop line was drawn from the base of the farthest ear, where there is visual contact with the top of the head.

If we were to walk around in front of this animal, we would see that this part of the ear is not in physical contact with the head at the point we see from the three-quarter view, being joined lower down. The contact is visual only, when we view it from the angle depicted. On the preliminary drawing of the lion I chose this starting point in order to establish the head angle first, using small and medium shapes, between the animal's profile and another guideline (shown in green).

In the more complicated composition of the cattle on page 30 I used the important negative shape from which my strongest vertical could drop, thereby helping me place the eye with the use of small contour lines following form.

Running the important horizontal guideline through the visual contact point where the noseband of the nearest animal and the collar of its neighbour meet, immediately placed the level of the second beast's eye. The basis of my personal grid was then established.

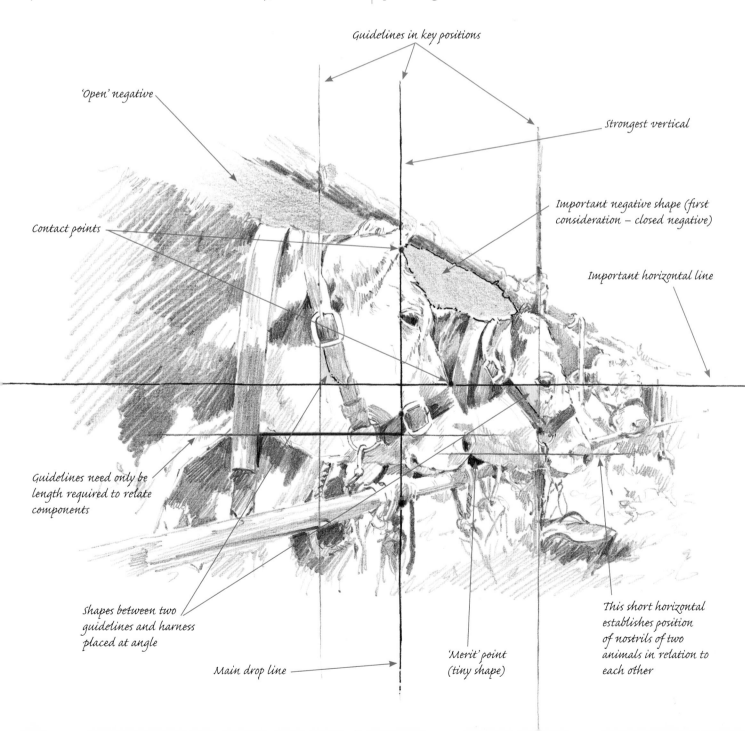

Guidelines in key positions

'Open' negative

Strongest vertical

Contact points

Important negative shape (first consideration – closed negative)

Important horizontal line

Guidelines need only be length required to relate components

Shapes between two guidelines and harness placed at angle

Main drop line

'Merit' point (tiny shape)

This short horizontal establishes position of nostrils of two animals in relation to each other

Contact points

In addition to visual contact points, where things overlap (cross) within our vision, there are also physical contact points. An obvious example is the bend of a limb – indicated on the lion drawing on page 28, far left.

Take a copy of one of your animal photographs (so that you do not damage the actual photo) and look for obvious contact points similar to those in the cattle picture here. Draw freehand your own 'drop' lines and horizontal guidelines on this copy, and you will discover how many components actually line up with each other; for example, the short horizontal line from the lowest part of the animal's nostril lines up with the upper part of the next animal's nostril in

the drawing. Think of this exercise as a jigsaw puzzle, fitting one piece into another until the whole is complete.

Although I have specified the parts of the animals to which I am referring on my drawings, the best way to place components correctly in your first investigative drawing/sketch is by not being conscious of the subject you are drawing – only the shapes involved.

By placing photographic reference upside down, many people find it easier to obtain accuracy, as they are less likely to recognize certain areas and thus rely on observing the shapes alone. When working from life this is not possible, and we need to try to forget the subject matter in order to place components (shapes) correctly in relation to each other.

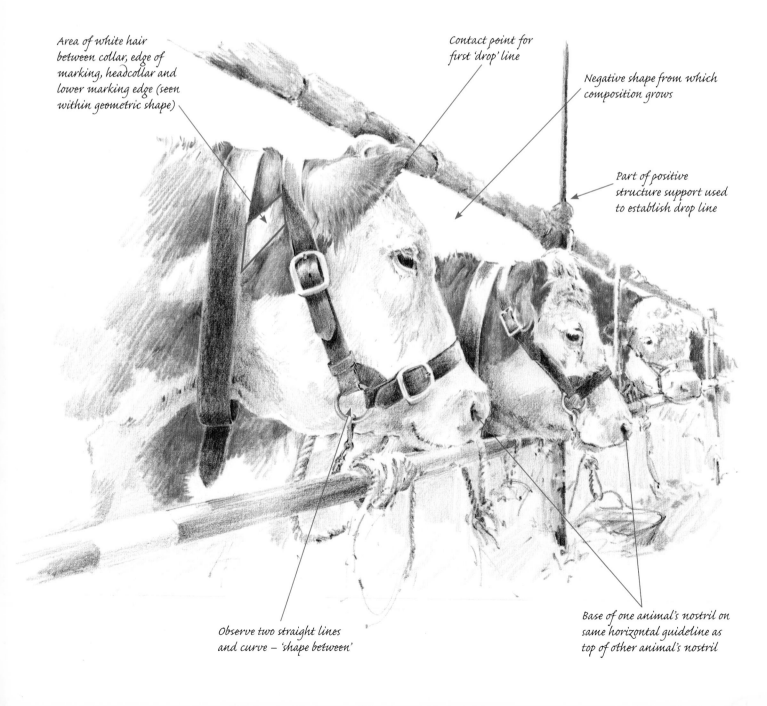

Area of white hair between collar, edge of marking, headcollar and lower marking edge (seen within geometric shape)

Contact point for first 'drop' line

Negative shape from which composition grows

Part of positive structure support used to establish drop line

Observe two straight lines and curve – 'shape between'

Base of one animal's nostril on same horizontal guideline as top of other animal's nostril

With an Artist's Eye

Throughout the following themes I frequently stress the importance of close observation and understanding of subject matter by the inclusion of investigative sketches, drawings and diagrammatic representations. Each animal species requires careful thought and a degree of understanding regarding form, confirmation, movement, skin/fur texture and so on, if it is to be depicted convincingly.

Sketchbook work

Sketching from life is essential, even if you know you will be working mainly from photographic reference; and to be effective, a sketchbook needs to be used on a regular basis.

Try to keep your sketchbook for personal reference, rather than for others to see. This will remove some of the pressure you may place upon yourself to produce 'finished' images, and will allow you to tentatively discover and develop your skills as well as being bold and spontaneous, at times resulting in what you may feel are drawing disasters. They are, in fact, not disasters, just you finding your feet – and they are all part of the learning process. Whether you place just an interesting line (or mark) on your paper as a result of what you see, or manage to give a convincing impression of the animal's form, you will be learning all the time. Try to welcome problems and enjoy the challenge of solving them, rather than being afraid of them.

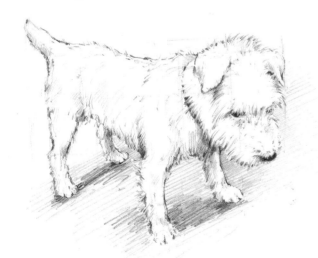

In these two photographs and the sketches I made directly from them, you can see an example of distortion. However, even with limited reference such as this you can use part of the image to create a drawing or painting that will provide a memory of the animal.

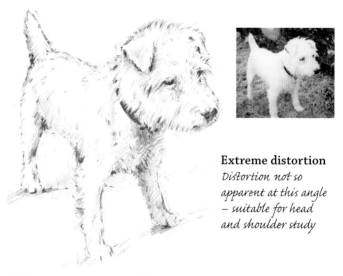

Extreme distortion
Distortion not so apparent at this angle – suitable for head and shoulder study

Observation and composition

Two or more animals in relation to each other present an obvious need for composition – whether or not a background environment is included, it is still necessary to compose a single animal's position on your paper – in relation to the format or within a mount.

The obvious consideration of allowing more space in front of the profile, in order that the head is not placed too close to the edge of the format on one side, with too much space behind the form, needs to be combined with other considerations. It is important to be aware of angles within the animal's pose, suggesting balance and weight distribution, and to ensure that the subject is convincingly grounded or anchored to its support – even if very little of this is actually shown.

Working from photographs

One of the main problems when working from photographic reference is that of coping with distortions: enlarged animal heads behind which body sizes decrease disproportionately produce unsatisfactory representations when copied directly from the reference material. Photographic reference is best used, not copied, and if you have already made sketches from life to accompany your photos, you will achieve more pleasing results. If, however, you have only a couple of photographs, and no other reference, you may need to limit the area you depict.

The extra – and vital – ingredient is an understanding of your subject. This may have been gained by watching the animal at play, at rest or doing normal activities, as well as a variety of photographs that enable you to visualize it from different angles.

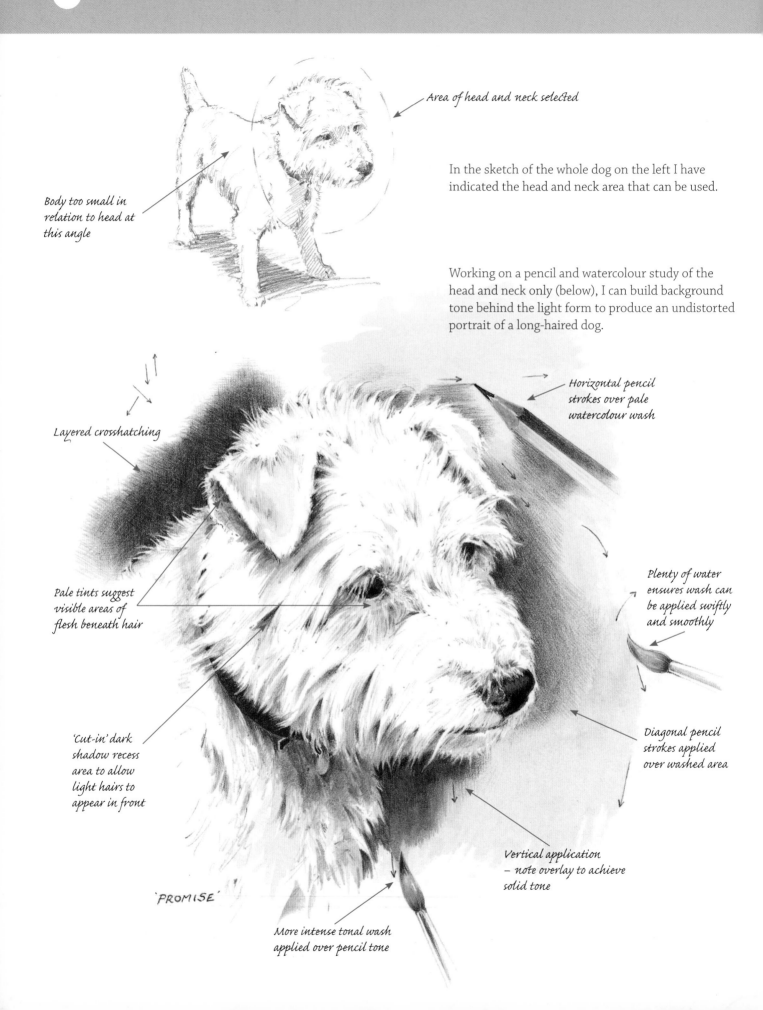

Area of head and neck selected

Body too small in relation to head at this angle

In the sketch of the whole dog on the left I have indicated the head and neck area that can be used.

Working on a pencil and watercolour study of the head and neck only (below), I can build background tone behind the light form to produce an undistorted portrait of a long-haired dog.

Layered crosshatching

Horizontal pencil strokes over pale watercolour wash

Pale tints suggest visible areas of flesh beneath hair

Plenty of water ensures wash can be applied swiftly and smoothly

'Cut-in' dark shadow recess area to allow light hairs to appear in front

Diagonal pencil strokes applied over washed area

Vertical application – note overlay to achieve solid tone

'PROMISE'

More intense tonal wash applied over pencil tone

Choose an easy angle

When photographing your subject, try to choose an angle that presents the fewest problems to start with. A simple side view for the body, with the head turned towards you, provides enough interest for your study; it may be necessary to edit in a tail or to change the tail's position to add interest to the composition, and a background can be adapted to suit the pose.

Depicting light whiskers or hair against dark fur

1 Draw line

3 Overlay pattern on fur directionally to appear behind whisker

2 Tone up to line on one side, leaving slim white strip; tone away from edge of white strip

Light underdrawing

Cut in with dark tone for shadow recess shapes within fur

Cut in crisply to point, then tone away, reducing pressure

'Wandering' line

Twist pencil as you work to create interest of line

Overlay tone to suggest pattern on fur

Apply first tonal areas diagonally

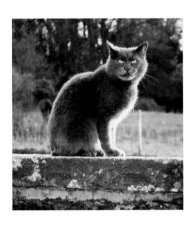

Editing in and editing out

Using the same dog as a model, in the next sketch the lead has been excluded and a piece of cloth substituted that relates to the dog's position. The background has been excluded, and an indication of the two furthest limbs has been included to help give stability to the pose.

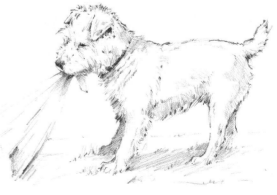

The exercises on these two pages relate to, and are in the media used for, the theme of domestic pets. Of all the groupings of animals featured in this book, domestic pets are often the best subjects for the artist, as familiarity with their owners means that they can be drawn and painted when they are relaxed and not ready for escape from what they see as a threat; you may also be able to get close to your pet for interesting close-ups.

Pencil Exercises

Watersoluble graphite

Watersoluble graphite pencils are available in different grades; each reacts differently when water is added, depending upon which paper is used (see page 36).

The pencils can be equally effective used alone or mixed with another media, and used wet or dry. The exercise here demonstrates how to lift pencil pressure a little while applying strokes, to achieve the effects of highlighted areas, and how to lift the pencil completely from the paper while continuing the stroke, to depict white markings on a coat.

Basic strokes

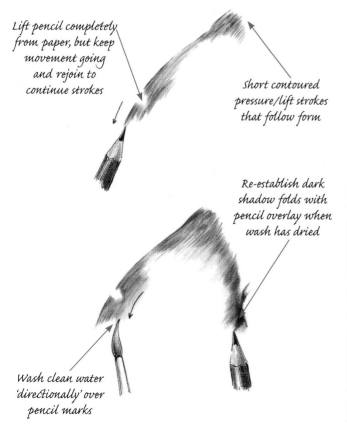

Lift pencil completely from paper, but keep movement going and rejoin to continue strokes

Short contoured pressure/lift strokes that follow form

Re-establish dark shadow folds with pencil overlay when wash has dried

Wash clean water 'directionally' over pencil marks

Graphite (drawing) pencil

Wandering line

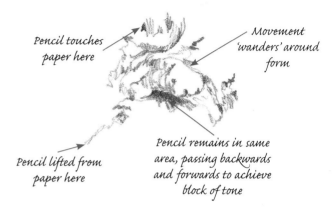

Pencil touches paper here

Movement 'wanders' around form

Pencil lifted from paper here

Pencil remains in same area, passing backwards and forwards to achieve block of tone

Combination lines

Here, the pencil produces contoured lines and tonal areas to suggest layers of thick fur and shadow recesses (see page 38).

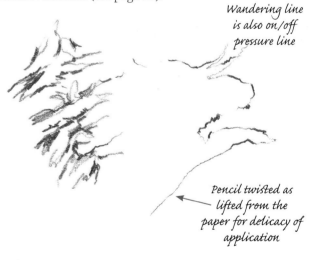

Wandering line is also on/off pressure line

Pencil twisted as lifted from the paper for delicacy of application

Individual 'pull down' lines

To achieve tabby markings (or marking effect), single contoured strokes are massed

Single contoured strokes

Massed to produce block of tone

Carbon pencils

These pencils produce rich contrasts when used upon brilliant white paper – for example, Bristol Board. When sharpened to a fine point they can be used to achieve a great level of detail (see page 44).

Soft pencil

A soft 6B carbon pencil on smooth white paper is ideal for rich black strokes that, when massed, can achieve the effect of irregular patches on a mouse's coat.

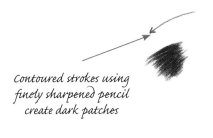

Contoured strokes using finely sharpened pencil create dark patches

Markings may vary in size, but contoured strokes need to follow form of animal

Hard pencil

A hard (B) carbon pencil can produces exciting linear variations if you twist the pencil from time to time while working. This exercise also relates to the previous wandering line interpretations.

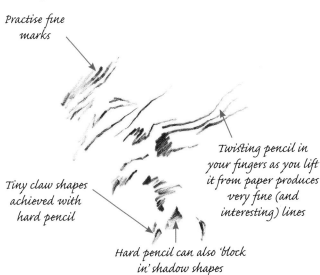

Practise fine marks

Tiny claw shapes achieved with hard pencil

Twisting pencil in your fingers as you lift it from paper produces very fine (and interesting) lines

Hard pencil can also 'block in' shadow shapes

Brush Exercises

Watercolour

Arguably one of the most versatile of media, whether used on its own, with pencil or with a variety of other media, watercolour can be either subtle and subdued or vital, bright and exciting. In this section I have used it in a monochrome representation of a rabbit (see pages 40–41) by mixing just two colours to produce a neutral hue, and for a more colourful image of a 'coloured' (skewbald) Shetland pony (see pages 46–47).

Blending fur

This first exercise is very simple and relates to contoured stroke application that follows form. Use plenty of water, as your strokes need to be fluid. Once you have established this area of tone (and before it starts to dry), practise a few little experiments around its edges.

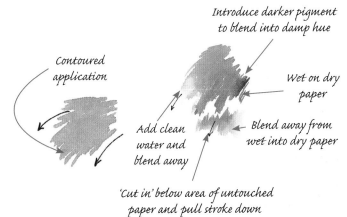

Introduce darker pigment to blend into damp hue

Contoured application

Wet on dry paper

Add clean water and blend away

Blend away from wet into dry paper

'Cut in' below area of untouched paper and pull stroke down

Hair details

A mixture of raw and burnt sienna produce the bright hue of the pony's markings. As these equines possess thick coats, we have an opportunity to observe hair direction and have fun depicting the various swirls that occur.

This little exercise demonstrates how, by pulling pigment away from areas that are to be depicted as the white hairs, we can suggest light in front of dark.

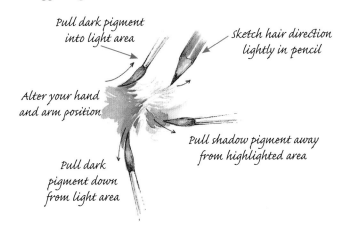

Pull dark pigment into light area

Sketch hair direction lightly in pencil

Alter your hand and arm position

Pull shadow pigment away from highlighted area

Pull dark pigment down from light area

Problems

Dog

watersoluble graphite pencil

Smooth-coated dogs, such as this beagle puppy, give the artist an opportunity to observe the animal's structure as well as skin folds and highlights on a glossy coat. A straightforward pose can be enhanced by an angled head position, but this can present a few problems for the novice artist.

The depiction of the black fur of an animal's coat can also present problems for beginners. This can be overcome by the use of watersoluble graphite in conjunction with watercolour paints. Giving strength to white areas without the use of a continuous outline can be a further problem faced by those who do not give enough consideration to the relevance of a background against which forms are placed.

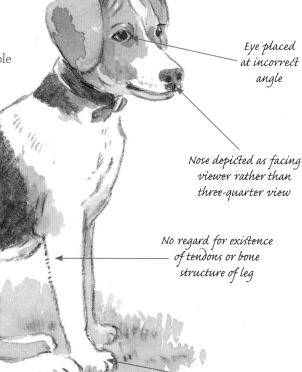

Eye placed at incorrect angle

Nose depicted as facing viewer rather than three-quarter view

Graphite pencil roughly applied without regard for form

Outlines unnecessary and should be avoided by use of subtle background toning

No regard for existence of tendons or bone structure of leg

Curved paws appear catlike

Techniques

Mixing basic browns
Blending watercolours to create natural browns.

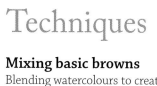

Mix of two basic colours

Basic colours

Fur blends
Method for dark fur of dog's back.

Apply graphite using directional strokes

Place blue-grey wash over graphite

When wash is dry, draw shadows between highlights with short, directional strokes

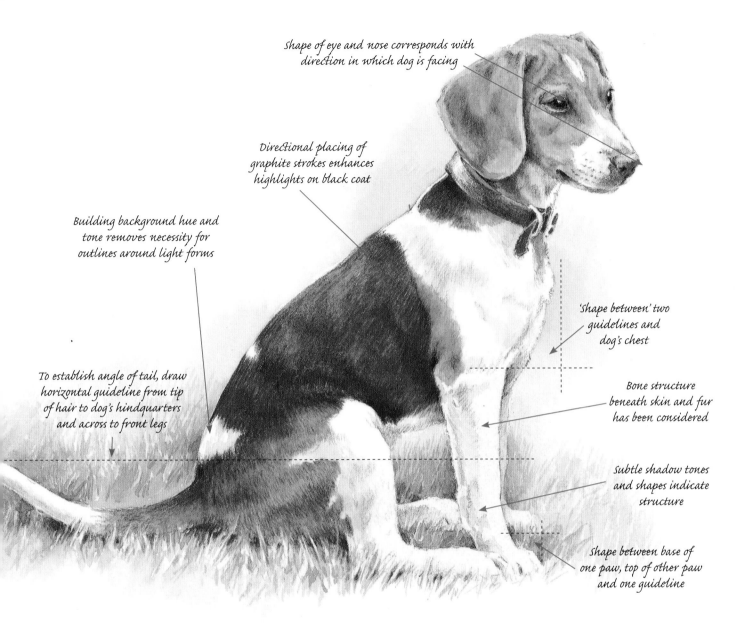

Shape of eye and nose corresponds with direction in which dog is facing

Directional placing of graphite strokes enhances highlights on black coat

Building background hue and tone removes necessity for outlines around light forms

To establish angle of tail, draw horizontal guideline from tip of hair to dog's hindquarters and across to front legs

'Shape between' two guidelines and dog's chest

Bone structure beneath skin and fur has been considered

Subtle shadow tones and shapes indicate structure

Shape between base of one paw, top of other paw and one guideline

Suggested palette

A limited palette of two colours is all that is needed alongside the graphite.

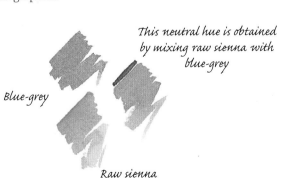

Blue-grey

This neutral hue is obtained by mixing raw sienna with blue-grey

Raw sienna

Tonal variations of background hue used to demonstrate painting behind white areas of fur, indicating presence of background and bringing white area forwards

Problems

Cat

`graphite pencil`

Whether the animal is smooth or long-haired, the subtle grace of a cat lends itself to being sketched in a loose style. Although capable of swift movements, a cat also has its languid moments. It is at these times that we are able to draw from life in our sketchbooks, capturing informal moments when the animal is relaxed in an expressive pose.

Tight, diagrammatic, lines around the image, as well as disconnected marks at the edges that do not relate to those within the form, contribute to the flat appearance of form in these two sketches.

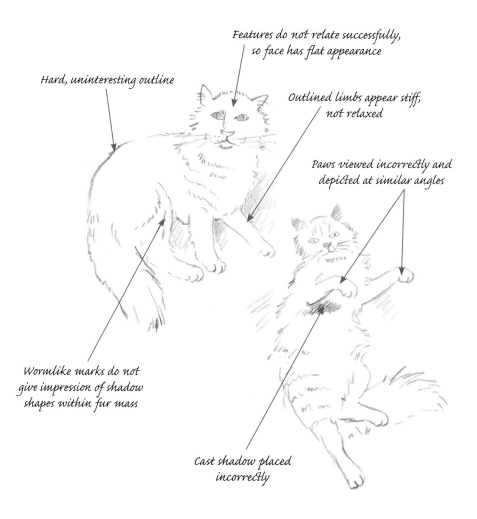

Hard, uninteresting outline

Features do not relate successfully, so face has flat appearance

Outlined limbs appear stiff, not relaxed

Paws viewed incorrectly and depicted at similar angles

Wormlike marks do not give impression of shadow shapes within fur mass

Cast shadow placed incorrectly

Techniques

Water-soluble graphite

A dark wash of 8B water-soluble graphite responds effectively to the addition of water when placed on Rough-surface paper.

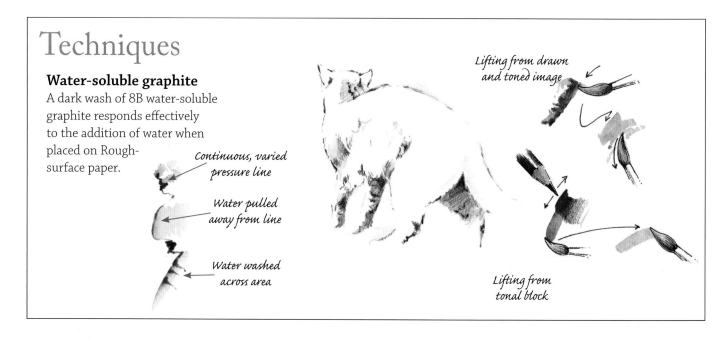

Continuous, varied pressure line

Water pulled away from line

Water washed across area

Lifting from drawn and toned image

Lifting from tonal block

The use of a 'wandering line' (where the 4B pencil hardly ever leaves the paper during the execution of the sketch) establishes these images loosely. If the cat remains in the same pose for some time, certain areas may then be enhanced with stronger lines and tones.

Try not to become too involved with the fluffy fur to the detriment of the structure beneath. Contour your tonal patterns to 'follow the form'.

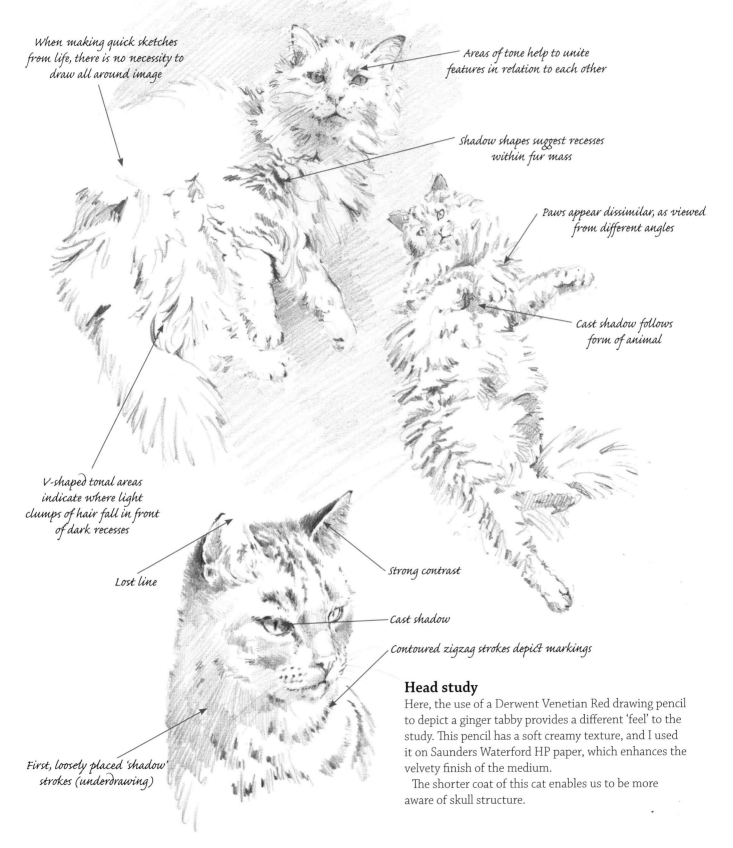

When making quick sketches from life, there is no necessity to draw all around image

Areas of tone help to unite features in relation to each other

Shadow shapes suggest recesses within fur mass

Paws appear dissimilar, as viewed from different angles

Cast shadow follows form of animal

V-shaped tonal areas indicate where light clumps of hair fall in front of dark recesses

Lost line

Strong contrast

Cast shadow

Contoured zigzag strokes depict markings

First, loosely placed 'shadow' strokes (underdrawing)

Head study

Here, the use of a Derwent Venetian Red drawing pencil to depict a ginger tabby provides a different 'feel' to the study. This pencil has a soft creamy texture, and I used it on Saunders Waterford HP paper, which enhances the velvety finish of the medium.

The shorter coat of this cat enables us to be more aware of skull structure.

Rabbit

watercolour

There are many types of pet rabbit, and they may be a variety of colours with different markings. Soft fur makes watercolour a natural choice for their depiction, where blending achieved by the 'dropping in' method can enrich dark fur recesses. 'Cutting in' and blending will bring forward the pale hairs and create strong contrasts.

The rabbit's large eye needs careful observation for highlights, and its soft, furry feet will be anchored by strong shadows beneath the form.

If only a suggestion of background is to be included, a delicately blended neutral hue behind, and 'cutting in' to the edge of a white fur area, will avoid areas unintentionally becoming 'lost'.

The main image opposite is unfinished in order to show the use of overlaid washes (wet on dry) that will gradually build form with subsequent layers of hue.

Application of colour up to this stage has taken time and thought, to ensure each layer is correctly placed and blended where necessary. When depicting a large expanse of one colour, if no thought is given to contours of form and the way some areas will appear lighter and others darker (due to highlights and shadow areas) the colour will appear flat and not suggest form. There is also the possibility of water marks occurring as one part of the wash dries while the remainder is still being applied.

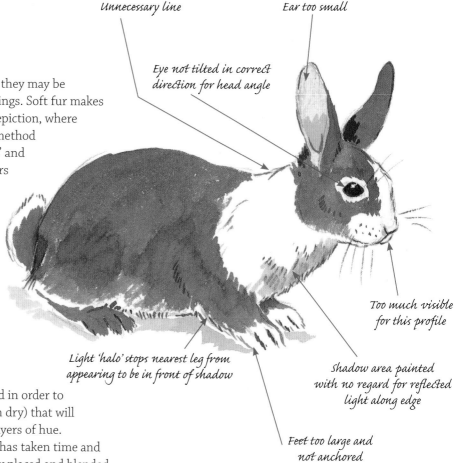

Unnecessary line

Ear too small

Eye not tilted in correct direction for head angle

Too much visible for this profile

Light 'halo' stops nearest leg from appearing to be in front of shadow

Shadow area painted with no regard for reflected light along edge

Feet too large and not anchored

Techniques

'Dropping in'

In this context, 'dropping in' involves touching an already wet area with a brush to which a darker tone of the same pigment has been added. When this pigment is 'dropped in' to the damp paper it will spread out and 'bleed', causing interesting effects as it meets damp or dry paper respectively.

These examples, showing part of a rabbit's hind leg, show the basic exercise executed with smoothly applied washes. When painting actual images, aim to allow the texture of the paper to influence the effects spontaneously.

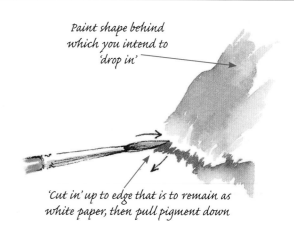

Paint shape behind which you intend to 'drop in'

'Cut in' up to edge that is to remain as white paper, then pull pigment down

Overlaid washes of wet into wet, blended and 'dropped in', have slowly built this image to the level of development you see here. A few more overlays are required before the desired intensity of hue and tone is achieved.

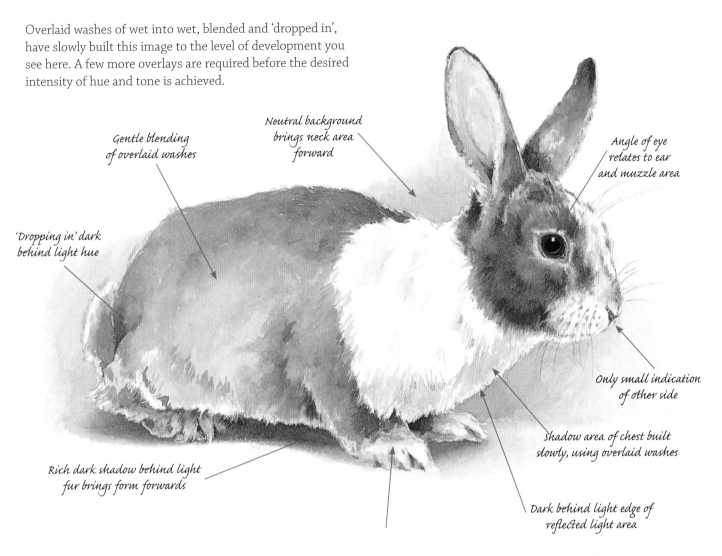

Gentle blending of overlaid washes

Neutral background brings neck area forward

Angle of eye relates to ear and muzzle area

'Dropping in' dark behind light hue

Only small indication of other side

Rich dark shadow behind light fur brings form forwards

Shadow area of chest built slowly, using overlaid washes

Dark behind light edge of reflected light area

Feet placed beneath weight of shoulders to support front convincingly

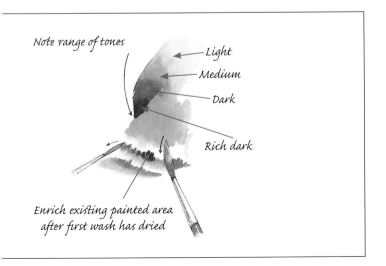

Note range of tones

Light

Medium

Dark

Rich dark

Enrich existing painted area after first wash has dried

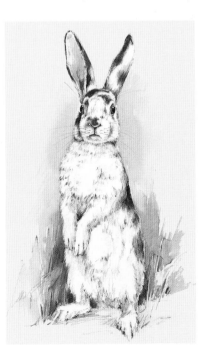

Sitting upright
This study used watercolour, water-colour pencil and gouache on tinted Bockingford paper; some overdrawing in pencil, in addition to the initial drawing, was also done.

Guinea Pigs

`acrylic`

The species of wild guinea pigs found in South America are a speckled brown hue, while the colours and markings of domesticated guinea pigs or cavies can vary considerably, as can the texture, length and growth direction of their fur. Whether they have smooth, long hair or rosetted fur, these attractive little animals are popular pets. The babies, born with their eyes open and with all their fur, look like small adults, but have heads a little disproportionate to their bodies.

One of the problems beginners sometimes experience with quick-drying, permanent acrylic paint is that of retaining delicacy of stroke application in areas of fine detail. Highlights in eyes may easily be placed too heavily, and 'feathery' edges to overlay fur masses can appear as blocks rather than thin hair.

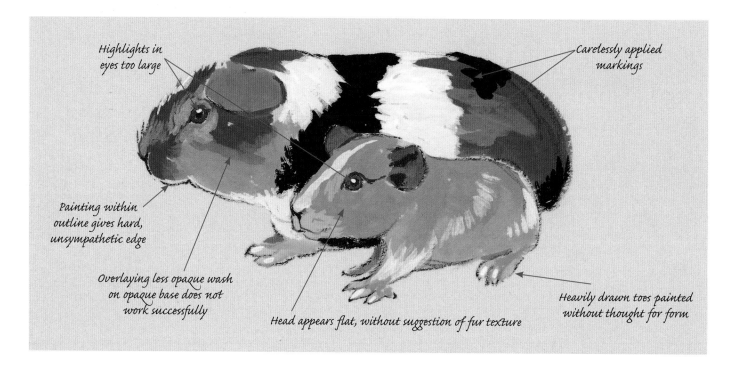

Highlights in eyes too large

Carelessly applied markings

Painting within outline gives hard, unsympathetic edge

Overlaying less opaque wash on opaque base does not work successfully

Head appears flat, without suggestion of fur texture

Heavily drawn toes painted without thought for form

Techniques

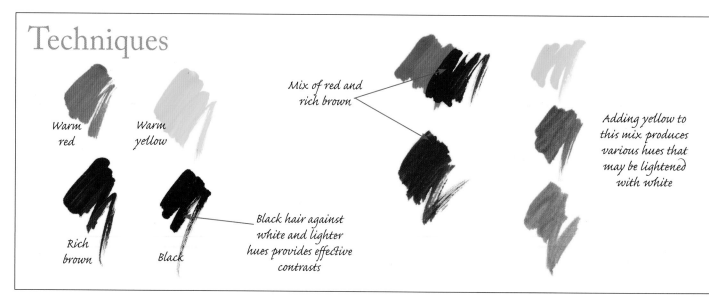

Warm red

Warm yellow

Mix of red and rich brown

Adding yellow to this mix produces various hues that may be lightened with white

Rich brown

Black

Black hair against white and lighter hues provides effective contrasts

Contoured stroke application indicates the form beneath the hair, and the transitions between markings – light over dark and dark over light – need to be treated with consideration for that form. Markings of pure white against tan and black can be effectively depicted in acrylic upon a tinted ground. This enables layers of paint to indicate light hair over dark and vice versa – suggesting a thick, silky coat.

It is important to choose your brushes with care – you will need a good point for the fine details – and to wash them thoroughly both during and after use.

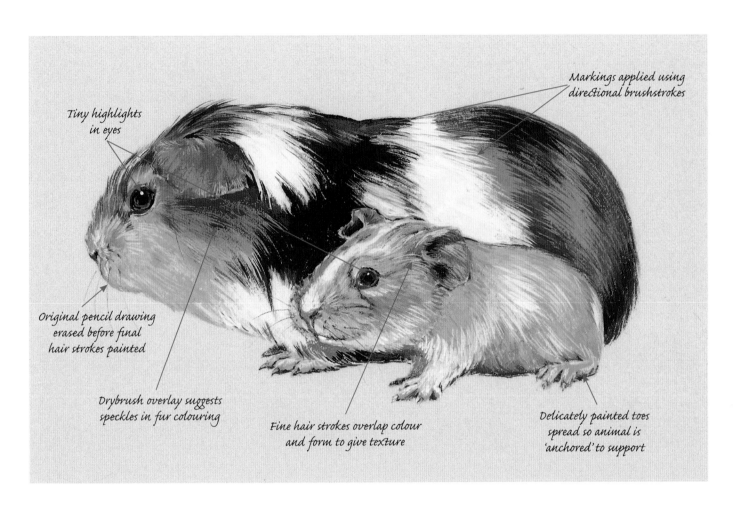

Tiny highlights in eyes

Markings applied using directional brushstrokes

Original pencil drawing erased before final hair strokes painted

Drybrush overlay suggests speckles in fur colouring

Fine hair strokes overlap colour and form to give texture

Delicately painted toes spread so animal is 'anchored' to support

Acrylic

Acrylic is a water-based medium that produces permanent colour, as you are unable to reconstitute the pigment. Although it can be used in many ways, from thin washes to thicker application, here I have taken the middle road: it is opaque enough to cover (light over dark), yet fluid enough to be placed using sweeping strokes.

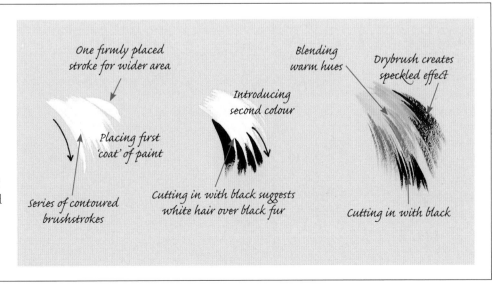

One firmly placed stroke for wider area

Placing first 'coat' of paint

Series of contoured brushstrokes

Introducing second colour

Cutting in with black suggests white hair over black fur

Blending warm hues

Drybrush creates speckled effect

Cutting in with black

Problems

Mouse

`carbon pencil`

Some domestic mice differ from their wild cousins in that the former are found with a wide range of colours and markings. In addition, the size of the eyes in relation to their heads may be smaller than some species, such as the tiny harvest mouse with its prominent 'beady' eyes.

Apart from the common white mouse, various different colours of patched mice give the artist an opportunity to use the rich contrasts that can be achieved with carbon pencil on pure white paper.

Lack of understanding with regard to the form of this tiny creature often leads to heavily drawn, disproportionate limbs. The depiction of patches can also be a problem if the fur texture has not been observed with regard to the way it follows the form.

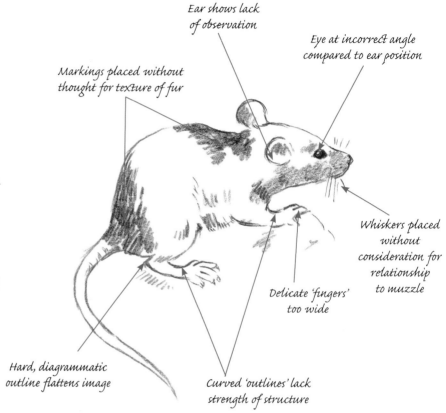

Ear shows lack of observation

Eye at incorrect angle compared to ear position

Markings placed without thought for texture of fur

Whiskers placed without consideration for relationship to muzzle

Delicate 'fingers' too wide

Hard, diagrammatic outline flattens image

Curved 'outlines' lack strength of structure

Techniques

Understanding form
While establishing the main position you have chosen to depict, observe how the limbs appear when seen at different angles and in relation to various surfaces.

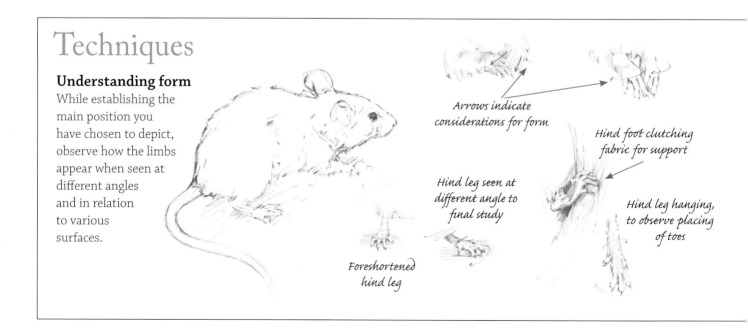

Arrows indicate considerations for form

Hind foot clutching fabric for support

Hind leg seen at different angle to final study

Hind leg hanging, to observe placing of toes

Foreshortened hind leg

There are various methods that can be used to find form: the inclusion of markings in fur is one, and another is to look for angles when depicting limbs. Although this small animal can be held in your hand, it is still important to be aware of structure and form. Delicate limbs are often hidden beneath overlapping fur, but handling these rodents and observing them close up will lead to a deeper understanding of body proportions.

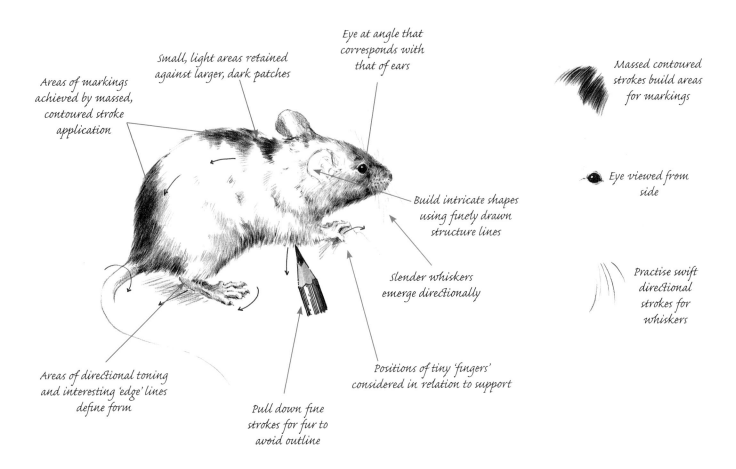

Eye at angle that corresponds with that of ears

Small, light areas retained against larger, dark patches

Areas of markings achieved by massed, contoured stroke application

Massed contoured strokes build areas for markings

Eye viewed from side

Build intricate shapes using finely drawn structure lines

Slender whiskers emerge directionally

Practise swift directional strokes for whiskers

Areas of directional toning and interesting 'edge' lines define form

Pull down fine strokes for fur to avoid outline

Positions of tiny 'fingers' considered in relation to support

Details
When sharpened to a fine point, great delicacy of detail may be achieved with carbon pencils.

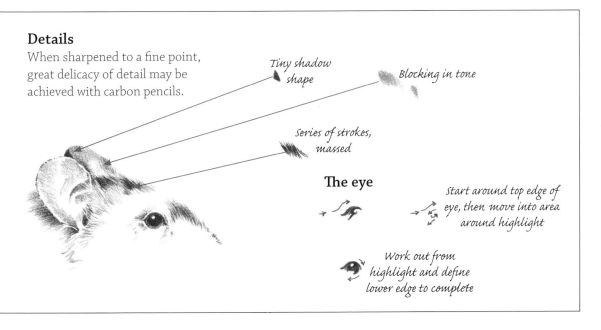

Tiny shadow shape

Blocking in tone

Series of strokes, massed

The eye

Start around top edge of eye, then move into area around highlight

Work out from highlight and define lower edge to complete

Shetland Pony

watercolour

With its compact body, deep girth and short back, combined with short muscular limbs, the Shetland pony's strength is disproportionate to its size. This makes it an excellent harness pony (in the 19th century it was used as a pit pony in coal mines).

When depicting a specific breed of pony, such as a Shetland, it is important to establish correct characteristics. If the legs are drawn too long, giving a greater distance between ground and body than is accurate for the breed type, identity will be lost. As the weather on the Shetland islands can be hostile, these ponies possess thick winter coats. When painting this type of hair you need to be conscious of the direction of hair growth in order to direct your brushstrokes accordingly.

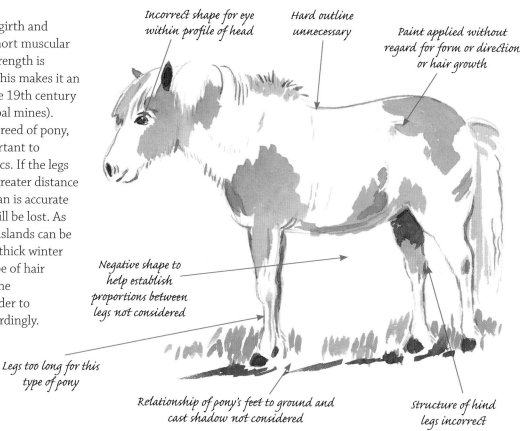

Incorrect shape for eye within profile of head

Hard outline unnecessary

Paint applied without regard for form or direction or hair growth

Negative shape to help establish proportions between legs not considered

Legs too long for this type of pony

Relationship of pony's feet to ground and cast shadow not considered

Structure of hind legs incorrect

Techniques

Using greens
Mixing yellow green and raw umber produces a useful green. Apply this as a pale wash first before 'cutting in' with a darker hue behind the white hair on the legs. The same method (in reverse) applied to dark hooves will leave light areas in front of this form; these may then be painted in green when the hoof area has dried.

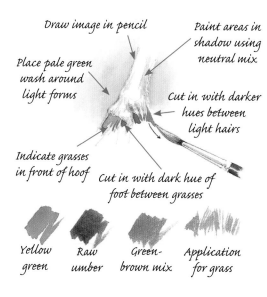

Draw image in pencil

Paint areas in shadow using neutral mix

Place pale green wash around light forms

Cut in with darker hues between light hairs

Indicate grasses in front of hoof

Cut in with dark hue of foot between grasses

Yellow green

Raw umber

Green-brown mix

Application for grass

Colours
A limited palette makes up the basic hues for the pony. Experiment with different proportions of colour to achieve variation of hues and the neutral tones.

Red violet

Raw sienna

Black neutral

Burnt sienna

Black-violet mix

Neutral mix

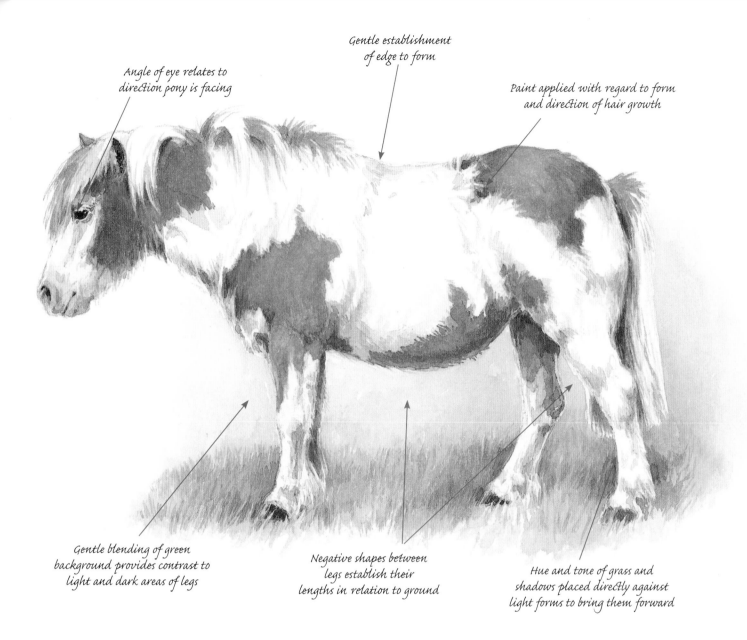

Angle of eye relates to
direction pony is facing

Gentle establishment
of edge to form

Paint applied with regard to form
and direction of hair growth

Gentle blending of green
background provides contrast to
light and dark areas of legs

Negative shapes between
legs establish their
lengths in relation to ground

Hue and tone of grass and
shadows placed directly against
light forms to bring them forward

Rough sketch

Use a rough sketch to establish the
two important negative shapes that
will solve the problem of leg length in
relation to body mass.

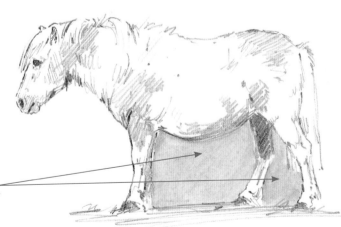

Establish these two negative shapes
correctly to achieve proportions of legs
and body in relation to ground

Pencil and Brush Exercises

These pencil and brush exercises, relating to farm animals, show a variety of contrasting strokes – from fine pen, coloured pencil and round brushwork to flat brush (blocking in) application.

Coloured pencil strokes upon a textured surface

Coloured pencils used on textured watercolour paper can achieve some exciting effects. To achieve the effect of a sheep's coat, emphasize the rich darks that are found within shadow recess areas of dense wool, using both linear strokes and blocking in. Combine varied pressure upon the pencil with frequent sharpening of the strip to achieve variety of application and resulting impressions (see page 56).

Bull: acrylic on acrylic-painted support

The versatility of this medium, where large areas may be covered using large brushes or small details enhanced using smaller brushes for detail, makes it ideal for depicting larger animals.

Although the depiction of the bulk of a bull may require the use of firm, sweeping strokes or blocking in with thicker paint, the further addition of water to the pigment with the use of a fine brush enables details, such as eyes, ears and fine hairs around hooves, to be treated with a delicately controlled approach. These exercises, applied over a prepared acrylic ground, show the two main stroke application methods used on the bulk of the bull's body on page 51.

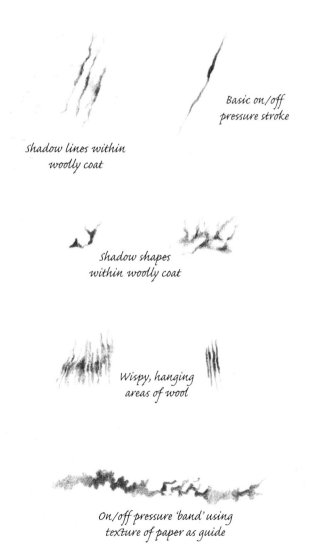

Shadow lines within woolly coat

Basic on/off pressure stroke

Shadow shapes within woolly coat

Wispy, hanging areas of wool

On/off pressure 'band' using texture of paper as guide

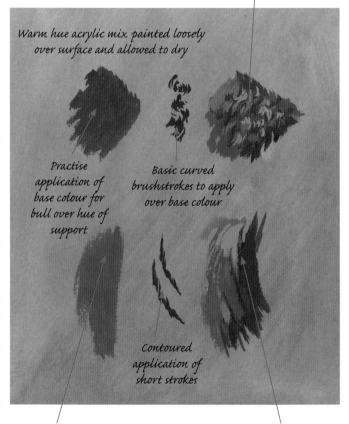

Build various contoured strokes using a variety of hues to indicate curly coat

Warm hue acrylic mix painted loosely over surface and allowed to dry

Practise application of base colour for bull over hue of support

Basic curved brushstrokes to apply over base colour

Contoured application of short strokes

For broader, contoured areas, such as a massive shoulder area, curve long brushstrokes to follow form

Build density with lights (highlighted areas) and darks (shadow recess shapes) between folds of skin and hair

Allowing pale hue to disperse over wet ground

Unlike acrylic, watercolour can be reconstituted and manoeuvred with ease if kept wet (or moist) for a while. A wet flat wash allows pigment to be lifted by suction (cotton-wool bud or squeezed dry brush) as well as producing paler areas where clean water has been dropped on to a wet or damp surface; the latter produces the lighter marks on dark wash ground. In order to achieve the soft, dappled effect on the coat of a horse, gently place pigment in a pattern over a clean water wash (see page 58). The following exercise demonstrates both these methods.

Lay flat wash and remove areas with pressure from cotton-wool bud

Lay flat wash and drop in clean water from tip of brush

Dappling

Lay wash of clean water and draw in pigment from brush around light areas

With fine brush, draw hair lines (where necessary) after dappled area is dry

Overlaid shadows

Sweep cast shadow overlay across dappled area over dried previous applications

Fine drawing and blocking in

Gouache has the advantages of both watercolour and acrylic. Although it is apt to dry quickly when used thickly, it can be reconstituted where necessary and applied as a thick, opaque wash. Layers can be built in the same way as with acrylic (see page 63). When an image is primarily white, as here, it may be advisable to use a rich, dark support. These exercises are painted on an acrylic wash, which means that the surface will not 'lift' when a further water-based medium is painted on top.

Round-brush 'drawing' using white paint establishes the position of the form, which is followed by overpainting using a flat brush to depict the various planes of the duck's surface feathers/forms using the blocking-in method.

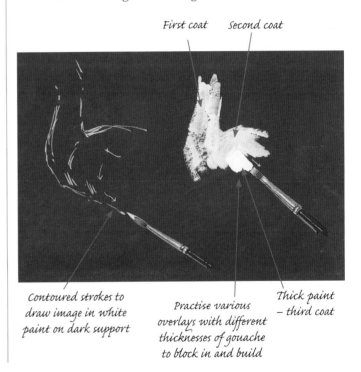

First coat *Second coat*

Thick paint – third coat

Contoured strokes to draw image in white paint on dark support

Practise various overlays with different thicknesses of gouache to block in and build

Forming feathers

A completely different watercolour approach to the above is that of considered strokes. This series of exercises shows the development from an initial curved feather stroke, through painting the 'up to and away from' stroke that places a central 'vein', and on to fine directional strokes 'pulling away' from that area. Practise leaving slim gaps and V-shaped gaps and painting solid areas, to understand the intricacies of one single feather (see page 60).

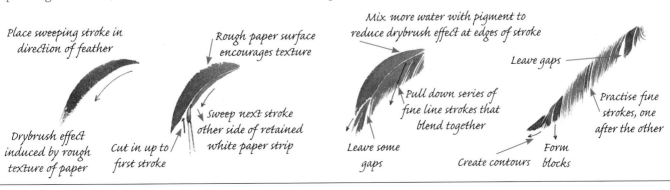

Place sweeping stroke in direction of feather

Drybrush effect induced by rough texture of paper

Cut in up to first stroke

Rough paper surface encourages texture

Sweep next stroke other side of retained white paper strip

Mix more water with pigment to reduce drybrush effect at edges of stroke

Pull down series of fine line strokes that blend together

Leave some gaps

Create contours

Leave gaps

Practise fine strokes, one after the other

Form blocks

Bulls

`acrylic`

To depict one animal in a number of poses or separate animals within a composite representation, it is important to consider relationships. We need to encourage the eye to travel through our composition, not meet with a barrier during that journey.

Scale is also a major consideration: although the animals may not literally relate to each other regarding their scale, they should still work successfully together. The way you treat the background is also vital, and images should sit comfortably within its content.

The sheer body mass of bulls makes viewing these impressive creatures from a few different angles, a tempting proposition. For this reason composite presentation seems a natural choice; the problem of how to arrange images within a composite representation can be overcome by making preliminary sketches.

Confusion in area where body image finishes, sky painting ends and grass in background relates to these

Not clear where trees end and grass begins

Application of cast shadow suggests animal has only three legs

Unfortunate visual link between two images

Wavy lines do not represent texture of animal's coat accurately

Techniques

Acrylic colour mixing

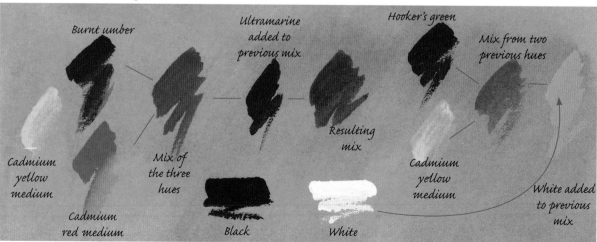

Burnt umber

Ultramarine added to previous mix

Hooker's green

Mix from two previous hues

Cadmium yellow medium

Mix of the three hues

Resulting mix

Cadmium yellow medium

Cadmium red medium

Black

White

White added to previous mix

Because white can be mixed with pigments in acrylic painting, it is helpful to work upon a tinted or coloured support. Coloured paper or board can be used, but it is possible to paint your own choice of hue in an acrylic wash over white watercolour paper.

If you do not feel confident enough to draw/paint directly on to an acrylic base wash, follow this method: first, establish the layout of images in relation to each other in pencil on drawing paper, then trace or copy them on to watercolour paper. Using a fine pen and waterproof ink, draw loosely over the drawn pages, and when dry, erase your pencil marks. Wet and stretch the paper on to a board. When it is dry, mix a translucent acrylic wash (in your chosen hue) and paint it loosely over the gently blotted paper. When the paper is completely dry (and flat), you will see enough of your ink images through the wash to start your painting.

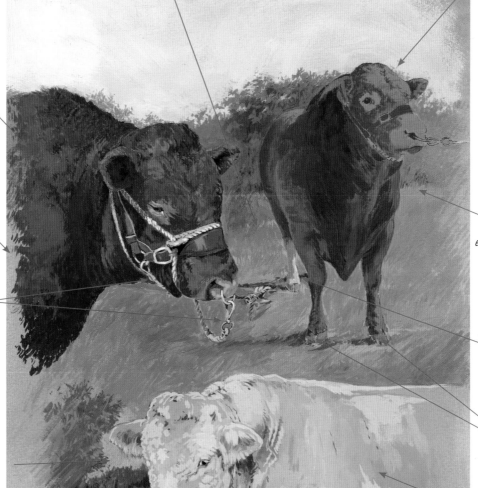

Interesting negative shape between animals relates forms

Unfinished head shows first blocking-in stages over coloured support

Image blends off paper

Base colour wash retained to demonstrate how warm support contributes to painting

Close observation contributes to accurate representation

Exclusion of sky behind lower bull helps continuity

Area where trees end and grass begins relates to position of both animals respectively

Cast shadow from hind leg hidden behind foreleg

Ink underdrawing still visible in early stages

Loose application of paint shows how drawing and blocking in work together to build image

Varied application of lines and tonal areas form base for subsequent painted layers

Problems

Pig

pastel pencils

The bulky heads and massive bodies of fully mature Gloucester Old Spot pigs, supported upon dainty trotters, present interesting front views; the intricacies of head structure can be captured to great effect with pastel pencils. A variety of directional pencil strokes used in the depiction of the animals can then be taken into the inclusion of a background that relates the pigs to their environment.

By incorporating the hue of pastel-board support within background image application, unity is achieved. It is also important to use a support colour that enhances rather than detracts from the pastel images.

As white, and light, shades are readily available in this medium, offering contrasts of hue and tone against darker areas, outlines may be easily avoided.

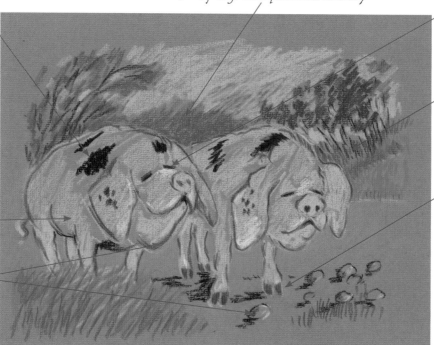

Green foliage mass placed too centrally

Dark marking strokes do not follow form

Eyes placed without consideration for shape in relation to skin folds

Strong, warm hue of background brings area forwards and loses sense of distance

Body mass filled in roughly with just one colour

Trotters placed vertically do not indicate animal is standing squarely upon ground

Outlines unnecessary if contrasting tones used

Techniques

Delicate treatment

Pastel pencils can be applied in a way that encourages the support colour to remain visible (inducing texture), or overlaid for smoother blending effects. Sharpened, they provide a fine drawing tool to be used alongside pastel sticks, where fine detail is required; and used blunt they can produce wide bands and blocks of colour for larger areas.

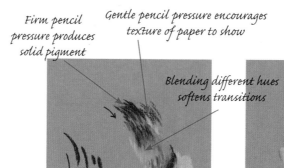

Firm pencil pressure produces solid pigment

Gentle pencil pressure encourages texture of paper to show

Short, firm, downward strokes

Blending different hues softens transitions

Contoured application for solid mass

Firm downward strokes fill in form

Basic, contoured, directional strokes

Two similar hues placed side by side, for gentle transition of colour

Directional strokes establish flat areas

Directional application of
strokes for dark markings
follows form

Dark foliage mass, situated
more behind one pig than
other, brings form forwards

Subtle, neutral hues
encourage background to
remain in distance

Eyes enclosed
by skin folds

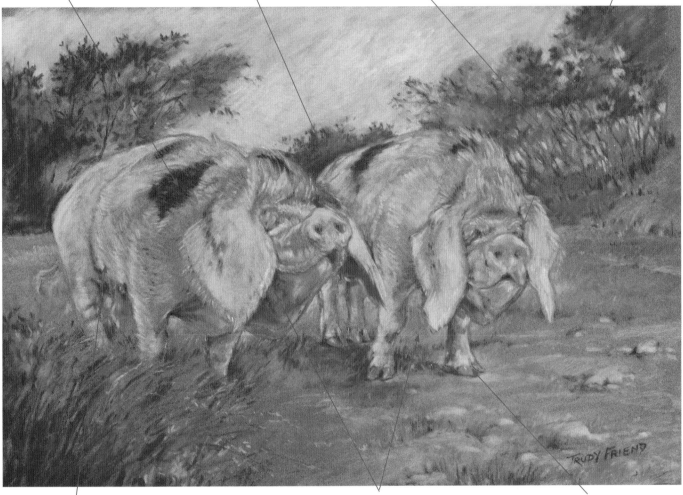

Coarse-hair body mass indicated
by directional strokes

Dark against light and light against dark images (look for areas of
counterchange) make outlines unnecessary

Trotter faces direction
that offers support to
bulk of pig

Note the amount of directional stroke application, which gives a feeling of movement to the composition even though the animals are static. Observe interesting negative shapes between the legs, through which grass can be seen, bringing the warmer hues of the pigs forwards. There are also 'busy' areas and shapes that 'rest the eye', such as sky (restful), foliage masses (busy).

Pastel sketch

This quick sketch demonstrates how the hue and texture of the support can enhance and enliven a study.

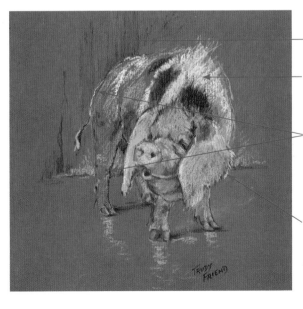

Suggestion of
background

Loosely applied
strokes

Interesting
application of
'edge' lines

Fine strokes

Problems

Goat

`pen and ink`

Goats roaming in a paddock can make an interesting few pages in your sketchbook, perhaps drawn with a pen. If the animal remains in one position for long enough to portray the whole body, this is a bonus. If not, even just a study of the head can be an interesting exercise.

There are many different breeds of goat; a long-haired breed, or one that has a thicker coat in winter, provides an opportunity to create interesting line effects. Hair may form into 'rosettes' in places, or stand erect at the shoulder, down the back of the neck or on the hindquarters. Observing and depicting these areas with quickly applied loose strokes of the pen will enhance your drawing.

When drawing from life, especially if the animal is moving around, beginners often experience difficulties as the pose changes. There is also a tendency to draw around the image rather than within the form. This can lead to a series of lines creating an outline effect, with very few marks within the form.

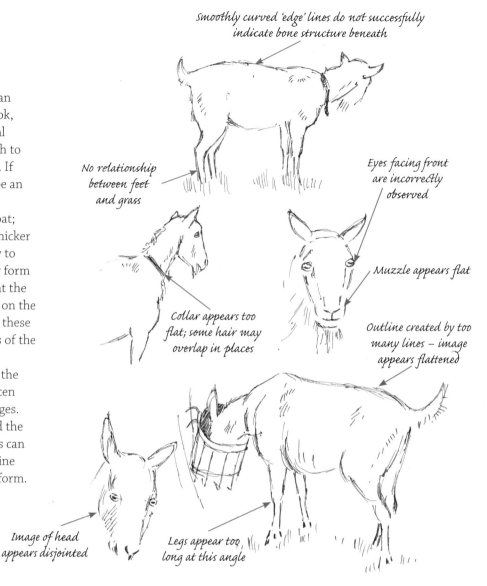

Smoothly curved 'edge' lines do not successfully indicate bone structure beneath

No relationship between feet and grass

Eyes facing front are incorrectly observed

Collar appears too flat; some hair may overlap in places

Muzzle appears flat

Outline created by too many lines – image appears flattened

Image of head appears disjointed

Legs appear too long at this angle

Techniques

Pen strokes

Pen and ink, used here in the form of pigment liner drawing and writing pens, is a convenient way to work in a sketchbook. When used upon a smooth white surface with directional application that follows the form of the animal, exciting images result.

These exercise strokes show transitions from straight to contoured lines and how, by going back over marks made, lines can be thickened and textured, contrasting with the more delicately applied strokes.

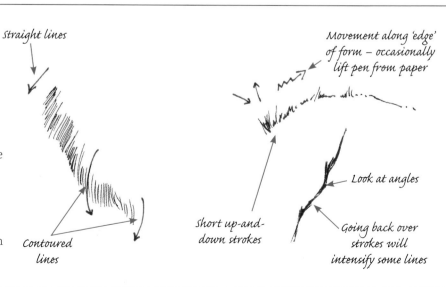

Straight lines

Movement along 'edge' of form – occasionally lift pen from paper

Contoured lines

short up-and-down strokes

Look at angles

Going back over strokes will intensify some lines

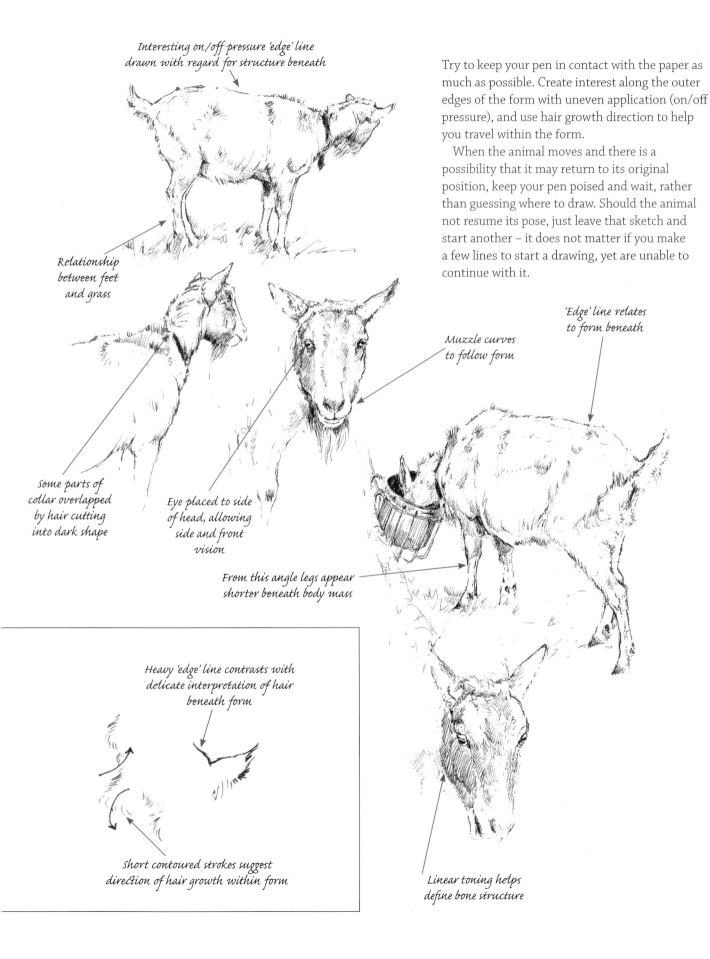

Interesting on/off pressure 'edge' line drawn with regard for structure beneath

Relationship between feet and grass

Some parts of collar overlapped by hair cutting into dark shape

Eye placed to side of head, allowing side and front vision

Muzzle curves to follow form

'Edge' line relates to form beneath

From this angle legs appear shorter beneath body mass

Heavy 'edge' line contrasts with delicate interpretation of hair beneath form

Short contoured strokes suggest direction of hair growth within form

Linear toning helps define bone structure

Try to keep your pen in contact with the paper as much as possible. Create interest along the outer edges of the form with uneven application (on/off pressure), and use hair growth direction to help you travel within the form.

When the animal moves and there is a possibility that it may return to its original position, keep your pen poised and wait, rather than guessing where to draw. Should the animal not resume its pose, just leave that sketch and start another – it does not matter if you make a few lines to start a drawing, yet are unable to continue with it.

Problems

Sheep

coloured pencils

The light hue and woolly texture of sheep give us the opportunity to consider how little, rather than how much, to include in their depiction.

The role of a background, in this instance, is an important element – where we can place as much, or more, emphasis upon working *around* the animal shapes than within the forms – the latter comprising mainly neutral hues. A hard outline, whether smooth or corrugated, does little to enhance the depiction of form, and a disjointed background relationship with the ground upon which the animals are standing only makes the flattened images more obvious.

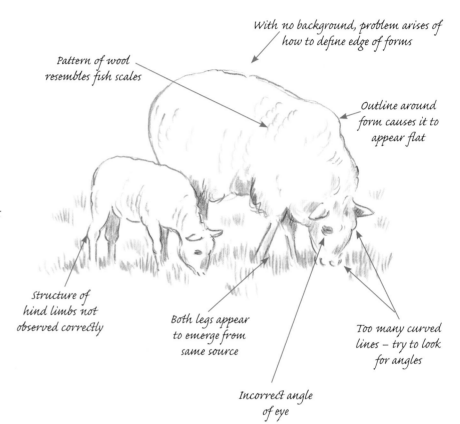

With no background, problem arises of how to define edge of forms

Pattern of wool resembles fish scales

Outline around form causes it to appear flat

Structure of hind limbs not observed correctly

Both legs appear to emerge from same source

Incorrect angle of eye

Too many curved lines – try to look for angles

Techniques

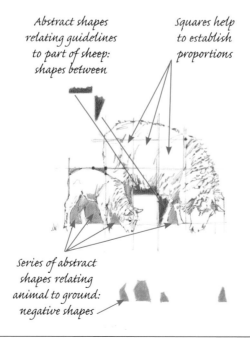

Abstract shapes relating guidelines to part of sheep: shapes between

Squares help to establish proportions

Series of abstract shapes relating animal to ground: negative shapes

Preliminary sketch

In order to establish the correct scale and proportions of the two animals, look for:
- Shapes between – an abstract shape between one of your guidelines and part of the animal.
- Negative shapes – areas where it is possible to pass between parts of the animal, such as the shape that can be seen between body and legs in relation to grass.

Grass green Olive green Cedar green Raw sienna

Raw umber Burnt umber Gunmetal

Colours

A number of greens were used for the background. The woolly coats were mainly comprised of pale shadow tones and retention of the untouched paper surface.

You can establish the position, scale and structure of animals with the use of vertical and horizontal guidelines; look for ways to help you find the correct proportions (see opposite). The problem of depicting hind limbs correctly has been overcome by observing negative shapes, rather than just thinking of the positive forms, and by closing the relating eye and ear positions, the eye angle has been corrected.

Although depicting the sheep's woolly coat may encourage the use of curved strokes, try to look for angles when working on areas where bone structure is apparent, primarily the face and legs.

Work background colours around lightly drawn form to bring light images forwards

Create interesting 'edge' to suggest texture of wool

Light indication of shadow lines within fleece

Pull pencil strokes down into foreground

Untouched paper

Dark, cast shadow areas across ground enhance light forms

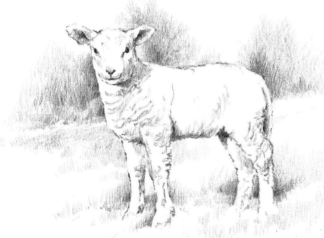

Monochrome study
A monochrome interpretation can be attractive and will allow you to concentrate on textures and tones. Burnt umber was used for this little study.

Problems

Horse

Between the tiny Shetland pony (see page 46) and larger heavy horses is the cob type, used for general farm work with its 'feathered' feet (longer hair that protects the foot while working in muddy conditions), a stocky body and a thick winter coat.

In addition to the obvious difficulty of producing a dappled effect on the animal's coat, the main problem experienced by beginners when depicting light dappled coats is how to avoid the necessity for outlines.

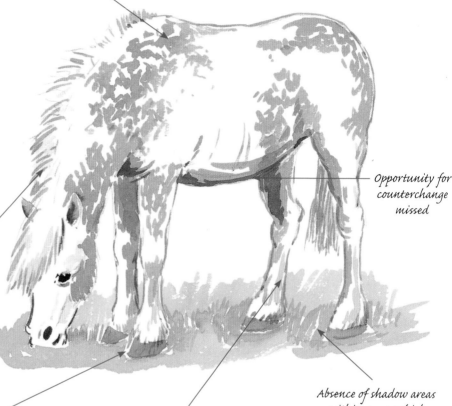

Dappling observed, but artist unsure of method for depiction

Opportunity for counterchange missed

Heavily painted lines used instead of shadow recess lines and shapes

White 'halo' around image means animal appears not to be anchored to ground

Off-white and stained areas of hair noted, but pigment carelessly applied

Absence of shadow areas within grass, which would enhance light forms

Techniques

Swirl clean water over image, taking care to keep water within image shape

Using tip of fine brush containing pigment, 'draw' around light shapes of dapples

When depicting light or dappled coats, consider how counterchange (using dark against light and light against dark) can be incorporated to avoid the necessity to resort to outlining too much of the image. I have used this method on the underside of the horse's body, where a shadow area behind the elbow is dark, and lighter hair is visible, further along, against the 'off' hind leg, which is in shadow.

Painting a dappled coat

There are various ways of achieving a dappled effect with watercolour (see page 49). For this study the whole animal image received a wash of clean water and, while this was still damp, I 'drew' with a fine brush containing pigment, around the dappled shapes that were to remain as white paper.

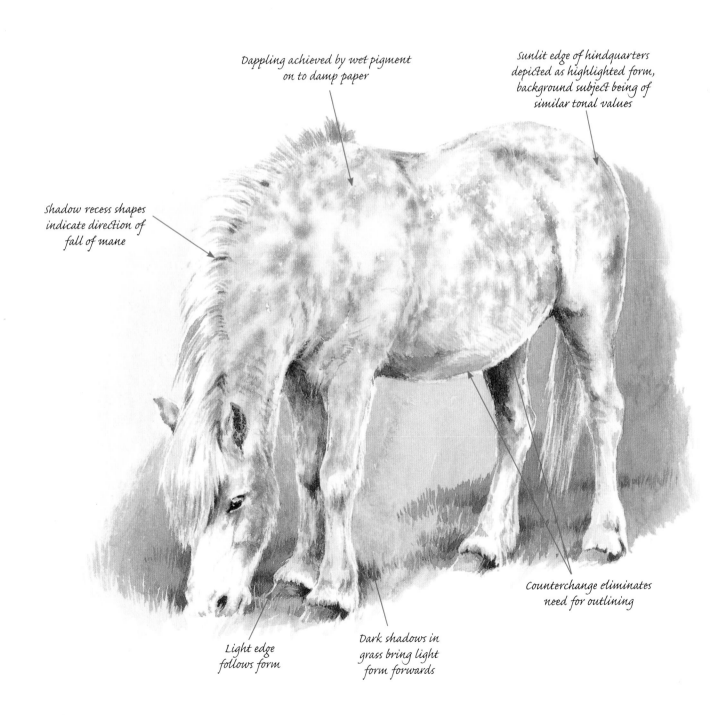

Dappling achieved by wet pigment on to damp paper

sunlit edge of hindquarters depicted as highlighted form, background subject being of similar tonal values

Shadow recess shapes indicate direction of fall of mane

Light edge follows form

Dark shadows in grass bring light form forwards

Counterchange eliminates need for outlining

Problems

Cockerel

watercolour

There is an angular feel to the form of some birds beneath their protecting feathered layers; strong wings and legs, delicate necks and bony body structure make an interesting combination.

Suppressed strength within a cockerel, quietly pecking at food or standing alert, requires an artist to be aware of angled forms when depicting this subject. For this reason we need to look for angles not only in the basic shapes but also in how feathers relate to these shapes and to each other – and these may not always be obvious. Feathers often cause problems for beginners, who may resort to a superficial 'scale-like' representation drawn in paint over a base colour.

White paper left by accident rather than design

No feeling for eye or head structure in paint application

Heavy, flat line

Superficial marks to indicate feathers do not suggest form

Series of markings does not represent accurately long wing feathers

Curved shape of leg lacks strength

Shadow applied carelessly does not anchor form

Techniques

Comb and feathers

Choose basic hue and add hint of other colours

Overpainting

Pale underlay

To indicate light neck feathers over dark, cut in from beneath

Pull down with sweeping strokes for breast and underside

Short, wider strokes for series of upper wing feathers

It is helpful to study closely just one feathered area and observe the shadow recesses between feathered layers, giving thought to the various contours of form beneath. This study is unfinished in order to show the diverse arrangements of feathers on various parts of the bird in their early stages of depiction. I have placed different types of feather arrangements – short, medium and long – in position, using their basic hues, in order to build on them as the painting progresses. I have also indicated gentle angles that occur along the back of the neck.

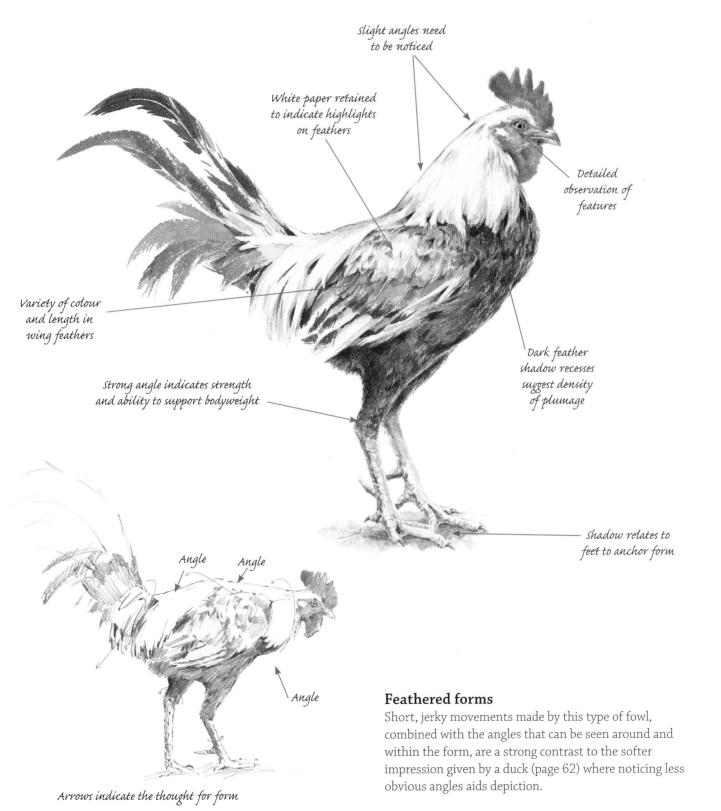

Slight angles need to be noticed

White paper retained to indicate highlights on feathers

Detailed observation of features

Variety of colour and length in wing feathers

Dark feather shadow recesses suggest density of plumage

Strong angle indicates strength and ability to support bodyweight

shadow relates to feet to anchor form

Angle

Angle

Angle

Arrows indicate the thought for form

Feathered forms

Short, jerky movements made by this type of fowl, combined with the angles that can be seen around and within the form, are a strong contrast to the softer impression given by a duck (page 62) where noticing less obvious angles aids depiction.

Duck

gouache

The softly contoured image of a farmyard duck, with its white plumage, is an inviting subject. Feathers and fat (to aid heat retention) cover the skeleton, and it is the latter that requires consideration when drawing and painting what outwardly appear to be soft, curved forms.

One of the problems encountered when trying to depict such a form is that the structure beneath can be forgotten. This can lead to numerous curved lines and contoured strokes (depicting tone) vying with flat application shadow areas that are unrelated, resulting in an image whose shadow shapes appear as pattern, rather than suggesting gentle contoured toning resulting from observation of angles.

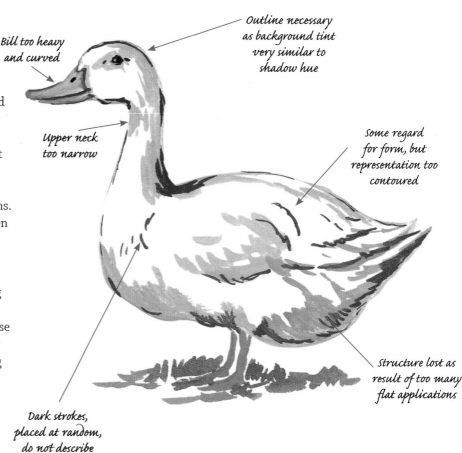

Bill too heavy and curved

Outline necessary as background tint very similar to shadow hue

Upper neck too narrow

Some regard for form, but representation too contoured

Structure lost as result of too many flat applications

Dark strokes, placed at random, do not describe form

Techniques

Investigative drawing: contact points
Throughout the initial drawing and resulting painting I remained conscious of angles and used them as contact points, through which guidelines pass, to help place components accurately. Use your initial investigative drawing to search for angles around and within the form. At each angle make a mark to emphasize this strength (angles = strength) and run your guidelines from and through these points.

Look closely at the outer edges of the painted image opposite and see how many (however small) angles you can notice. I have indicated with a * an example of an angled shape within the form in the painting.

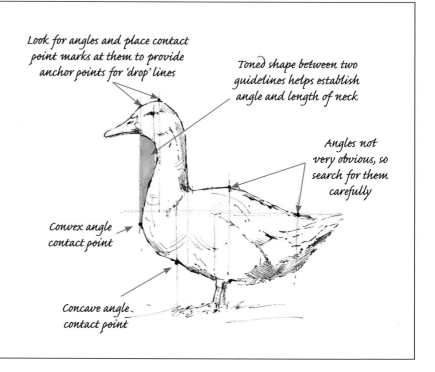

Look for angles and place contact point marks at them to provide anchor points for 'drop' lines

Toned shape between two guidelines helps establish angle and length of neck

Angles not very obvious, so search for them carefully

Convex angle contact point

Concave angle contact point

The undercoat of small, very soft (down) feathers lies close to the skin and is covered by contour feathers whose density gives the duck's outline shape its smooth appearance. I used gouache over a support painted with a rich (acrylic) hue, which enables the white image to contrast and appear crisp and clear, and also means that the white gouache (depicting soft pale feathers and their shadow areas) can be shown to maximum effect.

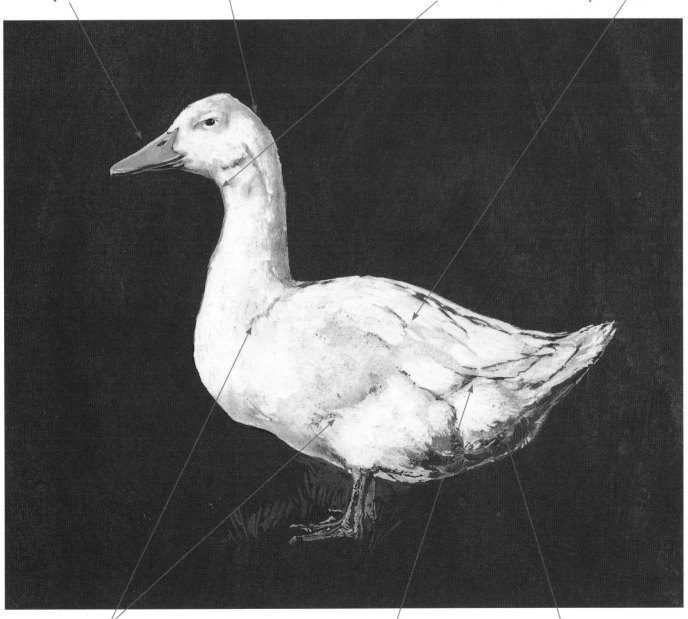

Close observation and careful painting create delicacy in depiction of bill

No unnecessary outline drawing, so light edges (depicting reflected light on shadow sides) help to define form

Neck width considered in relation to head and body

Layering of feathers over wing and body placed with regard for form beneath

Tinted areas of gentle tone suggest undulating surface of form

** Example of angle within form*

Blocked-in toning moulds structure

Pencil and Brush Exercises

The pencil and brush exercises on these two pages cover the media used for the depiction of zoo animals that follow, although they can, of course, be used to depict any animal.

Pen and ink on textured paper

Pen and ink is a very versatile medium whose effects vary according to the size of nib used, the type of pen, and the drawing surface. A piece of artwork may be executed in coloured inks or have a tinted watercolour wash placed over the drawing: pen, ink and wash were used for the illustration on page 75, and watercolour wash is explained opposite. For these basic exercises I used a 0.1 pigment liner for the finer strokes and a 0.3 for the slightly thicker ones.

Place a few contoured strokes

Add more to merge

Increase density

Start creating a stripe effect

'Flick up' and 'pull down' – vary contours and experiment with narrower, uneven shapes

Practise swiftly applied, sweeping contoured strokes

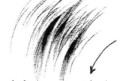

Look for negative (shadow recess) shapes within the mass of contoured strokes

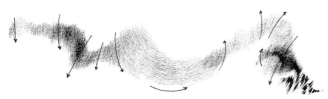

Try a continuous exercise of varied application to familiarize yourself with the pen in relation to the paper surface: the surface of Rough paper enables texture to appear in the marks, plus the 'grazing' style of application.

Watercolour pencils used dry

Watercolour pencils used dry can be applied using a variety of techniques. Used dry on dry, they possess a softness that is ideal for depicting delicate dense hair growth; on a tinted surface, the whole effect leads to a subtle interpretation of the subject (see page 76).

The strokes are placed en masse in a contoured formation. These exercises help towards the depiction of hair over the skull and limbs of smaller animals; retain areas of untouched paper so that highlighted areas are included.

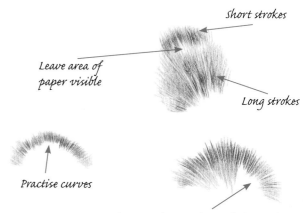

Short strokes

Leave area of paper visible

Long strokes

Practise curves

Short strokes can be made longer by rejoining the first marks and extending them with further strokes

Soft coloured pencils

Derwent Drawing soft coloured pencils, with their wide strip and rich velvety texture, are suitable for blending as well as achieving interesting textures. Used on smooth or slightly rougher surfaces – tinted or white – they provide a versatile drawing medium for animal subjects.

The exercise below demonstrates the use of contoured strokes with blending to indicate folds in the animal's skin, rather than the texture of hair; it is drawn on a Payne's grey watercolour wash (see page 70).

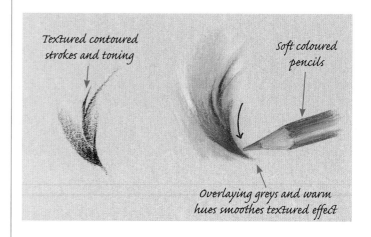

Textured contoured strokes and toning

Soft coloured pencils

Overlaying greys and warm hues smoothes textured effect

Clear-water brushwork

One of the methods using brushstrokes with watercolour pencils, watersoluble graphite, non-permanent inks and so on, is to apply clear water over an image drawn dry, causing pigment to move over the paper's surface and blend. It is important to apply the strokes in the same way as you would if pigment were already on the brush.

Watercolour glazes

Watercolour washes, whether overlaid or used as a glaze, give the technique of pure watercolour painting. They are also ideal when laid as tints over a permanent medium, such as ink or fixed charcoal.

Returning to the pen exercises for the initial drawing opposite, these exercises demonstrate how to lay a tinted wash, increase intensity of hue and apply a glaze. I used a 0.1 liner pen on lightweight Rough watercolour paper.

Cutting in watercolour strokes

Pure watercolour painting can include methods such as overlaid washes, wet into wet, dropping in, drybrush and so on, for which various sizes and shapes of brushes are used. For this second study of a big cat's fur I used a No. 4 round brush with a good point, so that the cutting in could be precise, allowing light hair over dark hair, and vice versa, to be depicted successfully (see page 72).

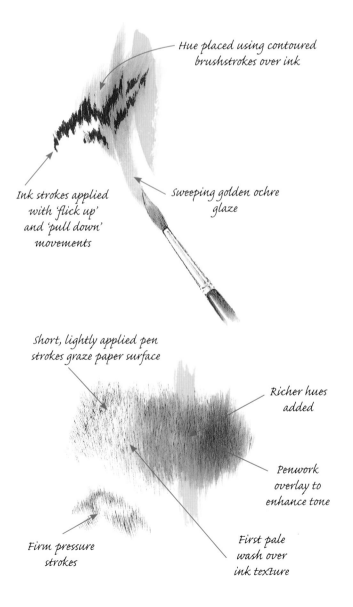

Hue placed using contoured brushstrokes over ink

Ink strokes applied with 'flick up' and 'pull down' movements

Sweeping golden ochre glaze

Short, lightly applied pen strokes graze paper surface

Richer hues added

Penwork overlay to enhance tone

Firm pressure strokes

First pale wash over ink texture

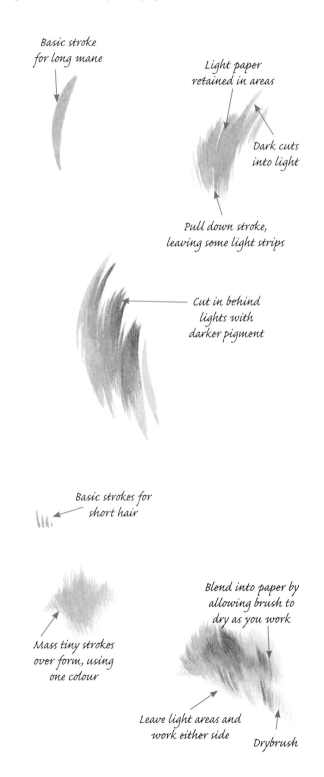

Basic stroke for long mane

Light paper retained in areas

Dark cuts into light

Pull down stroke, leaving some light strips

Cut in behind lights with darker pigment

Basic strokes for short hair

Blend into paper by allowing brush to dry as you work

Mass tiny strokes over form, using one colour

Leave light areas and work either side

Drybrush

Elephant

acrylic

Unlike watercolour, acrylic does not always benefit from being painted on a white support. The fact that opaque white is included in the palette makes its use over a coloured ground very advantageous. There is, however, a particularly effective way of building your hues upon a coloured ground, and one problem can be the lack of knowledge of this.

If your subject is viewed in a zoo environment – even in a zoo park – the surrounding area may prove to be uninteresting and not suggestive of the elephant's natural environment, so you may be tempted to include in your picture a background based upon memory or photographic reference, as I have done opposite.

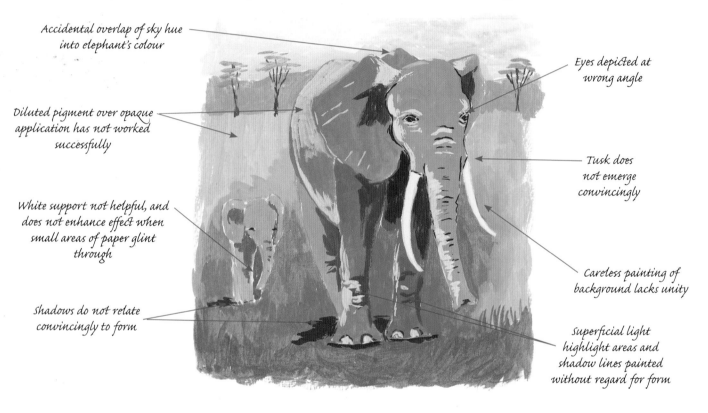

Accidental overlap of sky hue into elephant's colour

Diluted pigment over opaque application has not worked successfully

White support not helpful, and does not enhance effect when small areas of paper glint through

Shadows do not relate convincingly to form

Eyes depicted at wrong angle

Tusk does not emerge convincingly

Careless painting of background lacks unity

Superficial light highlight areas and shadow lines painted without regard for form

Techniques

Base painting

Drawing and painting exercises are combined in this example using acrylic paint, which shows how guidelines are used alongside freely drawn brush lines to establish the image prior to painting areas of hue and tone.

The image was initially drawn on paper that had received a coat of acrylic hue, with the intention of retaining some of this colour within the finished painting. Thought was given to form, and these thoughts were transferred to the paper (using off-white paint and a fine brush) with directionally 'drawn' contour lines to establish a firm base.

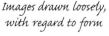

Images drawn loosely, with regard to form

Paint base colour freely over surface first, and allow to dry thoroughly

Up-and-down strokes establish background

Interesting shadow shapes blocked in

Blocked-in negative shapes indicate distance

Placing horizontal guidelines is a great help in establishing proportions when relating a baby elephant to the massive scale of its mother. When using acrylic, you are free to make as many alterations as necessary on the initial drawing, as all marks are easily covered as the painting progresses.

This painting is shown in the very early stages of development to give you an idea of what is involved prior to the final layers of pigment being added. A–G are preparation stages that serve to form a scaffold upon which the painting can then be built.

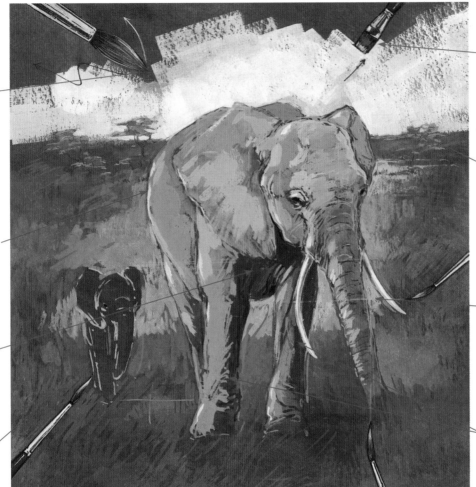

Flat brush quickly covers large areas

a) First wash of colour on paper using large brush

g) Background 'suggestive' – not detailed depiction

f) Background introduced – painting 'up to' form, yet retaining darker 'edge'

b) Guidelines placed vertically and horizontally to establish scale and relationship

e) Tonal areas contrast with light planes

c) Loosely drawn brush lines around and within form

d) Position of baby established in relation to mother

Practise various directional sweeps of brush for both images and background

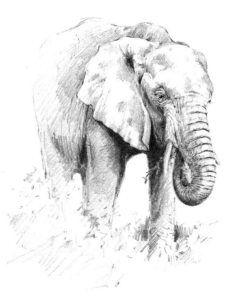

The learning experience

You may work from reference photographs that do not allow you to clearly see the whole animal; this can occur when an animal is observed in its natural setting.

It is therefore a good thing to make other sketches from various angles, with the elephant in different poses, to familiarize yourself with the whole form and bulk of the animal.

Rhinoceros

`charcoal pencil`

The white and black rhinos of Africa differ from each other in a number of ways, including the following: white rhino are larger than black; the latter has a shorter head, which is held more erect than that of the white rhino, which enables it to feed on branches and leaves from trees and shrubs as well as long grass; white rhino, with heavier disproportionate heads, have a broad mouth adapted for grazing short grass, in contrast to the prehensile upper lip of the black rhino.

The complex structure of the rhino's head has presented a number of problems in this study. These include eye angle, use of tone, creation of texture, depiction of skin folds and the expression of contour lines.

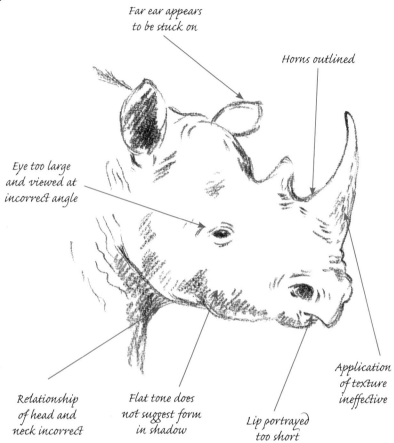

Far ear appears to be stuck on

Horns outlined

Eye too large and viewed at incorrect angle

Relationship of head and neck incorrect

Flat tone does not suggest form in shadow

Lip portrayed too short

Application of texture ineffective

Techniques

Texture and form

Charcoal pencil produces interesting textures when gently grazed over Rough paper; firm pressure strokes produce dark lines but, unless great care is taken, these may cause the charcoal strip to break. Avoid this by going backwards and forwards over the line you are creating in order to achieve intensity and width of mark. These exercise strokes are ideal for interpreting shadow recess lines in the skin of a rhino, combined with wider areas of tone that vary in intensity.

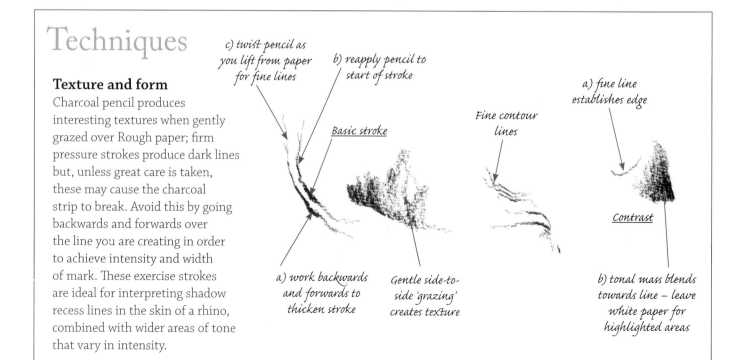

c) twist pencil as you lift from paper for fine lines

b) reapply pencil to start of stroke

a) fine line establishes edge

Basic stroke

Fine contour lines

a) work backwards and forwards to thicken stroke

Gentle side-to-side 'grazing' creates texture

Contrast

b) tonal mass blends towards line – leave white paper for highlighted areas

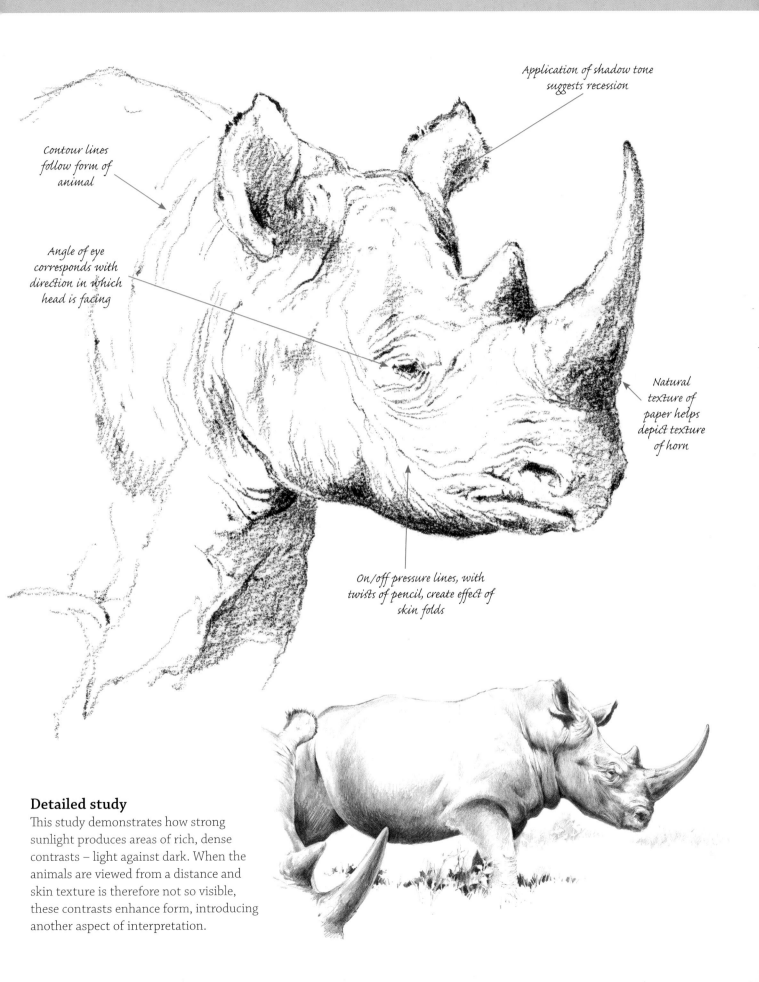

Application of shadow tone
suggests recession

Contour lines
follow form of
animal

Angle of eye
corresponds with
direction in which
head is facing

Natural
texture of
paper helps
depict texture
of horn

On/off pressure lines, with
twists of pencil, create effect of
skin folds

Detailed study

This study demonstrates how strong
sunlight produces areas of rich, dense
contrasts – light against dark. When the
animals are viewed from a distance and
skin texture is therefore not so visible,
these contrasts enhance form, introducing
another aspect of interpretation.

Problems

Hippo

coloured pencils

Spending its time between grassy feeding grounds and deep rivers – where it may remain in water for most of the day to keep cool and to support its massive frame – a bulky hippo is a challenge to the artist.

When working upon a prewashed support it is advisable not to erase pencil marks, and this may cause problems for beginners who find it necessary to correct parts of the drawing before coloured pencil application. As the background hue in this case is pale, it is possible to trace the pre-drawn image directly on to the washed surface when dry. This ensures that corrections are made upon the investigative drawing rather than on the final artwork.

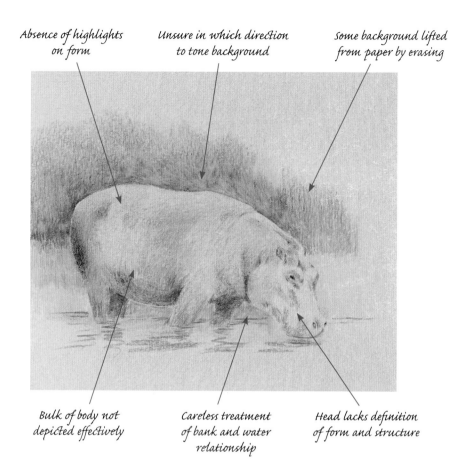

Absence of highlights on form

Unsure in which direction to tone background

Some background lifted from paper by erasing

Bulk of body not depicted effectively

Careless treatment of bank and water relationship

Head lacks definition of form and structure

Techniques

Laying a flat wash

When laying a flat wash, it is advisable to travel completely off the paper on either side; to avoid the gummed strip losing its adhesion, it is necessary to blot dry at the extreme edges. I used a wash of Payne's grey to lay a flat wash that would give a background hue suitable for incorporation with the subtle colours of the hippo's skin.

Note shape of brushmark as paint is applied beyond edge of paper and over gummed strip

Paint washed over edge of paper and on to gummed strip

Smooth, horizontal strokes

Reservoir here when wet – as pigment dries absorbed back up paper and smooth appearance of the wash is affected

At this point, where brush paused, pigment runs back and produces unwanted watermark

With the last horizontal stroke completed, gently lift paint along lower edge with tissue or squeezed dry brush

For this study of a hippo the Derwent Drawing range of soft coloured pencils was used on a pre-washed watercolour paper surface in order to make use of a coloured support for the rich, velvety finish of the medium.

Highlights depicted by white pencil help define form, so a tinted ground was chosen upon which to shade white as a contrast to the darks of shadow recess areas and larger contours that follow form.

The texture on the hippo's skin emerges naturally as a result of mixing media, with smooth effects created by firm pressure upon pencils and greater texture achieved by lighter pressure (see examples below).

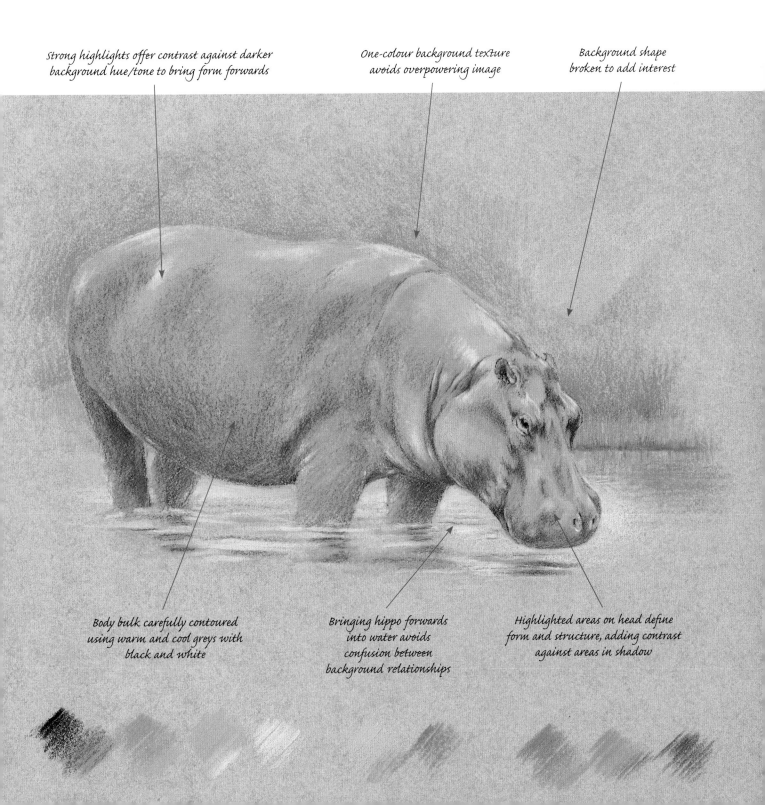

strong highlights offer contrast against darker background hue/tone to bring form forwards

One-colour background texture avoids overpowering image

Background shape broken to add interest

Body bulk carefully contoured using warm and cool greys with black and white

Bringing hippo forwards into water avoids confusion between background relationships

Highlighted areas on head define form and structure, adding contrast against areas in shadow

Problems

Lion

`watercolour`

The lion is the largest and most magnificent of the big cats. A thick mane surrounding the male's face and neck adds to his powerful appearance as protector of the pride. As the male ages, his mane gets darker, and this can offer exciting contrasts of hue and tone for the artist to depict in watercolour.

Viewed from the front, the upward-slanting eyes are sometimes portrayed by the novice painter as appearing at the same angle as human eyes – level. This gives the face a flat appearance.

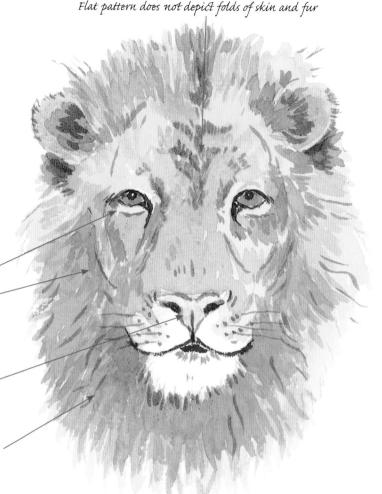

Flat pattern does not depict folds of skin and fur

Eyes placed level

Colour washes overlaid indiscriminately

Nose appears flat without shadow tones

Dark, wormlike marks do not suggest negative shadow shapes within mane

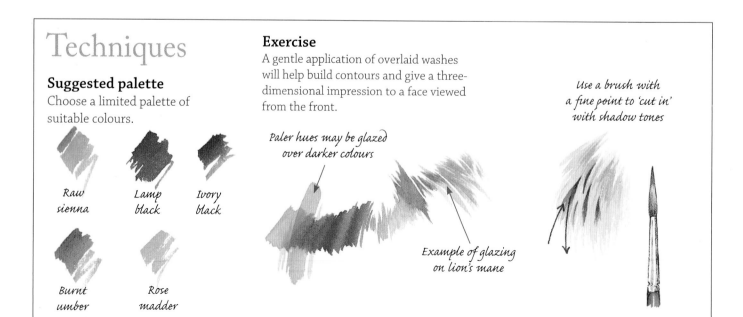

Techniques

Suggested palette
Choose a limited palette of suitable colours.

Raw sienna

Lamp black

Ivory black

Burnt umber

Rose madder

Exercise
A gentle application of overlaid washes will help build contours and give a three-dimensional impression to a face viewed from the front.

Paler hues may be glazed over darker colours

Example of glazing on lion's mane

Use a brush with a fine point to 'cut in' with shadow tones

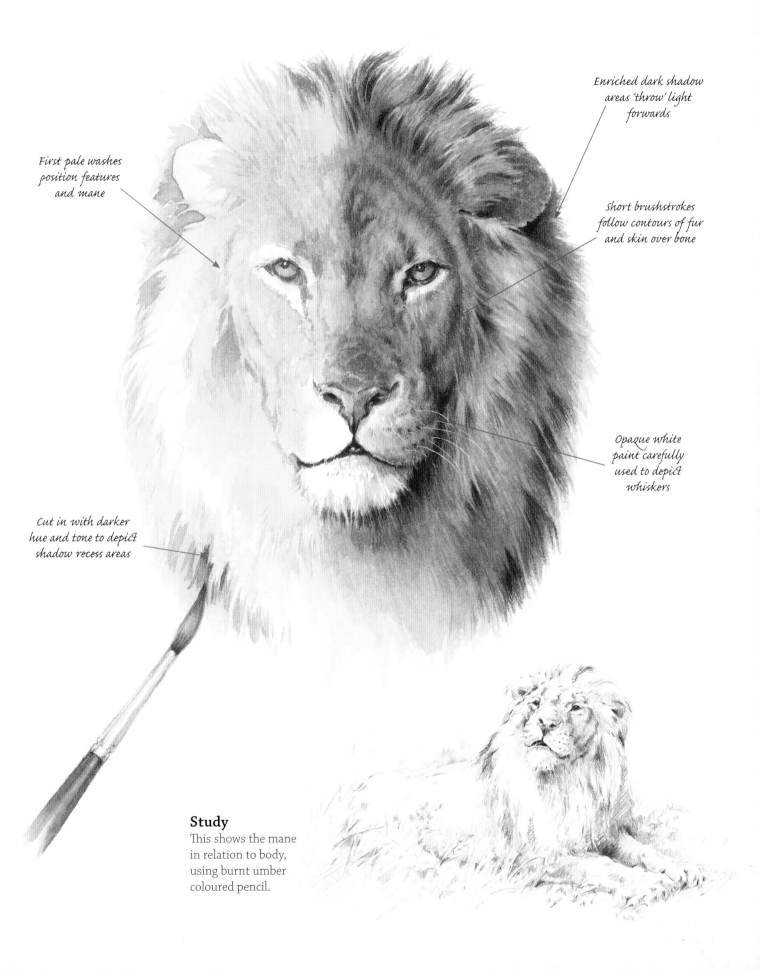

Enriched dark shadow areas 'throw' light forwards

First pale washes position features and mane

Short brushstrokes follow contours of fur and skin over bone

Opaque white paint carefully used to depict whiskers

Cut in with darker hue and tone to depict shadow recess areas

Study
This shows the mane in relation to body, using burnt umber coloured pencil.

Problems

Tiger

`pen and ink`

Intensity of texture and tone, developed by applying layers of ink and watercolour, culminate in gentle glazing and enriched darks that achieve the subtle blending in a tiger's face.

A problem often encountered when depicting animals with light whiskers is how to retain these light shapes while working on the darker areas of fur. Combining drawing (in the form of ink representation) with watercolour is one way of solving this dilemma.

Achieving the impression of a dense, thick coat can also prove difficult, and this problem can be solved by the use of the overlay method shown below and opposite, both in ink and watercolour washes.

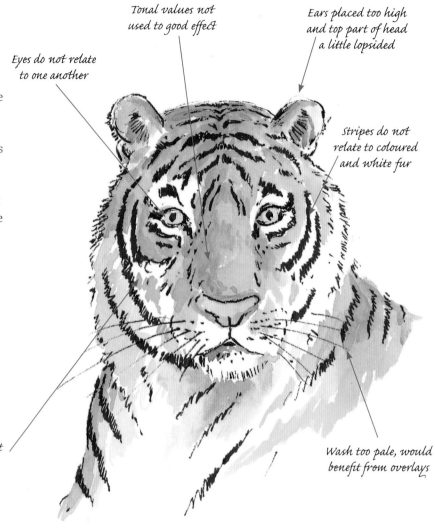

Tonal values not used to good effect

Ears placed too high and top part of head a little lopsided

Eyes do not relate to one another

Stripes do not relate to coloured and white fur

Careless application of paint

Wash too pale, would benefit from overlays

Techniques

Methods

Variety of directional pen strokes

Diagonally applied 'underlay'

Contoured mass

Crosshatching

Contoured negative shadow recess shapes

Establishing stripe, using massed strokes

Blending stripe into surrounding (lighter) hair

Examples of 'flick up' and 'pull down' strokes

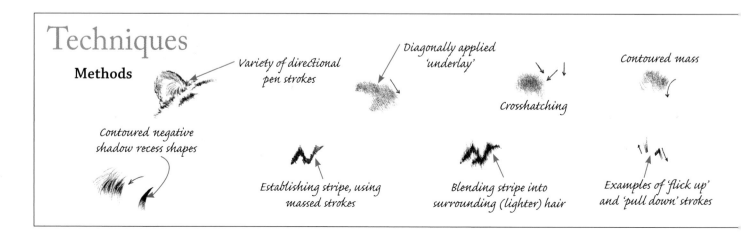

Using the technique of overlaid washes, you can achieve the effect of a dense coat, especially when the washes are painted over a base of pen strokes. If unwanted white paper appears within the striped areas or you feel they are not solid enough, overpaint with a mix of neutral black and red violet, using a fine brush. Finally, gently applied translucent glazes will bring colours to life when swiftly applied.

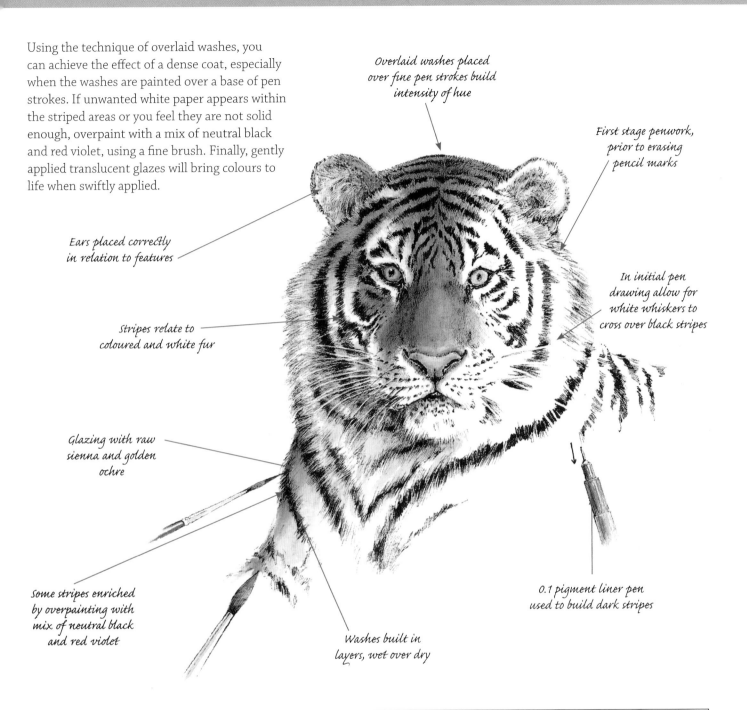

Overlaid washes placed over fine pen strokes build intensity of hue

First stage penwork, prior to erasing pencil marks

In initial pen drawing allow for white whiskers to cross over black stripes

Ears placed correctly in relation to features

Stripes relate to coloured and white fur

Glazing with raw sienna and golden ochre

Some stripes enriched by overpainting with mix. of neutral black and red violet

Washes built in layers, wet over dry

0.1 pigment liner pen used to build dark stripes

Working between whiskers

Establish whiskers by toning between contoured strips of white paper, predrawn in pencil

Fill in dark stripes to appear behind light whiskers – don't trespass on light strips

Glazes

Burnt sienna *Red ochre* *Raw sienna* *Yellow ochre*

Neutral black *Red violet*

Glazing with raw sienna

Glazing with yellow ochre

Problems

Monkey

watercolour pencils

The length and texture of fur within the vast diversity of primates requires careful consideration regarding methods of depiction. When drawing or painting these fascinating animals, there are many other things an artist needs to take into account, not least of which is the variety of hues to be seen within many of the different coats.

With so many elements to consider before putting marks on paper, beginners often start artwork without fully understanding what is involved. This results in what could be a successful interpretation being spoilt by disproportional components, unsympathetic outlining, careless application of hue and tone, and a disregard for essential directional stroke application.

Image outlined in black, disregarding effect of light on form

Pencil strokes over head placed in similar direction, without regard for form

Unsure how to depict fur fanning from central area on lowered head

Size of hands unrelated

Variety of hues over muzzle not noted

Leg too short in relation to other limb

Helpful negative shape not correctly observed to anchor animal effectively

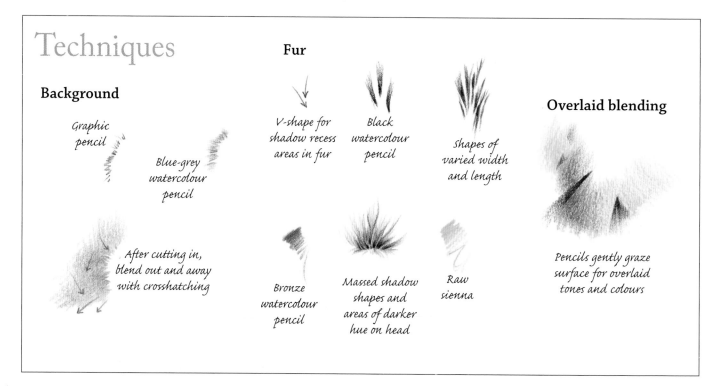

Techniques

Fur

Background

Graphic pencil

Blue-grey watercolour pencil

V-shape for shadow recess areas in fur

Black watercolour pencil

Shapes of varied width and length

Overlaid blending

After cutting in, blend out and away with crosshatching

Bronze watercolour pencil

Massed shadow shapes and areas of darker hue on head

Raw sienna

Pencils gently graze surface for overlaid tones and colours

As always, correct proportions and the use of tonal values in relation to the light source need to be carefully planned for an overall convincing representation. It is the initial observation of the subject and plan of execution that lead to a successful result – as long as this is combined with effective techniques.

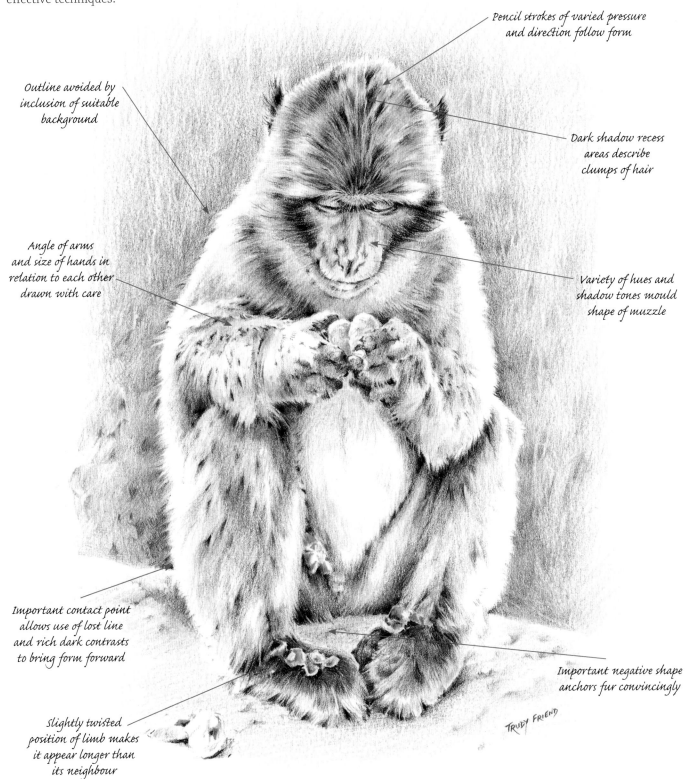

Pencil strokes of varied pressure and direction follow form

Outline avoided by inclusion of suitable background

Dark shadow recess areas describe clumps of hair

Angle of arms and size of hands in relation to each other drawn with care

Variety of hues and shadow tones mould shape of muzzle

Important contact point allows use of lost line and rich dark contrasts to bring form forward

Important negative shape anchors fur convincingly

Slightly twisted position of limb makes it appear longer than its neighbour

TRUDY FRIEND

Problems

Camel

coloured pencils

The dromedary camel possesses hairy ears, heavy eyebrows and long lashes, protecting eyes and ears from airborne sand and extreme heat of the sun.

To depict the longer hair behind the ear and around the neck, extending to its shoulders and a single hump, take advantage of a textured surface. Beginners who experience problems with more noticeable textures within a paper's surface may find the more obvious, heavier lines in the lightweight wrapping paper used here a disadvantage. It is tempting to draw the initial image using a black pencil for clarity, whereas a subtle chocolate hue may work better for the gentle application of 'edge' lines and darker tones.

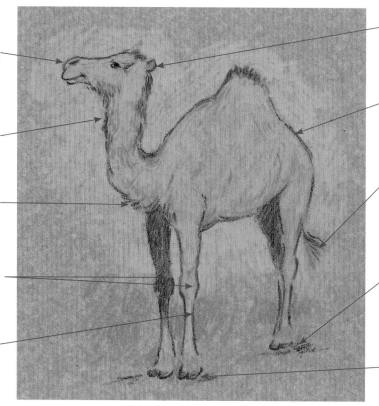

Forms of nostrils and lips not closely studied

Blue behind image not applied directionally or 'cut in' to form

Application of strokes suggest longer hair is disjointed, with edge separated from form within

Knees depicted too round

Shape of legs not suggesting bone structure beneath skin

Ear appears to be stuck to side of head

Unnecessary continuous dark outline

Angle of hairs on tail not related to body

Shadow not related to foot on ground

Animal appears to be standing on its toes

Techniques

Texture

The following exercises, executed upon ordinary brown wrapping paper, demonstrate how natural texture in the surface can be used to suggest sky in the background, while working across the grain to form the image.

The exercises demonstrate how you can retain contact with the paper as your pencil travels across its surface using strokes of varied pressure and width to suggest recessed shadow lines against tonal block areas within the form.

Arrows indicate directions used for textured hair effect on coat

Follow texture (grain) of paper for background area

Varied pressure strokes

Introduce small areas of different hues

Light pressure texture

Firm pressure blocking in

Rich contrasts of hue and tone bring image forwards

It is important to familiarize yourself with the habits of an animal in order to understand why certain parts of the body appear as they do. Constant kneeling causes calluses on camels' knees, for example, and you need to observe such details in order to depict accurately these 'ships of the desert'.

For this study I chose the vertically textured surface of ordinary brown wrapping paper, combining a loose, free style with soft coloured pencils. To differentiate between the application of background and image, I followed the natural texture of the paper for sky depiction and crossed it with line and tone to define the animal.

Varied pressure lines and tonal blocks work well together in this context, while incorporating the support colour and adding unity.

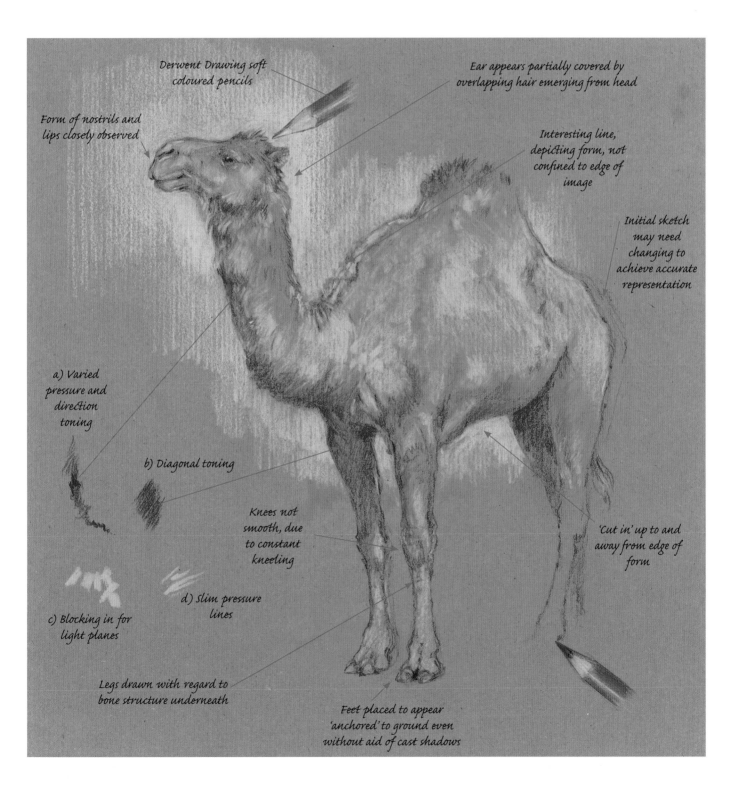

Derwent Drawing soft coloured pencils

Ear appears partially covered by overlapping hair emerging from head

Form of nostrils and lips closely observed

Interesting line, depicting form, not confined to edge of image

Initial sketch may need changing to achieve accurate representation

a) Varied pressure and direction toning

b) Diagonal toning

Knees not smooth, due to constant kneeling

'Cut in' up to and away from edge of form

c) Blocking in for light planes

d) Slim pressure lines

Legs drawn with regard to bone structure underneath

Feet placed to appear 'anchored' to ground even without aid of cast shadows

Problems

Giraffe

coloured pencils

No two giraffes' coat patterns are the same, and the patterns also change their appearance depending upon the angle at which the animal is viewed. The pattern on the head is made up of much smaller shapes, with areas of solid hues running between the eyes down to the muzzle.

With an animal of this unusual shape, where the long neck and legs relate disproportionately to the body mass, it is important to be aware of how markings vary, depending upon the narrow or wider areas they cover and the angles at which they are viewed. Another consideration is of how much light 'base' to retain between the patches.

Unnecessary outline, as placing of markings defines form

Smoothly drawn curve between neck and chest does not indicate strong structure

Carelessly applied shadow tone

Ears set incorrectly

Markings applied without regard for form beneath

Eye depicted at wrong angle for head in this position

Heavily interpreted tail results in shape of hind limb being lost

Foliage only placed at base of legs – light shading and more distribution required

Techniques

Negative shapes

By taking your strong horizontal line from the base of the muzzle across the top of the animal's legs and noticing three different-size negative shapes, you will be able to establish correct proportions.

Using coloured pencils it is possible to delicately place the edge of each patch in relation to its neighbour before filling in with colour. In this way a uniformity of light area surrounding each marking can be achieved.

It is important to depict folds in the skin at the base of the neck when the head is lowered to browse, and to notice slimmer folds in the more delicate skin between the front legs.

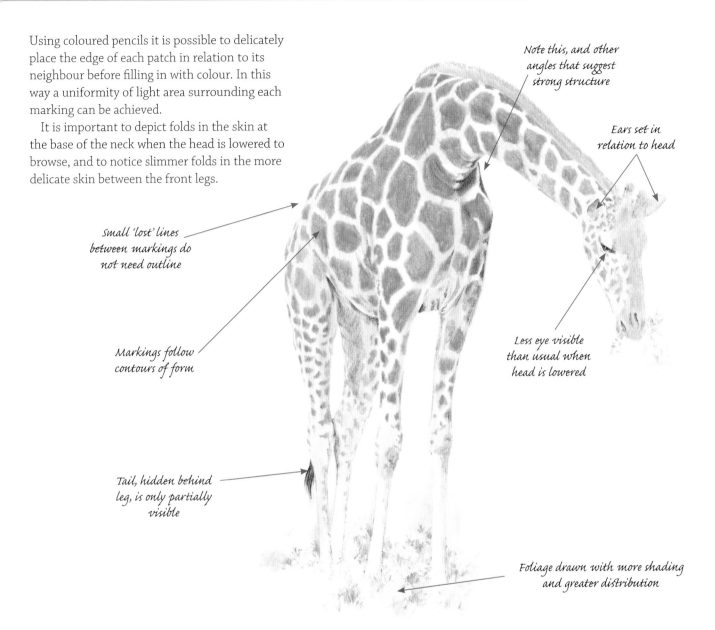

Note this, and other angles that suggest strong structure

Ears set in relation to head

Small 'lost' lines between markings do not need outline

Markings follow contours of form

Less eye visible than usual when head is lowered

Tail, hidden behind leg, is only partially visible

Foliage drawn with more shading and greater distribution

Patterns

Coloured pencils of any variety are suitable for blocking in pattern shapes, using either diagonally placed strokes, crosshatching or gentle, varied directional blending. Strokes around the edges should follow the direction in which the animal's hair travels. For this type of pattern, it is preferable to use a smooth-surfaced paper.

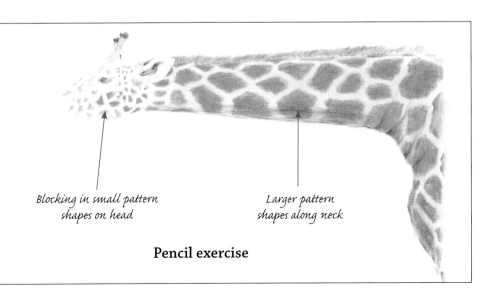

Blocking in small pattern shapes on head

Larger pattern shapes along neck

Pencil exercise

Problems

Zebra

`watersoluble graphite pencil`

Many animals possess markings, either over the whole of their body or in certain areas, that give the artist an opportunity to follow contours of form by their observation. In the case of a Grevy's zebra, we can see wider stripes on body and neck contrasting with narrower ones on the head and legs.

Apart from the frequently occurring problem of proportions, when animals are viewed from unfamiliar angles, beginners may experience problems as they try to see and depict the vast array of stripes. As these vary in width, length and follow the contours of various forms, they can be very confusing.

Continuous outlined curve does not take bone structure into consideration

Relationship of mane to neck stripes not observed correctly

Position of stripe along spine has been placed off-centre

Clear water washes carelessly applied, and painting over stripes unnecessary

Distinctive pattern on ears not depicted correctly

Negative shape not used to help accurate limb placing

Eyes placed without regard for angle of head

Change of direction where stripes follow form has been noticed but not understood

Incorrect structure of hoof in relation to leg bones and tendons

Techniques

Stripe detail

With its subtle blending both in its dry state and in response to the addition of water, watersoluble graphite pencil is very effective for animal studies. These exercises show how a sweeping stroke can, in an instant, produce an effective shadow side to form.

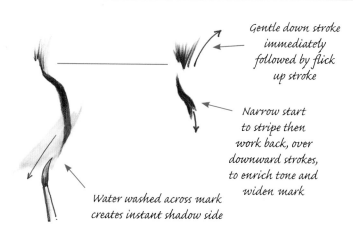

Gentle down stroke immediately followed by flick up stroke

Narrow start to stripe then work back, over downward strokes, to enrich tone and widen mark

Water washed across mark creates instant shadow side

As always, it is most important to establish convincing structure, proportions and the character of the animal before adding superficial markings (unless markings are used as a guide). This study relies upon basic sketches to place these components correctly. The stripes should be closely observed and carefully drawn in a way that 'describes' form before the

application of sweeping clear water washes indicates shadow shapes and indentations depicting muscle stress areas.

Although zebras are basically black and white, shades of brown on muzzle and tips of mane hair introduce a little colour, and this colour can also be extended into areas of the white coat to depict the effect of dust adhering to the coat.

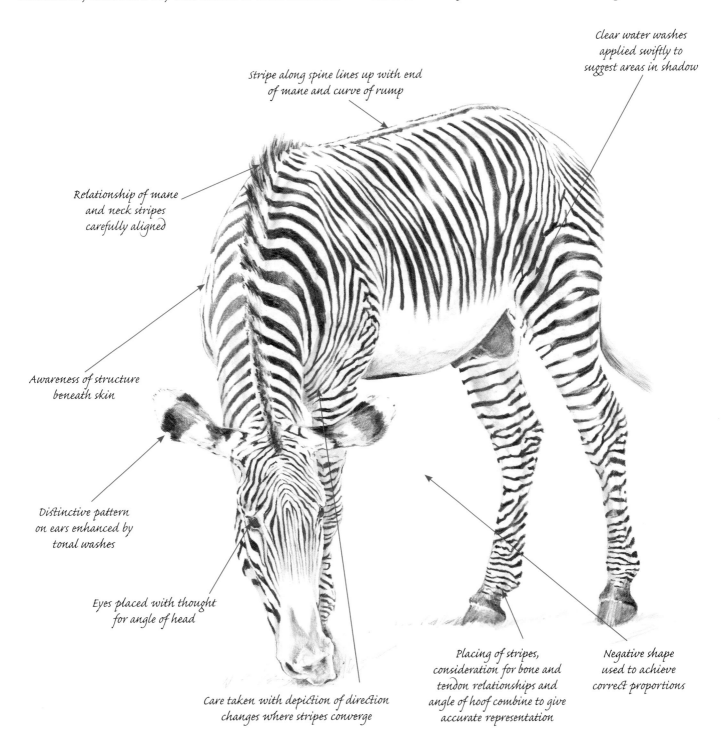

Clear water washes applied swiftly to suggest areas in shadow

Stripe along spine lines up with end of mane and curve of rump

Relationship of mane and neck stripes carefully aligned

Awareness of structure beneath skin

Distinctive pattern on ears enhanced by tonal washes

Eyes placed with thought for angle of head

Care taken with depiction of direction changes where stripes converge

Placing of stripes, consideration for bone and tendon relationships and angle of hoof combine to give accurate representation

Negative shape used to achieve correct proportions

Stripes not directly touched with brush and water – pigment only disturbed for depiction of areas in shadow

These exercises cover a variety of media from pencil, fibre-tip pens, watercolour pencils and pastel to watercolour. Don't forget that all of these exercises can be applied to every kind of animal – fur is fur and claws are claws – so be aware of the possibilities in all your work.

Pencil

Used as a tool for creating quick impressions, pencil is a good place to start with most of your depictions. Even a few brief marks can convey the essence of an animal's character when correctly applied (see page 91).

Make tonal block

Take the tone into up-and-down application, working down the paper

Introduce rich darks and 'V' shapes to suggest wet fur

Strokes applied in opposite directions depict silhouette of underside of otter seen in shadow

Varied pressure strokes that move into toned areas without pencil being lifted from the paper

Defining form

Used in abstract way for practice exercise

Fanned application suggesting contoured hair growth

Used solid is 'closed' application

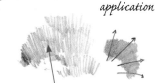

Where white paper is visible is 'open' application

Watercolour pencils

These pencils supply us with an interesting variety of neutral hues, some of which are ideal for certain animals where the fur is comprised of mainly monochrome hues (see page 88).

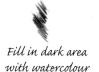

Pull clean water down from dark mass

Fill in dark area with watercolour pencil

With clean water flick brushstrokes upwards, away from dark mass

Fan area of tone using sharp pencil

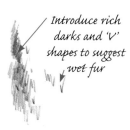

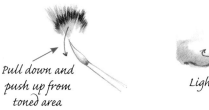

Pull down and push up from toned area

Nose

Lightly swirl clean water over drawn area

Watersoluble graphite

This is available in a variety of grades that respond when wet in various ways upon different surfaces (see page 100). Take time to experiment with them, one against the other, to discover which best suits your chosen subject as well as your personal style.

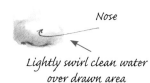

Basic 'tick' stroke ends in flick upwards

Clean water added behind strokes

Dark pencil areas blend readily on addition of water

To retain light hues, wash colour over untouched paper towards the pencil strokes

Watercolour painted over strokes and pulled down

Pigment blends upon contact with drawing

Fibre-tip pens

With their variety of strong colours, these pens can be used to produce bold interpretations (see page 92). Overlays on areas in shadow can subdue effects, as can the addition of a clean water wash – which may be more effective over some colours than others. The only way to discover various possibilities is to try a series of exercises and make notes as to the results.

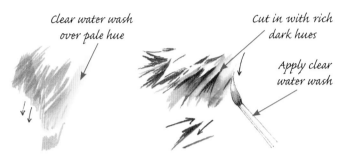

Clear water wash over pale hue

Cut in with rich dark hues

Apply clear water wash

Overlaying shadow tones

Strong, sharp strokes suggest wet fur

With heavyweight paper, it is possible to scrape back pigmented areas to reveal white paper beneath, a process called sgraffito (see pages 92–93). Before doing this, practise building layers of colour and cutting in for shadow recesses within dense fur.

Pastels and pastel pencils

These can be used to cover paper, both swiftly (to establish blocks of colour) and delicately (to enhance detail), and it is also possible to introduce carbon pencil when enhancing delicate dark areas (see page 94).

Practise blending colours

Draw over pastel with carbon pencil

Carbon pencils

When depicting small areas of rich tone or black, beady eyes, you can use a carbon pencil in addition to pastels and pastel pencils. Carbon pencils are also useful for working the shadow areas between digits on hands and feet, as well as whiskers and fine shadow recesses with fur. Practise placing solid areas of colour and drawing a sharpened carbon pencil across these to see how it contrasts with the paler hues.

Mixed media: draw, fix and paint

Place your palette of colours in small areas at the edge of your work or on a separate piece of paper. Using a brush dipped in clean water, 'lift' the colour(s), mix in a separate area and apply them to the relevant parts of your fixed drawing, following the form and/or hair-growth direction (see page 96).

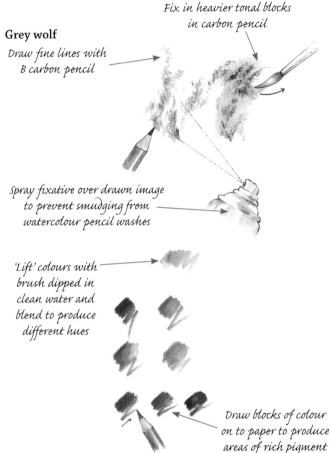

Grey wolf

Fix in heavier tonal blocks in carbon pencil

Draw fine lines with B carbon pencil

Spray fixative over drawn image to prevent smudging from watercolour pencil washes

'Lift' colours with brush dipped in clean water and blend to produce different hues

Draw blocks of colour on to paper to produce areas of rich pigment

Watercolour

The method of overlaying washes to produce richer hues and tones is referred to frequently in this book (see page 98); in order to perfect the method and to understand how and why the application works, you may need to practise frequently.

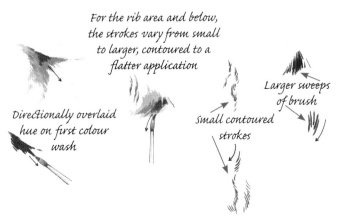

For the rib area and below, the strokes vary from small to larger, contoured to a flatter application

Larger sweeps of brush

Directionally overlaid hue on first colour wash

Small contoured strokes

Red Fox

`watercolour`

Characteristics of the red fox are large, sensitive ears and a pointed snout with black nose. The colours of the soft, dense fur can vary from yellowish-red to red-brown – and usually a white tip to the bushy tail. Most active just after dusk and before dawn, the fox has yellow-brown eyes that glow green when a light is shone into them and are specially adapted to night vision.

Many novice painters are unfamiliar with the methods of overlaying washes and glazing, and this gives them problems with how to make the eyes 'come alive' once the obligatory highlight has been placed. They also experience difficulties establishing the correct eye shape when viewed from a three-quarter angle.

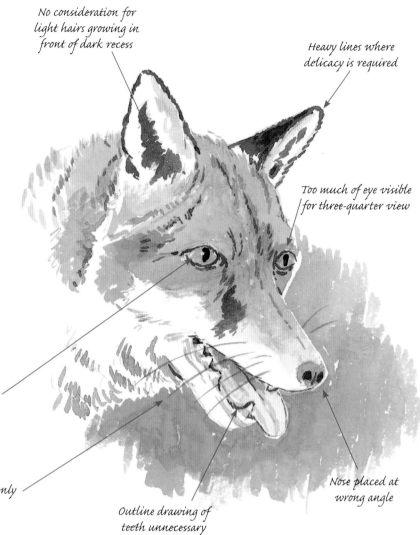

No consideration for light hairs growing in front of dark recess

Heavy lines where delicacy is required

Too much of eye visible for three-quarter view

Eye appears lifeless

Whiskers too evenly placed

Outline drawing of teeth unnecessary

Nose placed at wrong angle

Techniques

Eyes

There is no more delicate area to depict than the eye of an animal; without the sharp contrast of a carefully planned highlight, this important feature may appear lifeless in its depiction. The shape and size of the eyes within the framework of the head also require thought and concentration – when using watercolour, these are best painted initially over the 'support' of a pencil drawing. The latter can be carefully erased after the first watercolour brushstrokes have been positioned, before building the overlays.

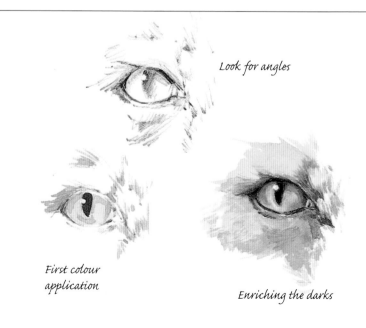

Look for angles

First colour application

Enriching the darks

A fox's eyes may appear smaller in relation to other features when surrounded by thick winter fur than in a sleeker summer coat. Highlights in eyes can vary according to the intensity and angle of the light source, and whether the image has been 'captured' photographically or observed in natural daylight.

This image demonstrates how an uneven area of white highlight can look on a head when we see it at a three-quarter angle.

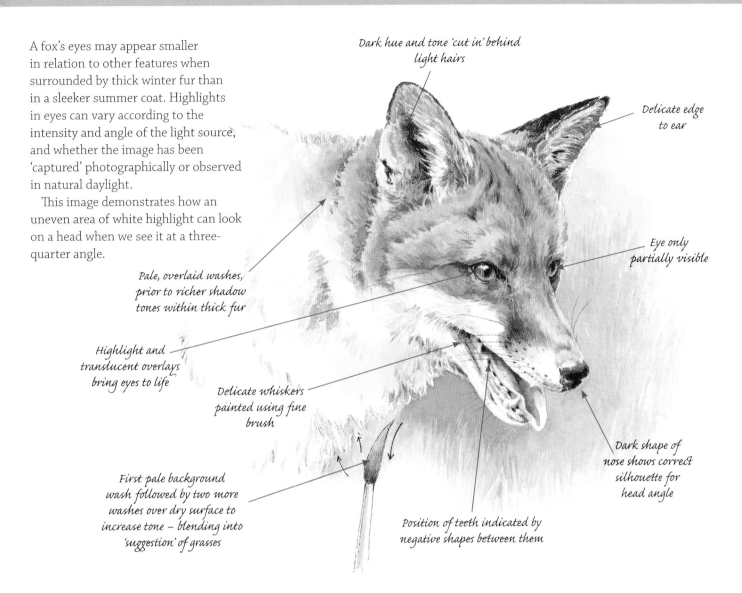

Dark hue and tone 'cut in' behind light hairs

Delicate edge to ear

Eye only partially visible

Pale, overlaid washes, prior to richer shadow tones within thick fur

Highlight and translucent overlays bring eyes to life

Delicate whiskers painted using fine brush

First pale background wash followed by two more washes over dry surface to increase tone – blending into 'suggestion' of grasses

Position of teeth indicated by negative shapes between them

Dark shape of nose shows correct silhouette for head angle

Building the image

This full-face image shows how a circular highlight area appears when the head is viewed from the front. I placed the pale hues and areas of tone prior to building the image using overlaid washes in the order shown.

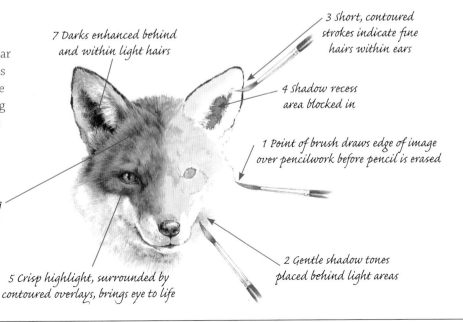

7 Darks enhanced behind and within light hairs

3 Short, contoured strokes indicate fine hairs within ears

4 Shadow recess area blocked in

1 Point of brush draws edge of image over pencilwork before pencil is erased

6 Using fine brush and placing strokes directionally, rich hues painted into fur undulations

5 Crisp highlight, surrounded by contoured overlays, brings eye to life

2 Gentle shadow tones placed behind light areas

Problems

Badgers

`watercolour pencils`

Some subjects lend themselves to monochrome, and the distinctive markings of badgers contrast black-and-white stripes on the head with a speckled effect on the body fur and black limbs. As the bulky body often partially hides short, strong legs, you may represent the head alone rather than the whole animal, but small 'detailed' sketches of limbs will contribute to your understanding of these creatures.

When working in watercolour pencils, problems may arise regarding the application of the media as well as drawing accuracy. With the method of drawing first (dry on dry) followed by the addition of water with a brush, it is often the direction of stroke application that causes problems, as well as how to achieve successful blending from the drawing into the paper beyond the image.

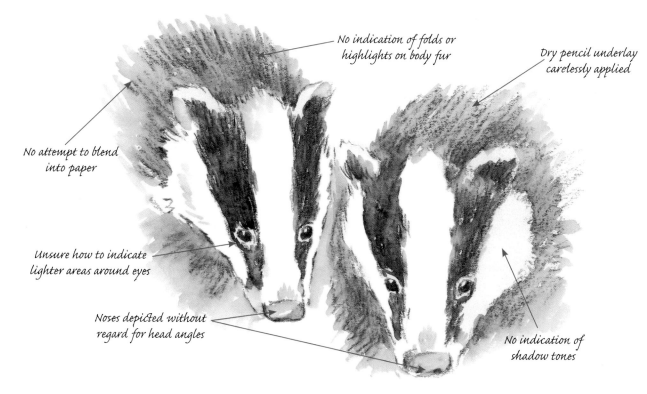

No indication of folds or highlights on body fur

Dry pencil underlay carelessly applied

No attempt to blend into paper

Unsure how to indicate lighter areas around eyes

Noses depicted without regard for head angles

No indication of shadow tones

Techniques **Watercolour pencils on Saunders Waterford HP paper**

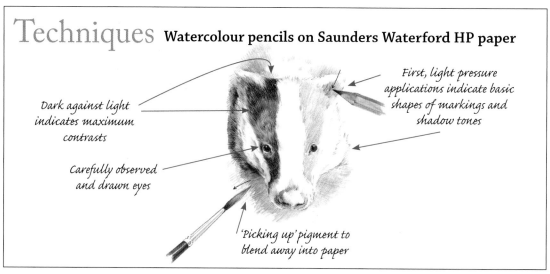

Dark against light indicates maximum contrasts

First, light pressure applications indicate basic shapes of markings and shadow tones

Carefully observed and drawn eyes

'Picking up' pigment to blend away into paper

A variety of wet or dry media may be used for monochrome representation, and it is a good idea to experiment with those that are usually part of a coloured palette, as this enables you to concentrate fully on tonal values and detailed drawing.

Here, I have chosen black watercolour pencil in order to establish the drawing first before using a fine brush to delicately enhance contrasts and the depiction of hair mass. The type of paper is an important consideration for this media: in the main study I have used Saunders Waterford CP Not, as the texture enhances the treatment of dense fur. In contrast, the study of the single head opposite was done on HP paper to produce a smoother depiction.

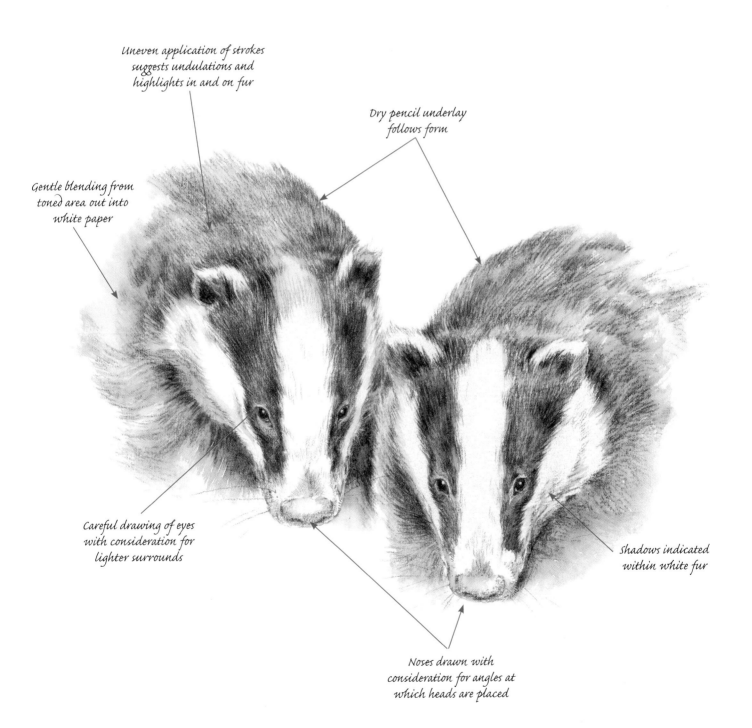

Uneven application of strokes suggests undulations and highlights in and on fur

Dry pencil underlay follows form

Gentle blending from toned area out into white paper

Careful drawing of eyes with consideration for lighter surrounds

Shadows indicated within white fur

Noses drawn with consideration for angles at which heads are placed

Otter

graphite pencil

An otter, standing alert and using its tail as a strut, appears to have a small head in relation to its body length, but this shape contributes towards its excellent swimming and diving skills. The webbed, paddle-like feet are spread wide to enable slow swimming, while for diving and fast movement below the water's surface, the front feet are trailed close to the body, which is swayed from side to side.

When drawing images swiftly it is tempting to do so in the form of an outline – whether continuous or broken – and to indicate fur texture with individually drawn short lines. Toning within the form can also cause problems when applied in a way that flattens form rather than following contours.

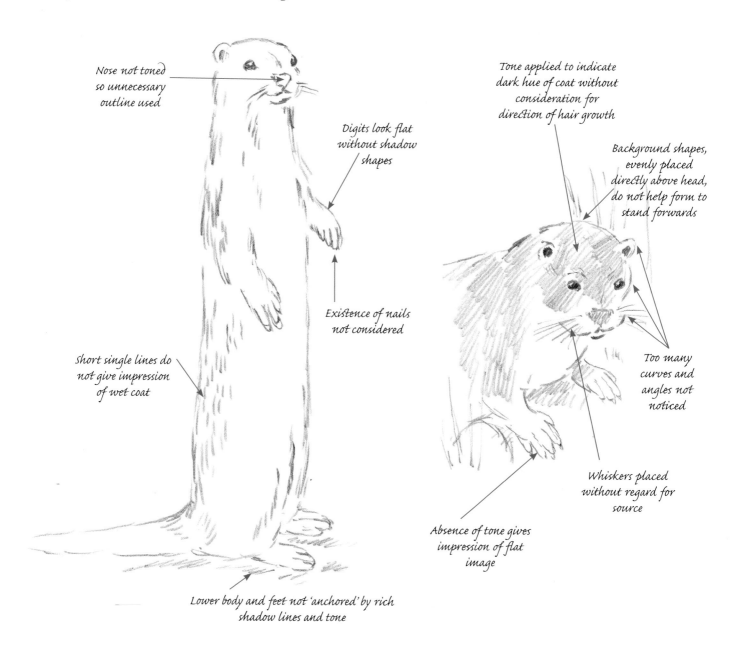

Nose not toned so unnecessary outline used

Digits look flat without shadow shapes

Existence of nails not considered

Short single lines do not give impression of wet coat

Lower body and feet not 'anchored' by rich shadow lines and tone

Tone applied to indicate dark hue of coat without consideration for direction of hair growth

Background shapes, evenly placed directly above head, do not help form to stand forwards

Too many curves and angles not noticed

Whiskers placed without regard for source

Absence of tone gives impression of flat image

By allowing the pencil to work up and down over the lightly drawn form (see page 84), the area of body mass can be swiftly covered; this allows more time for the careful positioning of on/off pressure shadow shapes between the toes and the inclusion of delicately drawn nails.

Because it spends most of its time in water, the otter's coat is usually in a damp or wet state; noticing the 'V' shapes of shadow tone helps its depiction in the form of quick pencil impressions.

swiftly applied diagonal toning establishes shape of nose

On/off pressure strokes add interest to shadow lines

After toning with chisel side of pencil, turn tip and use sharp side to draw nails

Basic 'V' shapes help to give quick impression of wet fur

Lower body and feet 'anchored' by rich shadow line and directional toning

Indicating hue by toning

Indicating hue and tone using a contoured (fanned) application of massed strokes, applying the chisel side of the pencil, will quickly cover the paper. Keep the application loose and free, enhancing the darks of the eyes, ears and nostrils by applying firmer pressure in these areas.

Tone applied to indicate dark hue of coat with consideration for direction of hair growth

Look for suggestion of angles

Whiskers placed swiftly with regard for areas from which they grow

Untouched white paper indicates position of nail

On/off pressure lines indicate shadow tones within forms

Shadow shape

Problems

Beaver

`fibre-tip pens`

Beavers thrive in deep, still waters which they dam to form ponds or lakes. Their fur colours can be anything from light tan to dark brown.

As with hippos (see page 71), beavers are adapted for life in the water, with ears, eyes and nose located near the top of the skull. It is important to be aware of shadow recess shapes between clumps of wet fur and to depict them as blocks rather than outlined V shapes. Problems occur when these areas have not been closely observed or understood.

Pen strokes depicting fur should follow the form of the animal – by applying them in a haphazard way, further problems will result when attempting to indicate highlights.

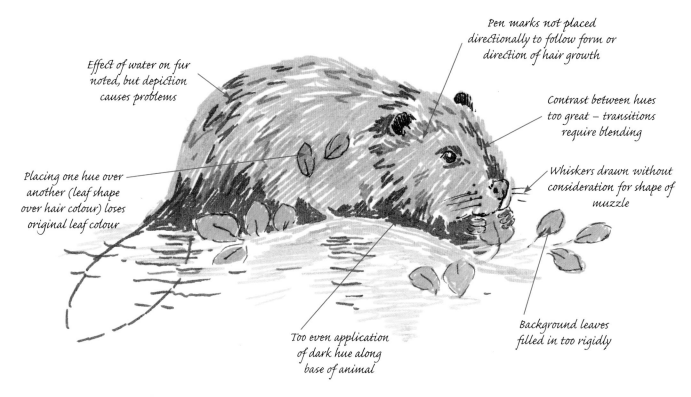

Pen marks not placed directionally to follow form or direction of hair growth

Effect of water on fur noted, but depiction causes problems

Contrast between hues too great – transitions require blending

Placing one hue over another (leaf shape over hair colour) loses original leaf colour

Whiskers drawn without consideration for shape of muzzle

Background leaves filled in too rigidly

Too even application of dark hue along base of animal

Techniques

Fur in detail

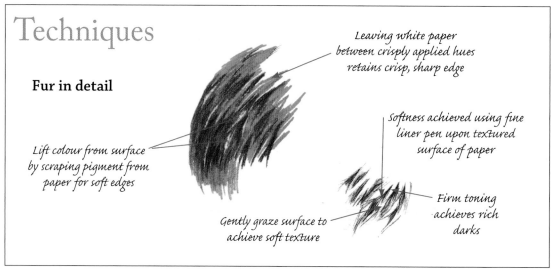

Leaving white paper between crisply applied hues retains crisp, sharp edge

Softness achieved using fine liner pen upon textured surface of paper

Lift colour from surface by scraping pigment from paper for soft edges

Firm toning achieves rich darks

Gently graze surface to achieve soft texture

You can be bold with your interpretation of a great range of brown fur by overlaying hues using fibre-tip pens and drawing into the dark shadow recess areas with fine liner pens in browns and blacks.

The bright hues presented in ranges of fibre-tip pens offer you the opportunity to use strong colours which, when overlaid, provide a rich base. Upon this base the sgraffito method of gently scraping the surface of the paper to reveal white beneath can enhance the effect of highlights on clumps of wet fur.

The annotation for this illustration shows the development of the stages of working.

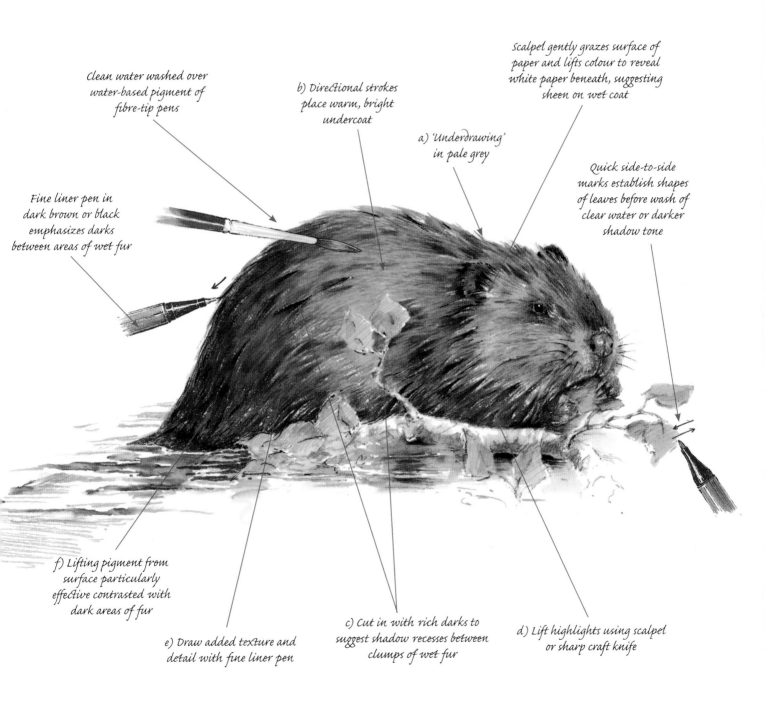

Clean water washed over water-based pigment of fibre-tip pens

b) Directional strokes place warm, bright undercoat

a) 'Underdrawing' in pale grey

Scalpel gently grazes surface of paper and lifts colour to reveal white paper beneath, suggesting sheen on wet coat

Quick side-to-side marks establish shapes of leaves before wash of clear water or darker shadow tone

Fine liner pen in dark brown or black emphasizes darks between areas of wet fur

f) Lifting pigment from surface particularly effective contrasted with dark areas of fur

e) Draw added texture and detail with fine liner pen

c) Cut in with rich darks to suggest shadow recesses between clumps of wet fur

d) Lift highlights using scalpel or sharp craft knife

Problems

Grey Squirrel

pastel pencils

The grey squirrel, introduced into the British Isles from eastern North America, resides within coniferous and deciduous woodlands, and is also a common visitor to parks and gardens. For this reason it is easy to observe and photograph.

 Although referred to as grey, this species has a sprinkling of other hues within its coat, and the depiction of these can sometimes cause problems for the novice pastel artist. The choice of support can present other problems; if an unsuitable background colour is used and left untouched, this can cause the image to appear rather stark.

Hues placed without regard to form

Whiskers too heavily drawn

Problems with depiction of tail

Curve of arm incorrect

Blunt pastel pencil results in hard outline

Without use of shadow areas, squirrel's form does not relate to support

Techniques **Derwent pastel colours**

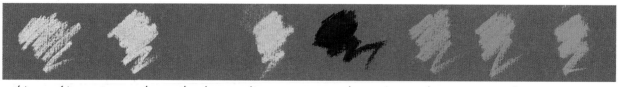

Chinese white	*Brown ochre*	*Chocolate*	*Olive green*	*French grey*	*French grey*	*Brown ochre*	*Terre verte*
	57F	*66D*	*51F*	*70B*	*70D*	*57B*	*77D*

Tinted textured Ingres paper responds well to pastel pencils, making it possible to produce delicate lines using a fine point as well as the broader application of a blunt colour strip. Both these applications are combined within this study, and I have chosen to introduce the second media of carbon pencil for even finer overdrawing.

A rich neutral hue was chosen for the support, as this allows a green background of pastel to contrast with neutral greys and warm tints in the squirrel's coat. It also adds a unity to the interpretation. Pastel pencils mix comfortably with carbon pencil (see page 45), which is used as overlay for the depiction of fine hairs and in the dark shadow recesses.

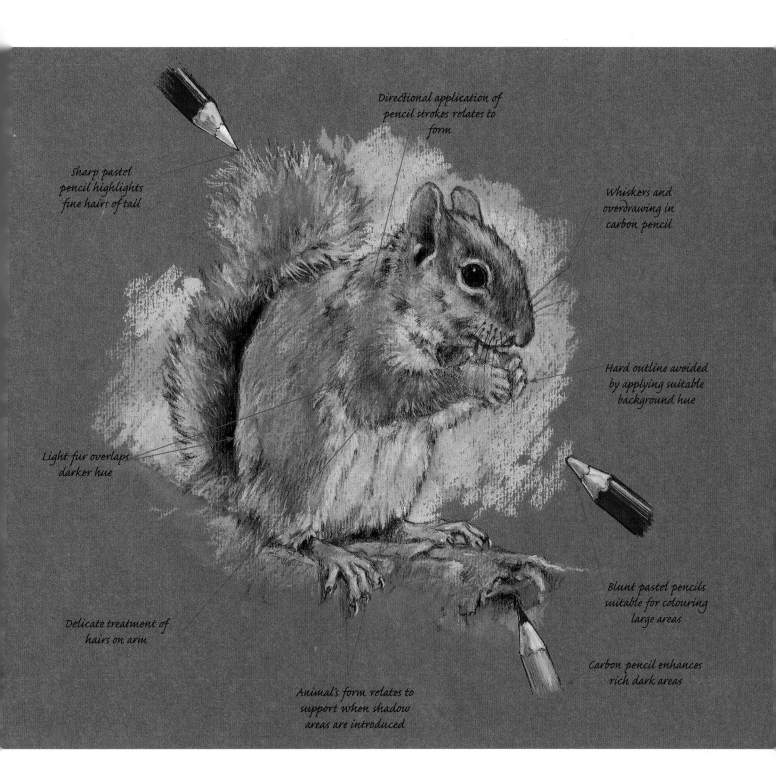

Directional application of pencil strokes relates to form

Sharp pastel pencil highlights fine hairs of tail

Whiskers and overdrawing in carbon pencil

Hard outline avoided by applying suitable background hue

Light fur overlaps darker hue

Delicate treatment of hairs on arm

Blunt pastel pencils suitable for colouring large areas

Carbon pencil enhances rich dark areas

Animal's form relates to support when shadow areas are introduced

Problems

Grey Wolf

carbon pencils and watercolour pencils

Most wolves are smoky grey with tawny-coloured legs and flanks. The light underfur consists of short, thick, soft hair and is protected by thick, hard, smooth guard hairs that act in a similar way to beaver fur (see page 92), shedding moisture and preventing ice collecting on the fur in winter.

Blending subtle colours can cause problems, as the pale washes need to be overlaid with care and consideration for the form. Achieving the effect of the dense coat found on a wolf causes difficulties when the artist is unsure how to suggest the dark areas in recesses and the cast shadows.

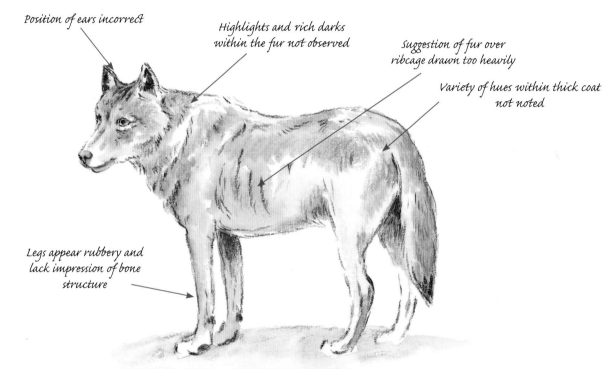

Position of ears incorrect

Highlights and rich darks within the fur not observed

Suggestion of fur over ribcage drawn too heavily

Variety of hues within thick coat not noted

Legs appear rubbery and lack impression of bone structure

Techniques

Carbon pencil and watercolour pencil washes

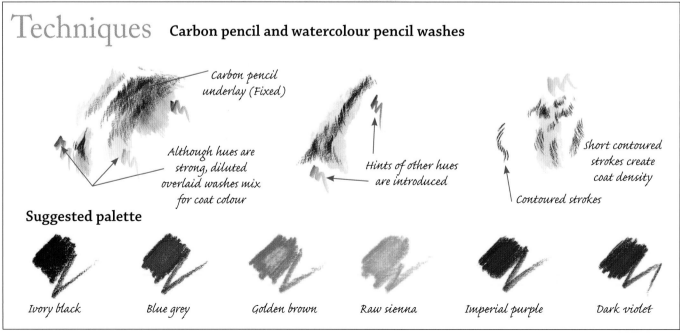

Carbon pencil underlay (Fixed)

Although hues are strong, diluted overlaid washes mix for coat colour

Hints of other hues are introduced

Short contoured strokes create coat density

Contoured strokes

Suggested palette

Ivory black	*Blue grey*	*Golden brown*	*Raw sienna*	*Imperial purple*	*Dark violet*

Three important steps are to draw, fix and paint: first, make your drawing using carbon pencil; next, fix the image to prevent it being disturbed by the addition of water; and apply washes of watercolour pencil directly over the fixed image.

If, on completion, you feel some of the dark areas require further enhancement, you can re-draw over the painting and fix again, to prevent smudging. I used the mixed media of carbon pencil and watercolour pencils, the latter being applied as washes picked up from a 'palette' made on the paper.

A variety of ochre, brown and grey watercolour pencils were combined to produce subtle colours to paint over the fixed drawing.

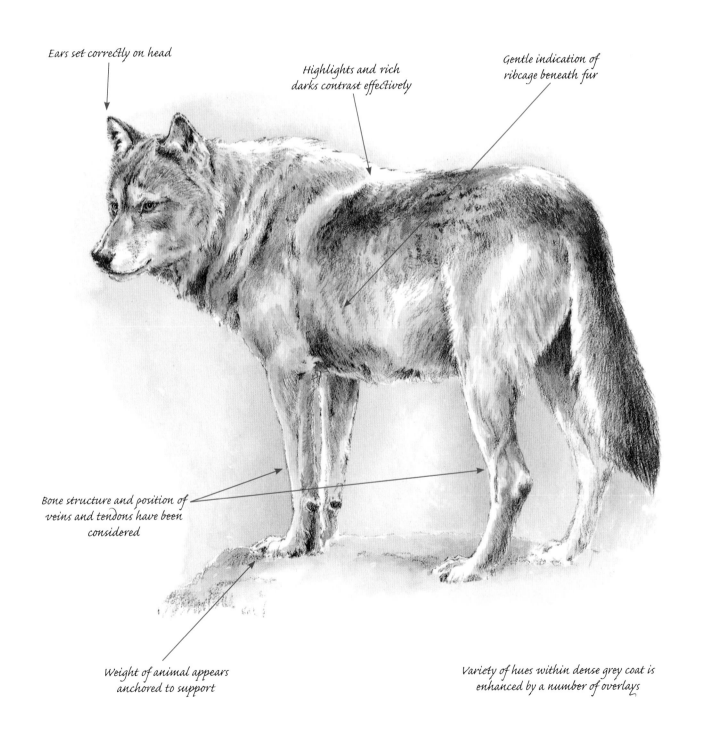

Ears set correctly on head

Highlights and rich darks contrast effectively

Gentle indication of ribcage beneath fur

Bone structure and position of veins and tendons have been considered

Weight of animal appears anchored to support

Variety of hues within dense grey coat is enhanced by a number of overlays

Moose

watercolour

The moose, the largest living deer, needs to eat a vast amount of food each day and browses on trees, marshy vegetation on lakes and underwater plants.

The moose has a Roman-nosed head with overlapping upper lip, and a beard hanging beneath its throat; broad, shovel-like antlers grow between medium-sized lanceolate ears – compare these antlers with those of a fallow deer opposite. Dark areas of coat are blackish-brown, with underparts and legs an off-white colour.

Depiction of variations in the hue of the coat within different body areas, as well as those of tone due to the effect of sunlight and shadows, can cause problems.

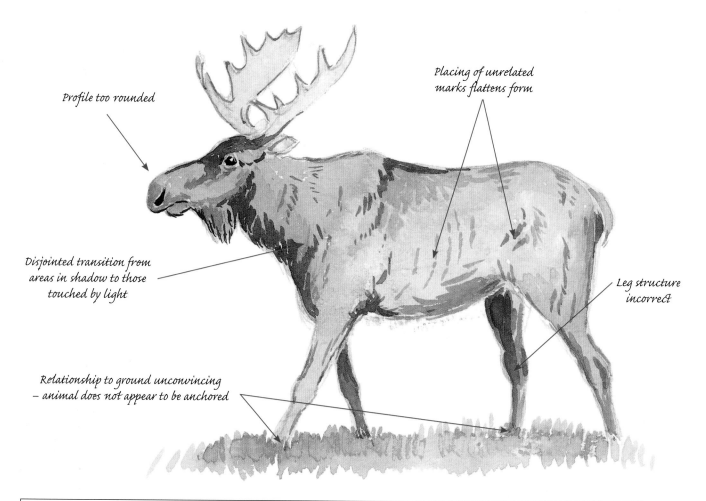

Profile too rounded

Placing of unrelated marks flattens form

Disjointed transition from areas in shadow to those touched by light

Leg structure incorrect

Relationship to ground unconvincing – animal does not appear to be anchored

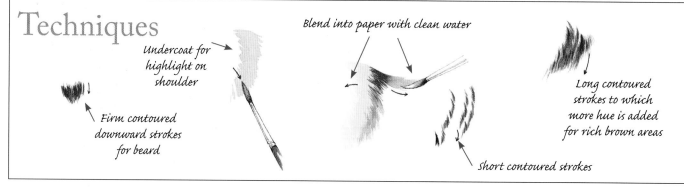

Techniques

Undercoat for highlight on shoulder

Blend into paper with clean water

Firm contoured downward strokes for beard

Long contoured strokes to which more hue is added for rich brown areas

Short contoured strokes

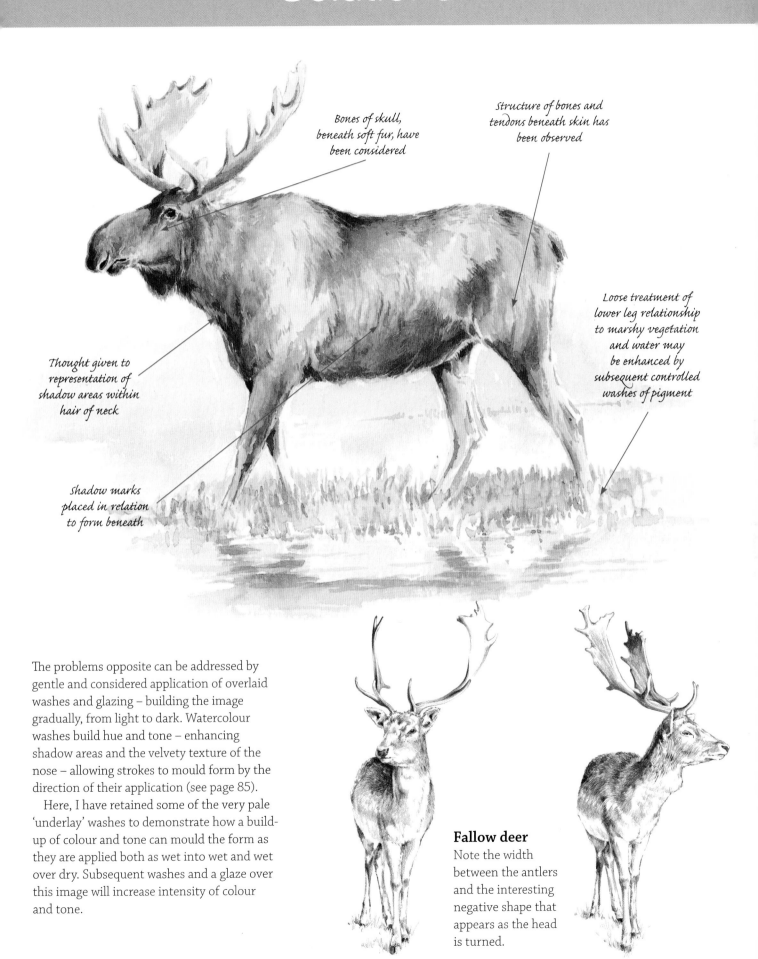

Bones of skull,
beneath soft fur, have
been considered

Structure of bones and
tendons beneath skin has
been observed

Loose treatment of
lower leg relationship
to marshy vegetation
and water may
be enhanced by
subsequent controlled
washes of pigment

Thought given to
representation of
shadow areas within
hair of neck

Shadow marks
placed in relation
to form beneath

The problems opposite can be addressed by gentle and considered application of overlaid washes and glazing – building the image gradually, from light to dark. Watercolour washes build hue and tone – enhancing shadow areas and the velvety texture of the nose – allowing strokes to mould form by the direction of their application (see page 85).

Here, I have retained some of the very pale 'underlay' washes to demonstrate how a build-up of colour and tone can mould the form as they are applied both as wet into wet and wet over dry. Subsequent washes and a glaze over this image will increase intensity of colour and tone.

Fallow deer
Note the width between the antlers and the interesting negative shape that appears as the head is turned.

Problems

Grizzly Bear

watersoluble graphite and watercolour wash

The long, silver-tipped hairs on its brown back and shoulders give the grizzly bear its name. Grizzlies have an excellent sense of smell and good hearing, compensating for poor eyesight. The paws are broad and flat with non-retractile claws that are used for breaking open logs, digging, tearing food apart, climbing and acting as a club on prey.

The problem of depicting thick ruffs of fur is often encountered by inexperienced artists who, unaware of how to define these areas, resort to individual strokes of the pencil, which can present a flat appearance to the image. Cutting in behind the V-shapes of shadow recess areas within the thick fur helps to solve this problem.

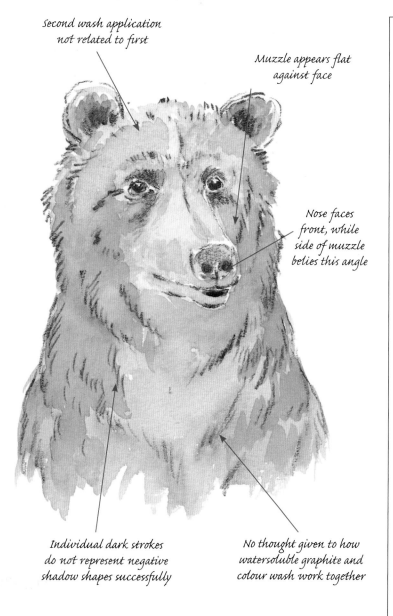

Second wash application not related to first

Muzzle appears flat against face

Nose faces front, while side of muzzle belies this angle

Individual dark strokes do not represent negative shadow shapes successfully

No thought given to how watersoluble graphite and colour wash work together

King of all he surveys

A grizzly is one of the world's most powerful animals, but when standing on its hind legs, it is not usually being aggressive, just viewing the surroundings. This pose offers an excellent opportunity to observe the paws with their strong nails and the texture of the thick fur.

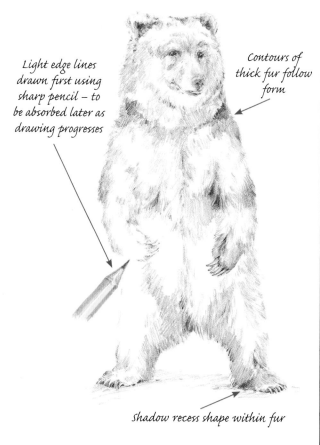

Light edge lines drawn first using sharp pencil – to be absorbed later as drawing progresses

Contours of thick fur follow form

Shadow recess shape within fur

It is important to be aware of structure and form beneath the dense layers of fur; by overlaying watersoluble graphite over watercolour after the initial drawing has been established as well as watercolour over itself, in a considered application, the effect of a three-dimensional image emerges.

Be prepared to build a number of layers – especially within shadow areas where dark recesses contrast with areas of light forms – using directional brush and pencil strokes.

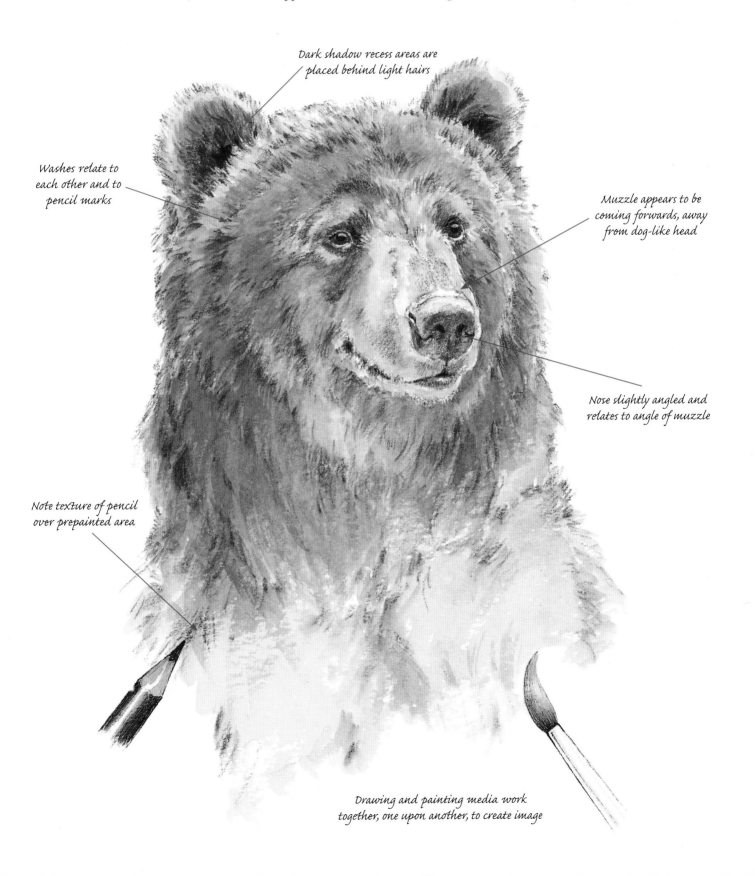

Dark shadow recess areas are placed behind light hairs

Washes relate to each other and to pencil marks

Muzzle appears to be coming forwards, away from dog-like head

Nose slightly angled and relates to angle of muzzle

Note texture of pencil over prepainted area

Drawing and painting media work together, one upon another, to create image

Pencil and Brush Exercises

These exercises relate to the mixture of birds, reptiles and insects in this section, and demonstrate a variety of techniques in both pure and mixed media.

Pen and watercolour

Mixed media of a watercolour wash (using the wet into wet method) combined with detailed ink drawing (using a pigment liner .01 pen) can be very effective where the texture of the watercolour paper also contributes to the overall impression (see page 114). Pen and wash is a popular combination and can be used loosely or, as in this instance, with more detailed representation.

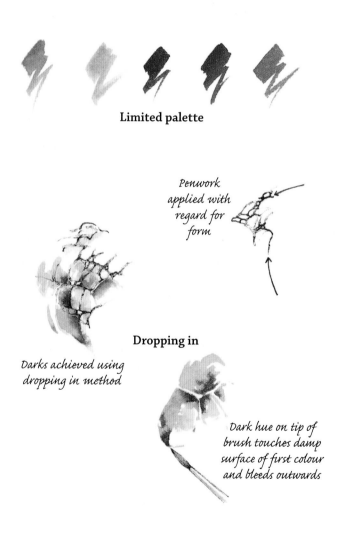

Limited palette

Penwork applied with regard for form

Dropping in

Darks achieved using dropping in method

Dark hue on tip of brush touches damp surface of first colour and bleeds outwards

Brush pens with pigment liner pens

These pens offer colourful contrasts against rich black areas on brightly patterned surfaces. Gentle blending is also possible when using the waterproof brush pens with the addition of a watercolour brush and a little water. The pigment liner pen creates a variety of textures.

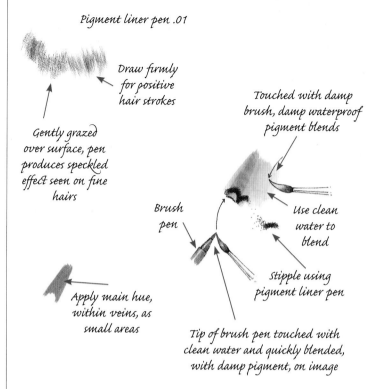

Pigment liner pen .01

Draw firmly for positive hair strokes

Gently grazed over surface, pen produces speckled effect seen on fine hairs

Touched with damp brush, damp waterproof pigment blends

Brush pen

Use clean water to blend

Stipple using pigment liner pen

Apply main hue, within veins, as small areas

Tip of brush pen touched with clean water and quickly blended, with damp pigment, on image

These exercises show how gently contoured lines, drawn using a pigment liner on textured paper, can produce the very delicate effects required for the fine hairs that cover parts of a butterfly's body. These are seen in contrast to the stippled application that helps depict delicate pattern at the edges of the butterfly's wings.

Brush pens

Used alone, these pens can be applied in various ways to create different effects (see page 104). A useful selection of neutral greys in the ranges available mean that you can, if you wish, make your initial drawing in very pale hues, adding brighter ones as the image develops, rather than drawing in pencil first.

Examples of stippling

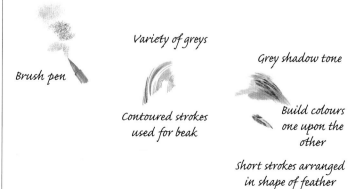

Brush pen

Variety of greys

Contoured strokes used for beak

Grey shadow tone

Build colours one upon the other

Short strokes arranged in shape of feather

Coloured pencils

These are very useful for depicting brightly coloured birds, as their rich hues can be overlaid to produce an intensity of pigment suitable for the vibrant colours, as well as the subtler hues created by gentle application.

Watersoluble graphite pencils

Practise exercises that use the versatility of this range with regard to texture, tone and subtle hues. Experiment upon a variety of surfaces to discover which textures best help to represent your chosen image.

Touch pencil mark with clean water and blend away and outwards

Practise gentle toning around highlight area to define form of eye

To avoid stark background, blend clean water away from edge lines into background to diffuse into paper and create gentle tint

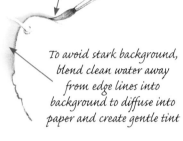

Gently touch edges of tonal area with stippling motion of brush to encourage tone and highlight areas to merge

Dry application

Overlap various hues and observe effects

Wet application

Sweep clean water across areas of dry pigment and observe effects

Pastel sticks

These allow you to make wide or narrow strokes, using the whole width of the length of the stick or just the blunt end (see page 110). Broken pastel sticks are also very useful, and a variety of marks can be made with this painterly medium. I used soft pastels for these exercises.

Practise short pull-down strokes

Practise contoured sweeping strokes

Acrylic

Acrylic often looks more effective when used on a tinted or coloured support, as do pastels, as this creates strong contrasts where white has been used against the hue of the surface (see page 108). When relying more on white for the background, rather than just for the image, you need to decide where the white area is to end; establish this before painting.

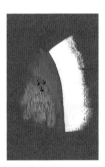
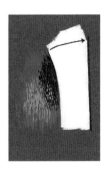
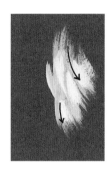

Place layers of colour, working towards light tones before applying rich darks, using short downward strokes

Use flat brush to paint white acrylic up to ink perimeter line

Thick white paint, overlaid on first (diluted) applications, represents longer feathers

Watercolour

In its pure form, watercolour is very sympathetic towards the delicate treatment of overlaid washes that are used to create subtle effects of hue and tone.

These exercises show the curved strokes that form the basis of a toad's back, where warts, with their highlighted areas, create an unusually textured skin surface. You can also practise the glazing method over scales (see page 112).

Contoured stroke application for texture of warts

Dropping dark hue into damp colour to blend

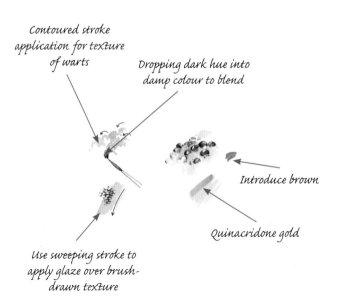

Introduce brown

Quinacridone gold

Use sweeping stroke to apply glaze over brush-drawn texture

Problems

Golden Eagle

`brush pens`

Basically a dark brown bird, the magnificent golden eagle gets its name from the gold-coloured feathers that develop on the bird's head and neck as it ages. Powerful talons capture and kill prey, while the curved beak can open tough animal hide for it to feed – it depends on carrion as well as killing birds and mammals.

When using brush pens, one main problem is heavy-handed application: very light contact with the paper is required, both for the stippling effect and that of fine lines used to depict feather forms. The problem of which paper to choose can also be resolved if you practise on a variety of different surfaces prior to making a decision. Even if your basic drawing of the bird has been carefully observed and placed, insufficient knowledge of the media and careless application can spoil the effect.

Stark contrasts of colours against brilliant white background prevent subtle interpretation

Colour filled in like colouring book, not applied with consideration for form

Density of feathers lost when white allowed to show through strokes indiscriminately

Blocks of white paper, if not intended to represent highlights, need to be covered

Untidy strokes

Techniques

Quick sketch showing width of head

We often see images of a golden eagle in profile – observing the head from a different angle gives an awareness of the width across the skull.

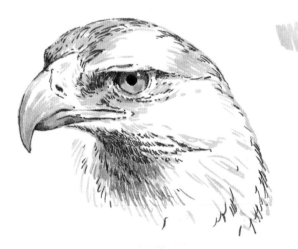

Basic angle established in shades of grey

Brown used for overdrawing

An eagle's eyesight is said to be eight times better than man's, and the characteristic stare from the hooded eyes invites artists to capture its expression.

Colourful brush pens can also be used for rich hues by building layers of colour, using two or three together, or as a monochrome interpretation. Rather than restrict application to 'filling in' the image, you can practise a variety of techniques upon different surfaces, with which you can suggest forms and textures (see pages 102–103). In many instances the paper chosen can make a great difference to the effects achieved; here, I used soft-textured cream Somerset Velvet to encourage subtle contrasts, rather than the starkness of strong colour against white; this surface is also sympathetic to the medium of brush pens.

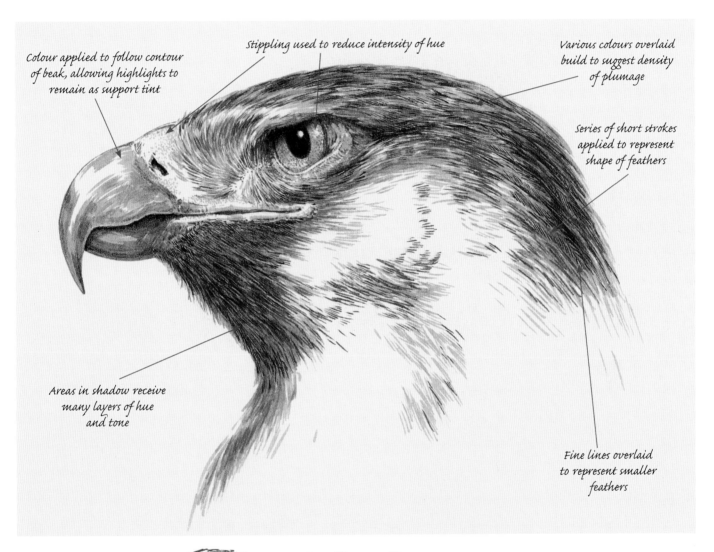

Stippling used to reduce intensity of hue

Colour applied to follow contour of beak, allowing highlights to remain as support tint

Various colours overlaid build to suggest density of plumage

Series of short strokes applied to represent shape of feathers

Areas in shadow receive many layers of hue and tone

Fine lines overlaid to represent smaller feathers

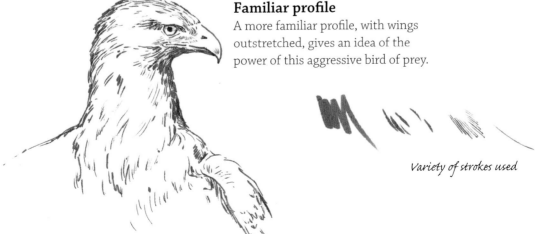

Familiar profile
A more familiar profile, with wings outstretched, gives an idea of the power of this aggressive bird of prey.

Variety of strokes used

Problems

Parrots

coloured pencils

When depicting the bright hues of parrot feathers, coloured pencils provide an ideal medium and can be equally effective applied to smooth or textured paper surfaces.

The social scarlet macaw lives in pairs, groups and flocks, and for this reason I have portrayed a pair of birds, rather than made an individual study. There is an interest of scale within the relationship, with one bird in the foreground and the other further back. A suggestion of background to indicate habitat is also helpful.

Creating the effect of short and longer feathers in layers over the bird's body often causes problems. The texture of these feathers, contrasting with the smooth surface of the bird's powerful bill, is an important consideration, and small, exploratory exercises can be a great help.

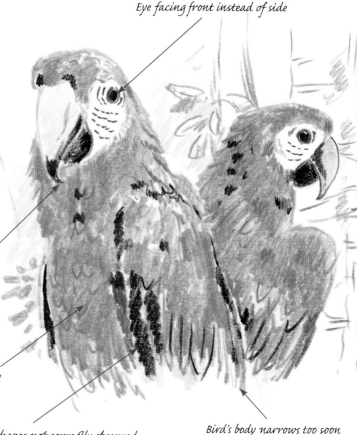

Eye facing front instead of side

Tip of bill too long and seen at wrong angle

Suggestion of feather shapes only outlined, and drawn over carelessly applied underlay

Dark feather shapes not correctly observed

Bird's body narrows too soon

Techniques

Exercise
It is a good idea to experiment with a series of directional strokes, which will help you understand how to depict overlapping feathers and the blending of hue and tone – especially on the multicoloured wing feathers.

Blue – pull strokes down

Yellow – pull strokes down

Black – 'cut up' in

Suggested palette
Using a carefully blended mix of vibrant colours will capture the parrot's bright and beautiful plumage.

Deep vermilion

Scarlet lake

Crimson lake

Deep cadmium

Raw sienna

Bronze

Prussian blue

Black

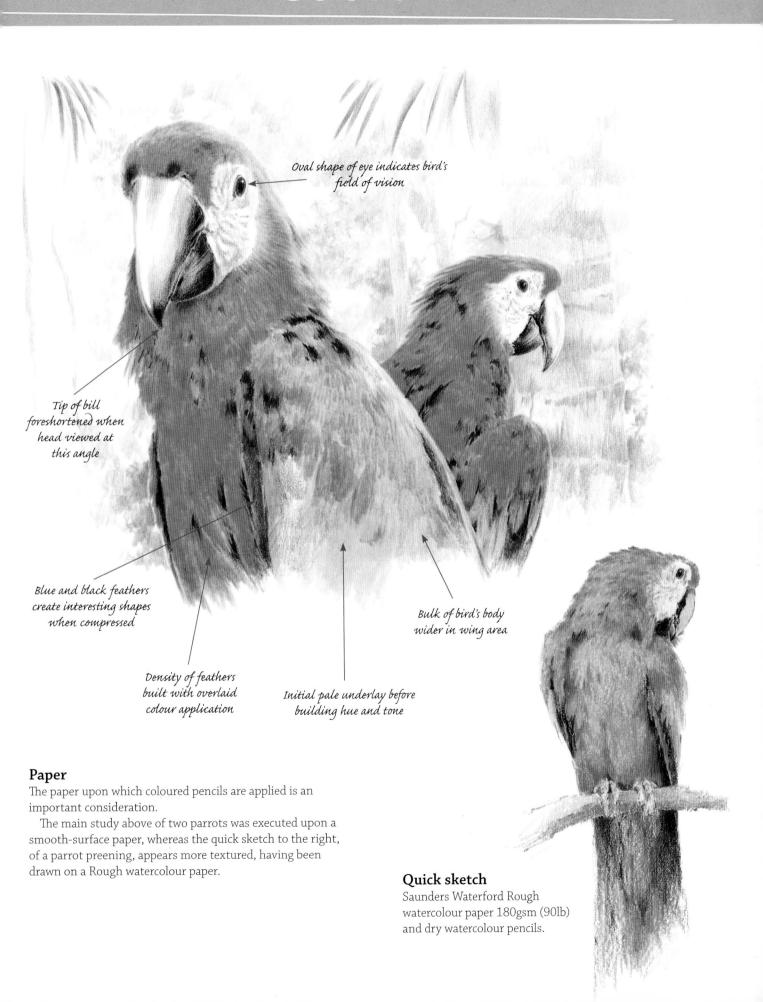

Oval shape of eye indicates bird's
field of vision

Tip of bill
foreshortened when
head viewed at
this angle

Blue and black feathers
create interesting shapes
when compressed

Density of feathers
built with overlaid
colour application

Initial pale underlay before
building hue and tone

Bulk of bird's body
wider in wing area

Paper

The paper upon which coloured pencils are applied is an
important consideration.

The main study above of two parrots was executed upon a
smooth-surface paper, whereas the quick sketch to the right,
of a parrot preening, appears more textured, having been
drawn on a Rough watercolour paper.

Quick sketch

Saunders Waterford Rough
watercolour paper 180gsm (90lb)
and dry watercolour pencils.

Problems

Emperor Penguins

`acrylic`

The heaviest and hardiest of all seabirds is the Emperor penguin, which can stand over 1m (3ft) tall and weigh up to 41kg (90lb). These birds rarely set foot on anything but ice, and it is in this environment, where the head, back and wings appear black against the stark blue-white of their surroundings, that the artist places their forms (the exception is in a zoo environment).

It is sometimes difficult to preplan the stages in which a painting can be built – from choice of support and its colour, through first drawings and composition to the building of overlaid paint to achieve texture and patterns, culminating in the finishing touches and knowing when to stop. There is another factor to consider – whether to make the painting entirely representational or more of an illustrative design.

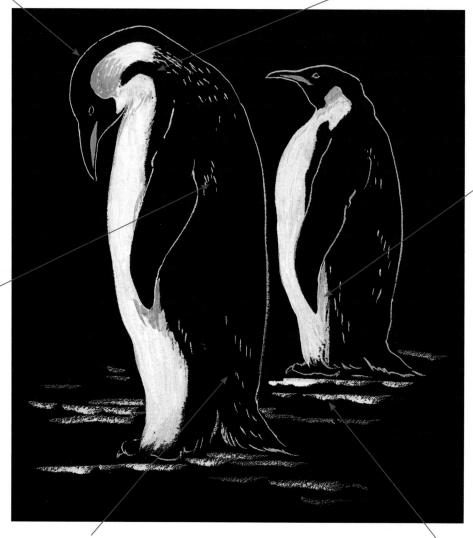

Outline flattens form

Black stripe down from neck not apparent if back and wings are retained as black areas

Line of contrast between black and white too vertical

Few short white lines not sufficient to suggest contoured highlights effectively

Using black paper to represent apparently black areas of birds requires light outline or light background

Unsure how to suggest icy surface

Penguins' streamlined appearance, which enables them to dive to great depths to feed (where they can stay underwater for up to 18 minutes), has a stark beauty of its own, and simple curved shapes lend themselves to depiction in acrylic.

Here, I have simplified the two forms, emphasizing pattern in the glossy backs, rather than approaching them representationally. It is still important to relate the two penguins by considering the shapes between (the white breast of the far bird and the back of the near one) and the negative shapes, and to give thought to planning both the composition and the execution in detail before commencing the painting.

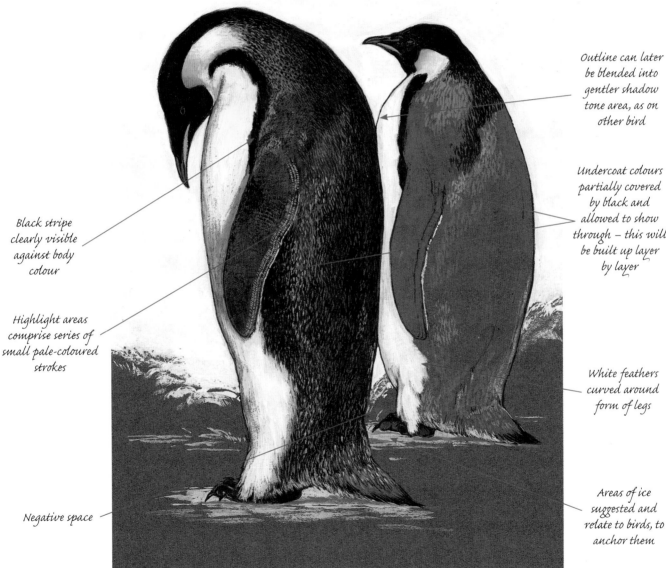

White background brings images of birds forward

Outline can later be blended into gentler shadow tone area, as on other bird

Undercoat colours partially covered by black and allowed to show through – this will be built up layer by layer

Black stripe clearly visible against body colour

Highlight areas comprise series of small pale-coloured strokes

White feathers curved around form of legs

Negative space

Areas of ice suggested and relate to birds, to anchor them

Use of support colour

When painting a light hue behind forms to give them clarity and bring them forwards, you can avoid the problem of when to stop that application by drawing a format, up to which you can paint, that only applies to the upper part of the work. At the base of the picture it is only necessary to indicate a suggestion of the environment – enough to anchor the subjects.

Mute Swan

pastel

Although named the 'mute' swan, this bird does make a variety of hisses and other sounds. A common sight on rivers and freshwater areas, the graceful swan, with its curved wing carriage, makes a delightful subject for pastels; however, knowing which surface to use for pastel work can prove a problem. Sometimes a white is chosen, but this may not enhance the subject matter – particularly a white-feathered bird – thus encouraging the use of outlines in the drawing. The opposite may also apply: a suitable colour may have been chosen for the support, making an outline unnecessary, but the absence of any background will mean that the image is not anchored.

Another problem is the surface texture – if this is too strong and indented, it can detract from the image itself.

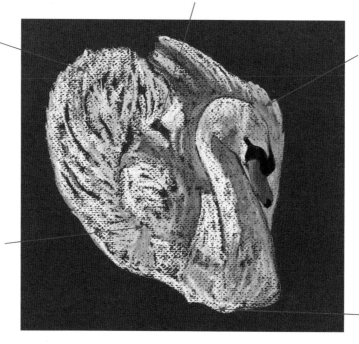

Distorted negative shape means that wings lose attractive formation

Strong texture of paper overpowers pastel image

Form of wings flattened by way pastel applied behind head

Random placing of blue pastel indicates lack of consideration for form

No indication of water surface to define form and anchor bird

Techniques

Working from negative shapes

However swift you intend the final representation to be, it is always advisable to produce an investigative drawing that establishes relationships within the pose.

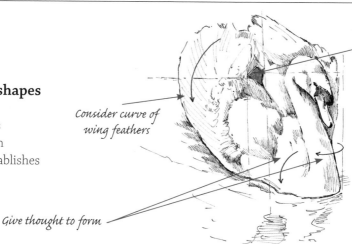

Vertical and horizontal guidelines help place head in correct relationship to wings

Consider curve of wing feathers

Give thought to form

Quick, sweeping application of pastel sticks in a simple representation can be enhanced by consideration for the support upon which the strokes are placed. The marks on this image were quickly placed to produce an impression rather than a detailed study. By choosing a rich coloured support, a unity may be achieved.

One of the most common views is to look down on swans from a bridge or a river bank as they glide majestically by. To enhance this I have chosen an angle seen as the observer looks down at the array of plumage contrasting with the water – here a strong negative shape between the wings leads the eye to the correct placing of head and neck.

Colour of pastel board support enhances image

Strong negative shape forms basis of pose

Slightly contoured strokes with light tips describe curve of wing

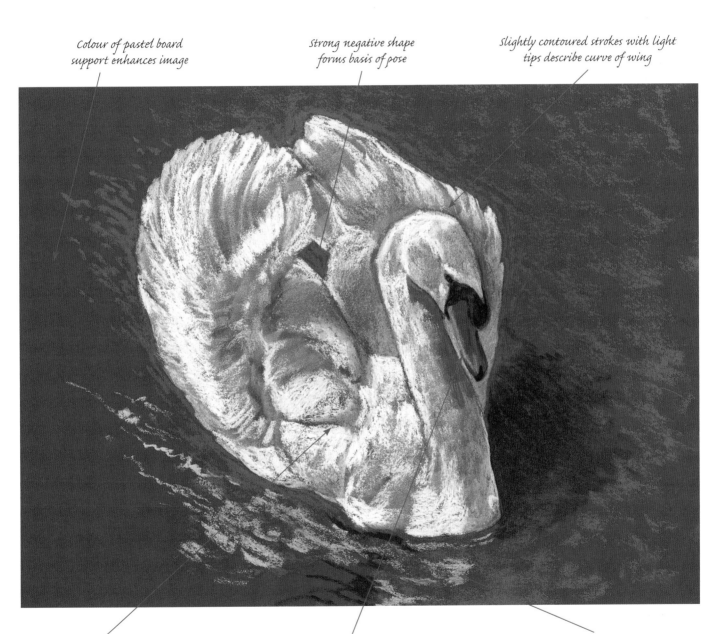

Care given to placing shadow tone areas

Slight separation between bill and neck brings these forwards

Little reflection in water surface anchors bird

Problems

Toad

`watercolour`

The common toad, with a mottled yellowy-brown skin, is well camouflaged in its natural habitat of gardens, fields and woodlands. As extra protection the 'warts' on its back secrete a poison that can prove fatal for some animals but is usually harmless to humans.

Mixing the subtle hues required for the depiction of a toad can cause problems, as can representing the texture of the skin covered by 'warts'. For the former a limited palette is of great help, and for the latter, painting an 'impression' (rather than individual shapes) on the body gives the desired effect.

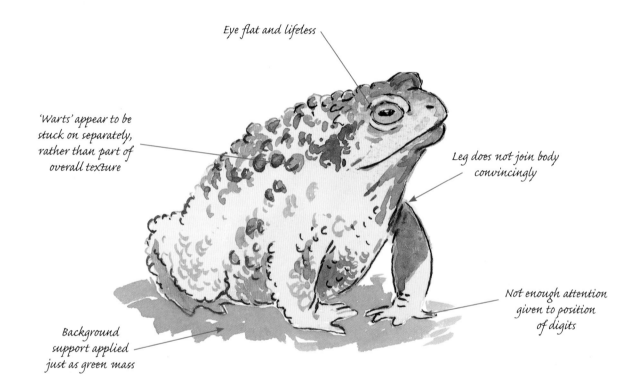

Eye flat and lifeless

'Warts' appear to be stuck on separately, rather than part of overall texture

Leg does not join body convincingly

Not enough attention given to position of digits

Background support applied just as green mass

Techniques

Colours and quantities
The basic colours are raw sienna, cobalt blue and sepia. Black is used very sparingly on features, and quinacridone gold lifts the muted effect.

Raw sienna

Cobalt

Sepia

Bright green

Mixing raw sienna and cobalt in various proportions provides different subtle hues

Sepia can also be included in the mixes to enhance darks

A bright green may appear unsuitable on its own, but can be made more subtle by introducing sepia

The variety of subtle neutral hues required in the depiction of skin surface can be mixed from a limited palette, with darker colours overlaid as watercolour washes to achieve intensity, and brighter areas enhanced by glazes. Lighter legs and underparts can be encouraged to stand forwards because of what is placed behind. The suggestion of a green leaf as support adds unity when gentle glazing is applied over both the leaf and the toad's form.

This illustration shows the various stages of paint application, from the first pencil drawing through to the overlaying of stronger hues around head and shoulders. Loosely draw the image first and then apply an undercoat of pale neutral hue, allowing the brushstrokes to curve on uneven areas of back and sides, resulting in drybrush effects to enhance texture in places. Gently drawn pencil marks can add to the effect if left visible.

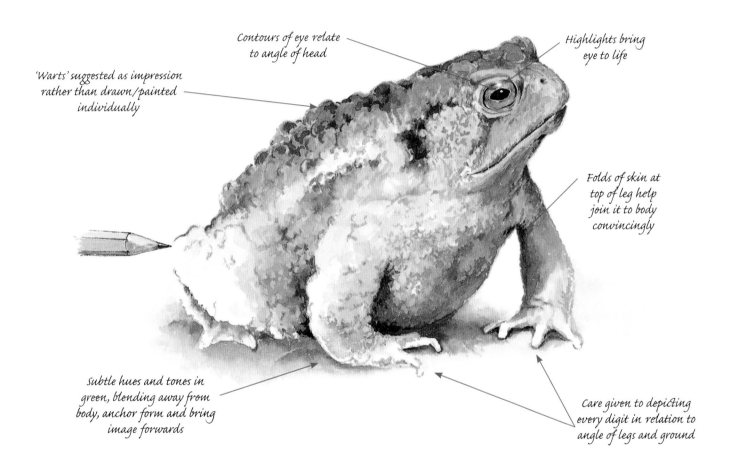

Contours of eye relate to angle of head

Highlights bring eye to life

'Warts' suggested as impression rather than drawn/painted individually

Folds of skin at top of leg help join it to body convincingly

Subtle hues and tones in green, blending away from body, anchor form and bring image forwards

Care given to depicting every digit in relation to angle of legs and ground

Quinacridone gold mixed with raw sienna and cobalt

Winsor & Newton quinacridone gold is ideal for mixing or using as a glaze

Experiment with small amounts of quinacridone gold added to sepia

Monochrome study

Smaller than the toad, a common frog enjoys the same habitat; however, it is much more agile, leaping swiftly away from danger.

Note length of folded hind limbs

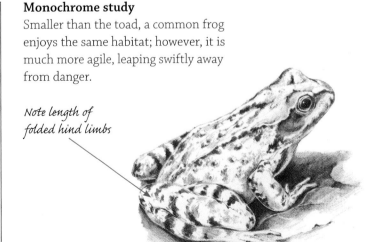

Crocodiles

pen and wash

The Nile crocodile, one of the largest in the world, has teeth in the lower jaw that fit into notches on each side of the upper jaw. Alligators differ in that all the upper teeth hang over those in the lower jaw. In both, the body bulk is not fully supported by the legs but is in contact with the ground.

Problems occur when trying to show how a reptile's scales follow the contours of the form – making them appear flat in places where the forms are rounded or curved. Difficulties can arise at points of transition, where a series of larger scales merge into smaller shapes and linear forms.

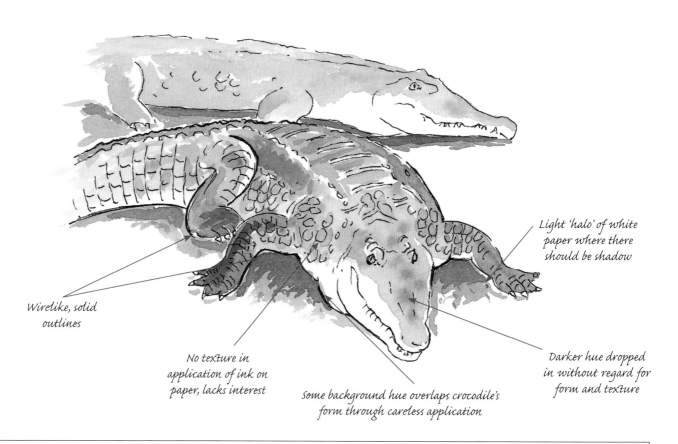

Light 'halo' of white paper where there should be shadow

Wirelike, solid outlines

No texture in application of ink on paper, lacks interest

Some background hue overlaps crocodile's form through careless application

Darker hue dropped in without regard for form and texture

Techniques

Contoured scales

The variety of shape and size of scales on body and legs provides interesting pattern formations. I used a textured watercolour paper surface, which enables a pen drawing to create more texture as it is applied by gently grazing the tip over the surface, rather than using heavier application. This illustration shows consideration for scale arrangements in relation to contours.

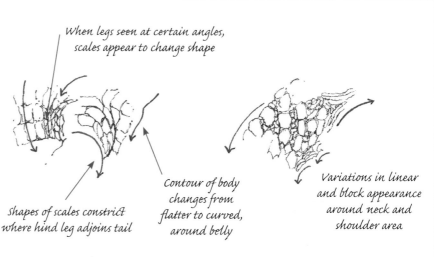

When legs seen at certain angles, scales appear to change shape

shapes of scales constrict where hind leg adjoins tail

Contour of body changes from flatter to curved, around belly

Variations in linear and block appearance around neck and shoulder area

Large, heavy reptiles such as this crocodile can go for long periods without eating, and have fat deposits along their back and tail. Preferring to wait in ambush for prey that is caught in strong jaws, a crocodile is a fearsome predator that can move remarkably quickly for its size. This 'feeling' for weight needs to be incorporated in your artwork.

The use of rich, dark shadow areas beneath the body and limbs effectively anchors this static reptile to its support.

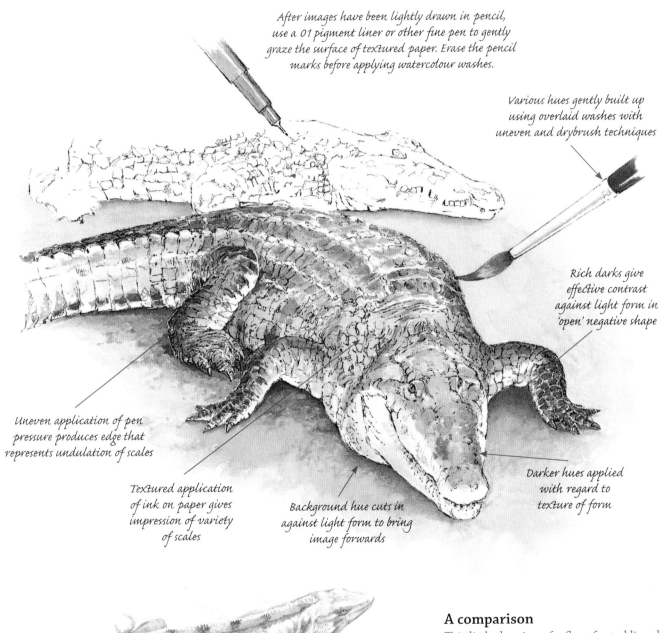

After images have been lightly drawn in pencil, use a 01 pigment liner or other fine pen to gently graze the surface of textured paper. Erase the pencil marks before applying watercolour washes.

Various hues gently built up using overlaid washes with uneven and drybrush techniques

Rich darks give effective contrast against light form in 'open' negative shape

Uneven application of pen pressure produces edge that represents undulation of scales

Textured application of ink on paper gives impression of variety of scales

Background hue cuts in against light form to bring image forwards

Darker hues applied with regard to texture of form

Negative light shapes

A comparison

This little drawing of a fleet-footed lizard shows the differences in the shapes of the body, legs and slim digits of the feet in comparison to the crocodile. Note the position of the cast shadow beneath the lizard's body, indicating distance between this and the ground as it runs at speed.

Butterfly

`brush pens`

With wings outstretched, a butterfly offers precise symmetry for the artist to portray; many butterflies warm their wings by spreading them, so this is a natural position to represent.

The butterfly's body is divided into three sections – head, thorax and abdomen – and most of the body, and appendages, is covered with a layer of flattened hairs. A pair of long antennae rise from between the eyes, expanding at the tip to form a club.

Although many artists can accurately reproduce the symmetry required by using the tracing paper method described below, they may experience problems with depiction due to being unfamiliar with the medium or a lack of close observation.

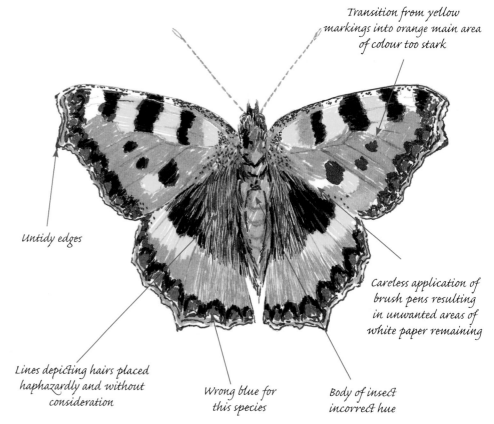

Transition from yellow markings into orange main area of colour too stark

Untidy edges

Careless application of brush pens resulting in unwanted areas of white paper remaining

Lines depicting hairs placed haphazardly and without consideration

Wrong blue for this species

Body of insect incorrect hue

Techniques

Tracing for symmetry

This has been divided into numbered steps to help you achieve a symmetrical image.

1 Place tracing paper over drawn image

Either draw *image and pattern for half butterfly on to tracing paper, using a pencil that is soft enough to produce a mark for tracing onto paper,* **or** *trace over an image*

2 Trace over your drawing

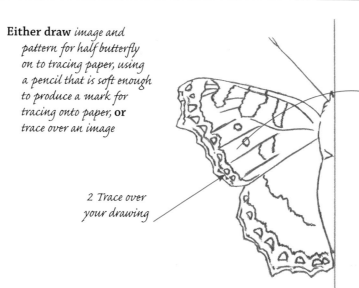

3 Turn tracing paper to expose unmarked side and trace over the image you can see using sharp pencil, to produce identical image adjoining your drawing

Using central 'guideline' helps achieve symmetry

Thoughtful application of the medium is important; give careful consideration to the transitions from one colour to another, to achieve accuracy of markings. I have divided the process involved in presenting this image into three numbered sections.

Looking down upon a butterfly with outspread wings, we are not able to see the three pairs of legs – each pair coming from one of the three segments of the thorax – but should you wish to 'anchor' or ground your image, place it over a leaf or flower.

Draw one set of wings, showing the position of markings in detail. Trace and transfer to other side of centrally drawn guideline

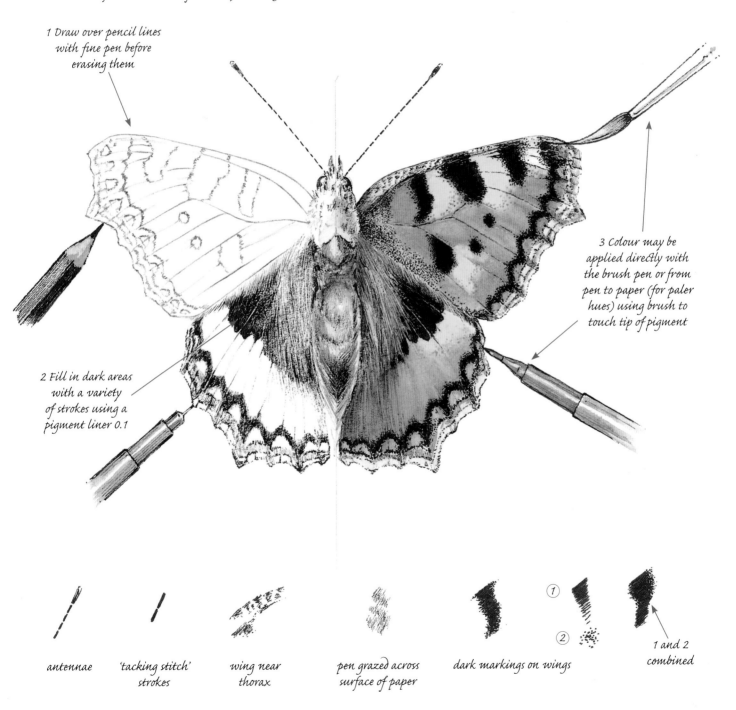

1 Draw over pencil lines with fine pen before erasing them

3 Colour may be applied directly with the brush pen or from pen to paper (for paler hues) using brush to touch tip of pigment

2 Fill in dark areas with a variety of strokes using a pigment liner 0.1

antennae

'tacking stitch' strokes

wing near thorax

pen grazed across surface of paper

dark markings on wings

1 and 2 combined

Problems

Grasshopper

Preferring a grassy habitat where their colour allows them to merge with the surroundings, grasshoppers are not always easy to discover, but when disturbed, they can be seen leaping great distances.

Problems with depiction occur when the various components of this complex creature are not closely observed or its movement understood; the same can be true of other tiny insects.

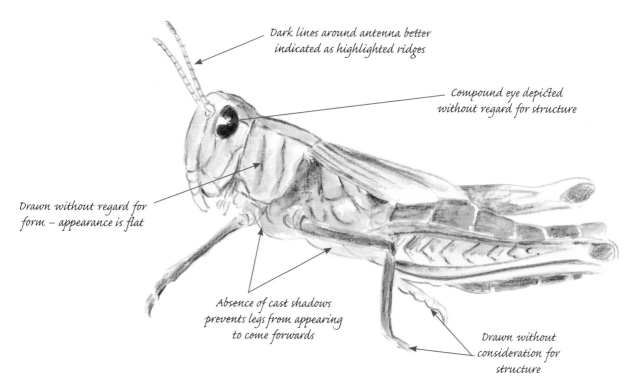

Dark lines around antenna better indicated as highlighted ridges

Compound eye depicted without regard for structure

Drawn without regard for form – appearance is flat

Absence of cast shadows prevents legs from appearing to come forwards

Drawn without consideration for structure

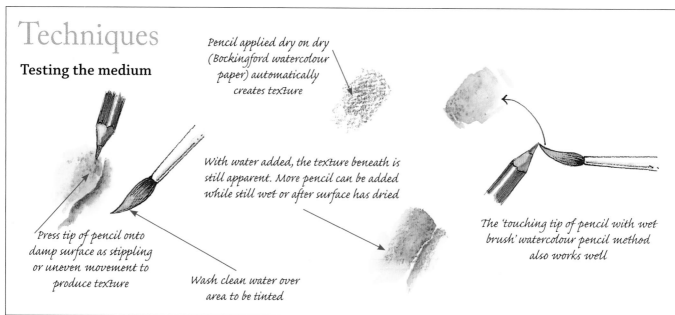

Techniques

Testing the medium

Pencil applied dry on dry (Bockingford watercolour paper) automatically creates texture

With water added, the texture beneath is still apparent. More pencil can be added while still wet or after surface has dried

The 'touching tip of pencil with wet brush' watercolour pencil method also works well

Press tip of pencil onto damp surface as stippling or uneven movement to produce texture

Wash clean water over area to be tinted

You will need clear photographic reference for a subject like this, that is so very small in real life, if you want to enjoy depicting the intricacies involved. Try to understand how the separate components relate to each other in order to depict them convincingly.

The exciting range of tinted graphite pencils produced by Derwent are ideal for depicting a grasshopper. Here I have used a palette that is limited by the subject matter, and these few colours demonstrate their versatility.

Working on different types and weights of paper will produce a variety of effects and shades of colour; with the pencils used dry on dry you can create graphite drawings with a hint of hue, yet once they are in contact with water, vibrant colours emerge.

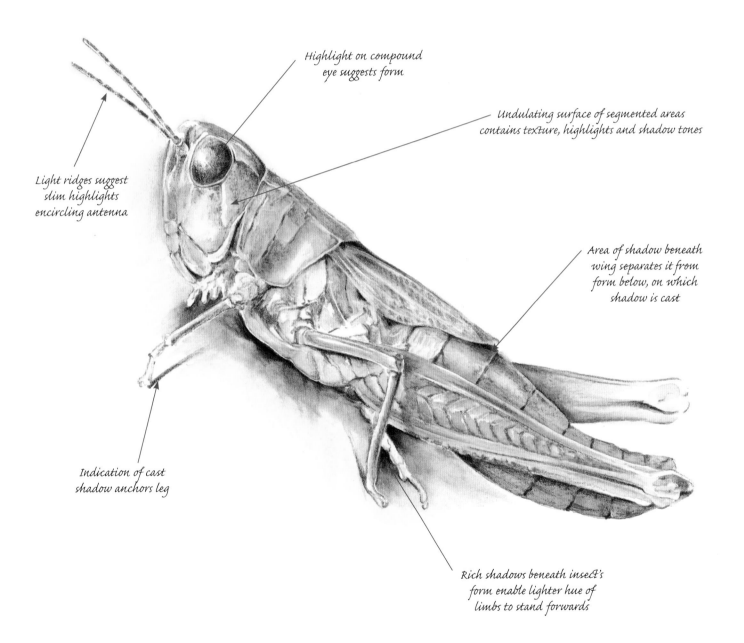

Highlight on compound eye suggests form

Undulating surface of segmented areas contains texture, highlights and shadow tones

Light ridges suggest slim highlights encircling antenna

Area of shadow beneath wing separates it from form below, on which shadow is cast

Indication of cast shadow anchors leg

Rich shadows beneath insect's form enable lighter hue of limbs to stand forwards

Conclusion

Within the variety of subjects, media and techniques in the themes in this book, I hope you have found areas of interest that may be new to you or that may help to enhance your own depictions of animals.

Images that are based on close observation and understanding of the subject matter can only be further enhanced if the structure is sound; this is the reasoning behind the guideline method and observation of both positive and negative shapes shown on pages 28–30. These exercises in accuracy are intended as a learning process, to give a firm base from which to develop your own style. To build the 'scaffolding' on which recognition of different species depends, we can consider three definite stages.

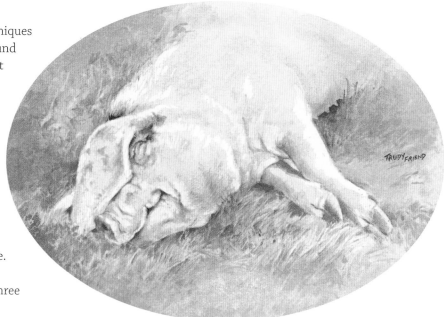

The process

The process of creating a piece of artwork based upon the exercises can be divided like this:

1. Be aware of your subject. Absorb content into your subconscious.

2. Forget your subject as you start drawing, in order to place it correctly. Look for shapes and relationships.

3. Be aware again, in order to make images recognizable.

Unless the subject matter has been suggested, for example in a class, beginners often choose to depict either a subject that interests them or one they think will be 'easy'. If you have ever done the latter, I hope the exercises on pages 28–30 will encourage you to select subjects for the first reason, not the second.

The guideline method works well with any subject. The most important aspect about being aware of your subject is understanding it, and the way to achieve this is by close observation.

Whether you are finding inspiration from photographs in books, watching images on film or working from life, there is no substitute for investigative observation as step one.

Once awareness of your subject matter has been absorbed, which means that understanding of content has been established, you can start the actual preliminary drawing/sketch by forgetting subject matter and concentrating fully on the relationships of shapes within vertical and horizontal guidelines. This will enable you to piece your visual jigsaw together.

When this 'finding out' image is complete, the next step is to tape this 'rough' to a window, place a new sheet of paper over it and lightly trace all the important 'edge' lines on to the new piece of paper. You are then free to add tone and establish three-dimensional impressions.

There are many other advantages to be gained from executing exercises that relate to the particular animal you wish to portray, and practicing them before starting the artwork can be a sort of warm-up, in the same way a musician or athlete prepares for the big moment.

Even with limited time it is possible to love your art to such an extent that you live it – by closely observing animal subjects whenever possible and studying their small movements as well as being aware of those that are more extensive and obvious.

With all these considerations in your artistic repertoire, you will indeed be seeing the animal world 'with an artist's eye' – and what a wonderful world it is!

Index

acrylic
 as base coat 11, 48, 51, 63, 66–7
 exercises 48, 103
 mixing 13, 50
 techniques 11, 13, 42–3, 66–7
angles 31, 33, 57, 61, 62, 81, 89, 111

backgrounds 18, 32, 36, 37, 47, 53, 56, 57, 77, 113, 115
brush exercises 35, 48–9
brush pens 7, 9, 102, 117
 application 104–5
 and pigment liner pens 102

carbon pencils 44–5, 85, 95
 exercises 35
 and watercolour pencils 96–7
charcoal pencil 68–9
clear water wash 65, 83, 85
coloured pencils 8–9, 70–1, 103, 107
 creating tones 20
 exercises 48, 64, 78, 81, 106
 see also watercolour pencils
composition 21, 27, 31, 50–1
contact points 29, 30, 62, 77
contrast 69, 88
counterchange 53, 59
crosshatching 15, 32, 76
'cutting in' 22, 33, 40, 65, 72, 73, 85, 100

dappled effect 49, 58–9
details 15, 33, 45
'dropping in' 10, 40–1, 102
drybrush 10, 43, 113

eyes
 highlights in 22, 40, 43, 86, 87, 113, 119
 shape/position of 37, 41, 45, 47, 69, 86

feathers 23, 49, 60–1, 63, 106
fibre-tip pens 85, 92, 93
fixing images 85, 97
form
 finding 44–5

and lines 16–17
and markings 45, 82, 83
and texture 68
fur
 acrylic 43
 black 36
 dense 75, 89, 100–1
 and fibre-tip pens 92, 93
 and graphite pencil 91
 and watercolour 12, 35, 40
 and watercolour pencils 76
 wet 15, 85, 91, 93

glazing 10, 65, 75, 99, 113
gouache 11, 20, 49, 63
graphite pencils 91
 exercises 34
 sketching with 38–9
 tinted 118–19
guidelines 28, 29–30, 37, 57, 67

hair
 and acrylic 13
 and mixed media 15
 and pencil 14, 78
 and watercolour 12, 14, 35, 46–7, 98
heads 22–3, 26
highlights
 on bodies 71, 93, 97, 109
 on eyes 22, 40, 43, 86, 87, 113, 119
hue 91

lifting colour 10
limbs
 observing 44, 45
 vs. body mass 26–7
lines
 and form 16–17
 'lost' lines 17, 18, 81
 and markings 18

markings 18–19, 45, 82–3
mixed media 15, 85
mixing colours 12–13, 36, 46, 50, 112–13
monochrome 6–7, 88–9
movement 24–5, 53

negative shapes 17, 25, 26, 47, 53, 56, 57, 77, 109, 110, 115
 and composition 27, 30, 111

open/closed 28, 29
and proportions 80, 83

overdrawing 41, 95

paper
 coloured 17, 51, 71, 95
 textured 48, 64, 68–9, 78–9, 89, 95
 white 22
pastels
 colour range 94
 pencils 8–9, 20, 52–3, 85, 94–5
 sticks 8, 85, 103
 supports for 110, 111
patterns 80–1
pen, ink and wash 23, 75
pen and ink 7, 23
 exercises 54–5, 64
 techniques 17, 74
pen and watercolour 19, 102
pencil
 exercises 34–5, 84
 textures 14, 15
pencils 6
 see also individual types
pens 7
 see also individual types
photographs 28, 30, 31, 119
 choice of angle 33
 and distortion 31–2
pigment liner pens
 and brush pens 102
 and watercolour 19
pressure, on/off 6, 16, 17, 55, 69, 91
proportions 56, 67, 80, 83

scale 50, 56, 67
scales 114, 115
sgraffito 85, 93
shadow shapes 18, 91
 within fur/hair 12, 22, 33, 39, 77, 89, 92, 93
shadows
 cast 21, 26, 39, 115, 119
 overlaid 10, 49, 82
shapes 28, 56
sketches 16–17, 31–2, 38–9
 investigative 47, 56, 62, 67, 110
 moving subjects 24–5, 54–5
skin 15, 71

softness 23, 62–3
stippling 15, 23, 102, 105
strokes
 contoured 15, 23, 34, 43, 69, 91
 directional 22, 52, 74
 short 10, 18, 73
subject observation 31, 77, 79
supports
 coloured 8, 51, 52, 53, 63, 66, 109, 111
 textured 8, 15, 53, 110
 see also paper
symmetry 116–17

texture 14–15, 68, 71
tonal values 20
tone
 and composition 21
 and hue 91
tracing images 51, 70, 116

underdrawing 51, 70, 86, 113
unity 111, 113

'wandering' lines 16, 33, 34, 39
washes
 laying flat washes 70
 overlaid 41, 65, 72, 75, 85, 87, 96, 99, 101, 113
water marks 40, 70
water-soluble graphite 34, 38, 84
 exercises 82, 103
 and watercolour 36, 100–1
water-soluble pens 7
watercolour 10, 22
 cutting in 40, 65, 72, 73
 exercises 35, 49, 85, 103
 mixing 12, 36, 46, 112–13
 techniques 10, 14, 58, 72, 98
 and water-soluble graphite 100–1
watercolour pencils 7, 9
 creating tones 20
 exercises 64, 84
 techniques 76, 88
 using with carbon pencils 96–7
wet-in-wet 10, 41, 102
whiskers 33, 73, 74, 75
white areas
 using opaque paint 73
 and white of paper 22
wool 14–15, 48, 57